Key Monuments

of the

Italian Renaissance

also by
Laurie Schneider Adams

Giotto in Perspective, editor (1974)
Art on Trial (1976)
Art and Psychoanalysis (1993)
A History of Western Art (1993)
The Methodologies of Art (1996)
Art Across Time (1999)
Key Monuments of the Baroque (2000)

Key Monuments

of the

Italian Renaissance

Laurie Schneider Adams

Icon Editions
Westview Press
A Member of the Perseus Books Group

Copyright © 2000 by Laurie Schneider Adams

Published in 2000 in the United States of America by Westview Press, 5500 Central Avenue, Boulder, Colorado 80301-2877, and in the United Kingdom by Westview Press, 12 Hid's Copse Road, Cumnor Hill, Oxford OX2 9JJ

Find us on the World Wide Web at www.westviewpress.com

A CIP catalog record for this book is available from the Library of Congress.
ISBN 0-8133-3426-8

The paper used in this publication meets the requirements of the American National Standard for Permanence of Paper for Printed Library Materials Z39.48-1984.

10 9 8 7 6 5 4 3 2 1

Contents

Preface

The title of this volume, *Key Monuments of the Italian Renaissance,* reflects the view that not all art is created equal. It is intended to affirm the existence of individual genius and of identifiable styles of art within recognizable historical periods. It implies that in any given context (time and place) some events are more significant than others. In the history of art, the significant "events" are key works of art: primarily pictures, sculptures, and buildings. And although works of art may be influenced by external circumstances—for example, social, economic, and political factors; available technology and training; prevailing styles and conventions; cultural attitudes toward religion, secularism, race, gender, class, and so forth—these do not account for artistic production with the same force as the will and talent of the artist.

This bias is not intended to imply that only a single significant style emerges in a given time and place, for history is dynamic. We sometimes speak of "movements" in art, a term that connotes both the fluid nature of artistic development and the coexistence of more than one style at a time. Nevertheless, there is usually what is called a "prevailing" style, which is the characteristic one, coexisting with preferences for earlier (sometimes called "old-fashioned" or "retardataire") styles as well as with newer developments (called "modern" or "avant-garde"). Such aesthetic forces, combined with the abilities of the artists themselves, create the dynamic tensions of art history.

Nor should the external circumstances of context be ignored or underestimated. For example, under the totalitarian regimes of Nazi Germany and Stalinist Russia, avant-garde art was considered degenerate and thus prohibited. As a result, some artists emigrated, some remained and changed their style (as Kasimir Malevich did), whereas others worked in a relatively safe zone in an occupied country (as Henri Matisse did). As has been said many times, where there's life there's hope, a sentiment that can be applied to the production of art no matter what the odds. As with the old adage that "truth will out," one could say that history has shown that "talent will out." Despite the traditional Western bias against training women to be artists, some women made successful careers in art. Michelangelo's father opposed his ambition to become an artist and, according to his biographers, beat him physically,

abused him emotionally, and, for a time, tried to bar him from artistic training. And Vincent van Gogh persisted in making art, indeed made some of the greatest art, even though there was absolutely no market for his work during his lifetime.

A book of this size necessarily limits the options available to its author. This book begins around the turn of the fourteenth century with Cimabue and Giotto and ends with the last painting of Titian, on which the artist was still working at his death in 1576. Obviously there are many more key monuments than those discussed in this volume, and there will inevitably be disagreement about some of the selections. In general, as I have used the term here, a key monument is a significant work by a major artist, such as Masaccio's *Tribute Money*; a work such as the guild church of Or San Michele that is noteworthy as a reflection of a particular context; or a work that exerted a particular influence on the art or viewing public of its time. Examples of the latter category include Bernardo Rossellino's tomb of Leonardo Bruni and Pisanello's medal of John VIII Paleologus.

The advantage of focusing on the highlights of a specific historical period is that it allows occasional forays into different critical and methodological approaches. By limiting the selections to key monuments, it is possible to consider them from different points of view, thereby acknowledging both the primacy of individual genius and the contextual forces that interact with artistic production. The aim of this book is to introduce the reader to some of the greatest works of art and to the artists who created them in one of the most extraordinary periods of Western civilization.

The book consists of an Introduction and eight chapters. Words in boldface in the text are defined in a Glossary at the end, and boxed asides define artistic media, provide brief biographical sketches, and other background information useful for a survey of Italian Renaissance art. The Bibliography is intentionally brief; it includes the works cited in the endnotes to each chapter and suggestions for further reading.

Several people have been extremely helpful in the preparation of this volume. John Adams, Paul Barolsky, Carla Lord, and Mark Zucker have read the manuscript thoroughly and offered many useful suggestions. The copyediting by Alice Colwell has also improved the text a great deal. My editor, Cass Canfield, Jr., has been, as always, supportive and helpful from the beginning to the end of the project.

Laurie Schneider Adams

Key Monuments
of the
Italian Renaissance

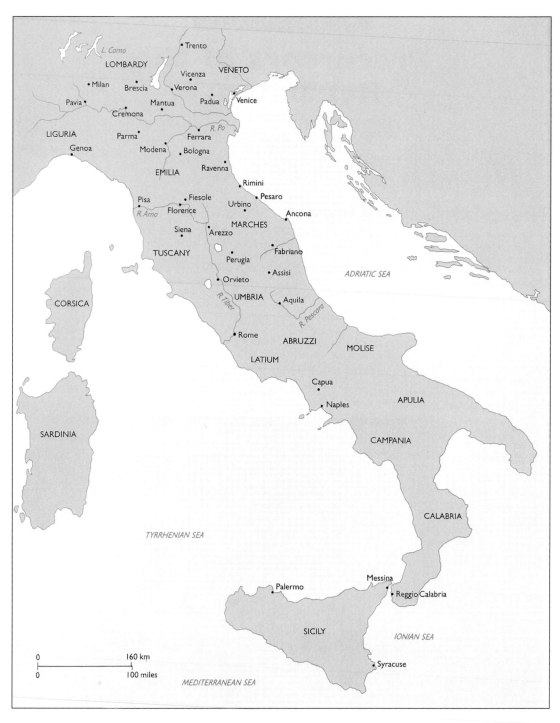

Map of Renaissance Italy

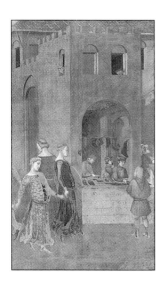

Fourteenth-Century Precursors

talian Renaissance, as used in this volume, refers to the period from roughly 1300 to around the middle of the sixteenth century. The term *Renaissance,* coined in nineteenth-century France, corresponds to the Italian term *rinascità,* meaning "rebirth." Insofar as this denotes the entire period, it characterizes the waning of the Middle Ages and the rebirth of the Classical past—at first the Roman past and later the Greek past. *Rinascità* was also used by Giorgio Vasari, the sixteenth-century Mannerist artist and biographer of artists, to describe the stylistic innovations of Giotto di Bondone (1266/67–1337). In Vasari's view, Giotto's genius as a painter marked the end of medieval painting, with its two-dimensional depiction of space and Byzantine gold backgrounds, and opened the way for the development of Renaissance **naturalism.**

Taking a leaf from Vasari's *Lives,* this text considers the innovations of Giotto at the turn of the fourteenth century. Born in the Mugello, near Florence, Giotto worked throughout Italy—especially in Florence,

Padua, Rome, and Naples—and possibly in France, mainly as a **fresco** painter. His style laid the foundation for a revolution in the visual arts. As it happened, the cultural context was also developing in ways that encouraged new artistic styles. The most important of these developments was the emergence of humanism. Before turning to Giotto's paintings, therefore, it is necessary to review the role of humanism in fourteenth-century Italy.

The Origins of Humanism

Humanism is a complex concept that embraces different facets of Renaissance culture. The term itself is derived from Latin (*humanitas*) and refers to a curriculum designed to demonstrate the dignity of man, a notion that would develop fully in the fifteenth century. As a cultural trend, humanism includes a revival of interest in artworks and texts in science, geography, history, mythology, philosophy, and mathematics

Giorgio Vasari

Giorgio Vasari (1511–1574) was a Mannerist painter and architect but is best known for his biographies of Renaissance artists—*The Lives of the Most Eminent Painters, Sculptors, and Architects,* published in two editions, in 1550 and 1568. His stated purpose was to preserve the memory of the great Italian artists and to record their works. Vasari conceived of the history of art in terms of human development, evolving in three stages from infancy through youth to maturity. In his view, the major artist of the first stage was Giotto, whereas Michelangelo exemplified artistic maturity.

Vasari's *Lives* not only is *the* key monument of Renaissance art history written in the mid-sixteenth century but also provides a biographical framework of the period. Vasari relates the work of each artist to his or her character and talent rather than to social, political, or economic factors. In this approach, Vasari reflects the new synthesis of mind and body, of intellect and achievement, of the contemplative and the active life that distinguishes Renaissance from medieval thought. A product of his time, Vasari includes many conventional contemporary anecdotes about artists, some of which have proved to be inaccurate. Nevertheless, the *Lives* is an invaluable resource for the study of Renaissance art and thought.

Ideals of government also informed humanist thought; the notion of civic humanism led to a revival of the republican spirit associated with Rome before its empire. And although the so-called republican cities of the Renaissance—notably Padua and Venice, Florence and Siena—were actually oligarchies, they nevertheless encouraged citizen participation in government.

Humanists collected, copied, and translated Roman and Greek texts and also wrote commentaries on them. They preferred Roman to Gothic script and modeled their works on those of Classical authors. In 1314, for example, Alberto Mussatus (1261–1329) was crowned poet of Padua—an ancient Roman ceremony—for plays written in the style of Seneca, the Roman dramatist. Around the same time, Paduan lawyers became interested in the works of Cicero, the first-century-B.C. Roman orator and statesman whose writings would become a model for many humanists. The University of Padua itself was a crossroads of cultural interchange.

In Florence the banker Giovanni Villani (c. 1276–1348) wrote the earliest surviving history of the city, depicting Florence as a descendant of republican Rome. Like the Roman historian Pliny the Elder (A.D. 23–79), who discusses artists and their media in his *Natural History,* Villani includes artists among the famous men who bring honor to the city. This was an early manifestation of social changes that brought about a gradual rise in the status of the artist in the course of the fifteenth and sixteenth centuries.

Florence, like Padua, was an early center of humanism. Both were free cities, or *comuni,* and supported thriving mercantile

of ancient Rome and Greece. In contrast to the medieval emphasis on spirituality, contemplation, and salvation but at the same time maintaining the tenets of Christianity, humanism stressed the importance of nature and human achievement. This aspect of the Renaissance reflected the Greek maxim "Man is the measure of things."

economies. These led to increased wealth among private citizens, in contrast to the feudal system of the Middle Ages. As a result, the nature and range of art patronage expanded. Whereas the primary art patron had been the Church, private individuals now began to commission works of art.

Florence had the most dynamic economy in fourteenth-century Italy, although it suffered serious reverses at various times. The Bardi and Peruzzi banks failed, bubonic plague devastated the city along with much of Europe in 1348, and political struggles continued. The Guelfs, who supported the pope in Rome, were the party of the merchants in Florence. Supporters of the Holy Roman Emperor, the Ghibellines were the party of the Florentine nobility and had territorial designs on other Italian city-states. In 1378 the Ciompi rebellion— a revolt by wool workers in support of the right to join a guild—erupted. Despite these and other conflicts, however, Florence prospered. The florin, the Florentine monetary unit first minted in 1252, set the international standard.

Petrarch and Boccaccio

The leading literary exponents of fourteenth-century humanism were Francesco Petrarca (1304–1374) and Giovanni Boccaccio (1313–1375). Petrarch's rediscovery of forgotten Classical Latin texts, especially those of Cicero, was seminal for the development of humanism. He created his own personal dialogue with the Roman past by writing letters addressed to Cicero, Seneca, Pliny, Livy, Virgil, and other Classical authors. His private library of ancient manu-

scripts was renowned. Influenced by Livy's (50 B.C.–A.D. 17) *History of Rome*, Petrarch wrote *De viribus illustribus* (*On Famous Men*), a series of biographies of famous Romans that spurred the Renaissance interest in fame. And the *Aeneid* of Virgil (70–19 B.C.) inspired Petrarch's epic poem *Africa*, about the second Punic war, waged between Rome and Carthage. Although Petrarch never mastered ancient Greek, he admired Greek authors and collected manuscripts of Homer and Plato.

Petrarch was also instrumental in reviving the Roman notion of the countryside as providing respite from urban tensions. He saw nature as conducive to contemplation and the life of the mind. In a famous passage describing his ascent of Mount Ventoux, in France, Petrarch wrote:

> The impulse to make the climb actually took hold of me while I was reading Livy's *History of Rome* yesterday, and I happened upon the place where Philip of Macedon, the one who waged the war against the Romans, climbed Mount Haemus in Thessaly. . . . At first, because I was not accustomed to the quality of the air and the effect of the wide expanse of view spread out before me, I stood there like a dazed person. I could see the clouds under our feet, and the tales I had read of Athos and Olympus seemed less incredible as I myself was witnessing the very same things from a less famous mountain.[1]

Throughout the Renaissance, this passage would reinforce the new approach to nature and the view of man's place in it.

Boccaccio's *Decameron* (c. 1350) shares Petrarch's humanist interest in nature. In that work, "nature" is human nature, observed by Boccaccio as people confronted the devastation of bubonic plague, known as the Black Death. His account of ten young Florentines who escape the epidemic by fleeing to the countryside is an insightful view of human character. In contrast to the romanticized, courtly tales characteristic of medieval narratives, Boccaccio grounds his stories in contemporary reality. Each tale is a mirror of one man's personal experience, through which a detailed picture of the human condition emerges.

According to Boccaccio, Petrarch had restored ancient Rome—its myths, literature, sense of history, and practice of rhetoric—to its rightful position in Italian culture. Boccaccio's admiration of Petrarch fueled his own interest in Classical texts. He learned more Greek than Petrarch and arranged for a professorship of Greek to be established at the University (*Studium*) of Florence.

Boccaccio took a similar view of Giotto. He believed that Giotto had resurrected the art of painting, literally calling it back from the grave where it had lain buried since the fall of the Roman Empire. In his allegorical *Amorosa visione* (Amorous Vision), Boccaccio describes a vast hall decorated with frescoes depicting great personages of the past. The paintings were of such genius, he wrote, that no artist but Giotto could equal them. Some 200 years later, Vasari would echo Boccaccio's sentiments, writing that Giotto revived good painting, which had lain "buried for so many years under the ruins of war."[2]

Boccaccio elaborated his view of Giotto's genius with a metaphor that would resonate throughout the Renaissance and be applied to other great artists. On the one hand, he asserted, Giotto rivaled nature itself, for his pictures contained so much truth that they were often mistaken for the real thing. On the other hand, Giotto, like Petrarch, had succeeded in restoring light—formally and figuratively—to the art of painting. The notion of the painter's light became associated with the transition from the "darkness" of the Middle Ages to the more "enlightened" *rinascità*. With enlightenment went insight and understanding, so that Giotto's work was said to appeal to those who saw clearly rather than to the ignorant.

The Myth of Giotto

The humanist conviction that Giotto had singlehandedly restored painting to the light of day took on mythic proportions. This is evident in the Renaissance revival of the ancient Greek and Roman tradition of constructing anecdotes about artists. Typically, such anecdotes encapsulate an artist's personality and reveal salient aspects of his style. The popular anecdotes that circulated about Giotto reinforce Boccaccio's metaphor and confirm the esteem in which the artist was held by his contemporaries.

Following the humanist custom of linking the Classical past with the present, Giotto was compared with Socrates. Both were not only proverbially ugly, they were also endowed with wisdom and insight. Just as Plato had described Socrates as ugly on the outside but beautiful on the inside,

provided that one *listened* to his words, so Giotto went unnoticed by the ignorant but was appreciated by those who knew how to *look* and therefore to *see*. The Italian poet Dante reportedly spoke of this very juxtaposition of light and dark with beauty and ugliness. In the tale of his encounter with Giotto, Dante inquires why the artist's children are so ugly when his paintings are so beautiful. Giotto's reply: "I create by daylight, but I *procreate* in the darkness of night."

The well-known story of Giotto's *O* relates that he turned himself into a compass by making himself rigid and extending his arm in order to draw a perfect circle for the pope's messenger. The pope, who is among the enlightened, recognizes Giotto's genius the moment he sees the *O*. In this tale, Giotto identifies physically with the compass; in so doing, he exemplifies the Greek maxim that "man is the measure of things" by literally becoming his own instrument of measurement. Giotto's physical relationship to his art—whether by comparison with procreation or by merging with the compass—reflects humanist efforts to fuse mind and body in a new way. During the Middle Ages, in contrast, the body had been considered physically corrupt and distinct from the purity of the soul.

To the medieval representation of God as architect of the universe, the Renaissance added the image of the artist creating works that rivaled nature. Drawing on antiquity, Renaissance authors cited the myth of the Greek artist Daedalus, whose lifelike sculptures were believed to be able to walk and talk. Giotto's **illusionism** was compared to that of the Classical artist Zeuxis, whose realistic paintings of horses caused live horses to neigh when they saw them and whose depictions of grapes made live birds peck at them. Boccaccio noted that Giotto's realism was equal to that of Apelles, the personal portrait painter of Alexander the Great.

The biographical character of the anecdotal tradition reflects the Renaissance emphasis on personal as well as cultural history that had also been a feature of Greco-Roman antiquity. In the Early Christian and medieval periods, the interest in artists' biographies had been replaced by hagiography and the miracles of the saints. With the emergence of humanism in fourteenth-century Italy, biography ceased to be used for purely religious purposes and became associated with the primacy of man.

Giotto and Cimabue

Another connection between the ancient anecdotes and those describing Giotto's genius is their shared theme of competition between artists. The Greek story in which Apelles and Protogenes compete in drawing the finest line became the paradigm for artistic rivalry. In the mythic tradition of Giotto, the anecdotes recount his triumph over the leading Byzantine-style artist of the previous generation, Cenni di Pepi, known as Cimabue (c. 1272–1302). Cimabue was reputed to have been Giotto's teacher, and although this is most likely not the case, the anecdotal tradition depicts him in that role. As such, Cimabue is surpassed by his pupil—both in the ability to paint from nature and in subsequent fame.

According to one anecdote, Cimabue comes upon Giotto, who is a shepherd boy,

drawing a sheep on a rock. The older artist, like the pope in the tale of the compass, recognizes Giotto's genius and obtains his father's permission to take him on as an apprentice. The mythic quality of this account is highlighted by the historical probability that Giotto would have come from a middle-class family and would have been apprenticed by his father to a master painter.

His training would have been rigorous. Like all apprentices, the young Giotto would have been given menial tasks, such as cleaning the shop, grinding **pigments**, making brushes, and preparing wood panels and plaster walls as surfaces for the master's paintings. He would spend years copying his master's style, contributing peripheral details to his master's work, and eventually helping with the main part of the work. Finally, when his training was complete, he would prepare a work of his own—the "masterpiece"—and submit it for entry into a guild as a master in his own right.

In contrast to his anecdotal reputation as a natural genius, Giotto, like all artists in the Middle Ages, would have been considered an artisan. Once he achieved success, he was accorded the status of *familia hospitii,* equivalent to a member of a royal household, when he worked for the Angevin court of Naples. Nevertheless, painting was not yet considered a liberal art, and artists remained craftsmen. The anecdotes, therefore, reflect early efforts by artists to elevate their social and intellectual status.

After Giotto had come into his own as a painter, he reportedly used his superior talent to make fun of Cimabue by painting a fly on the nose of one of his teacher's figures. Cimabue, like the horses and birds who took images for reality, was duly de-

The Guilds

A guild was a group of workers organized according to their craft. Guilds were not new to the Renaissance—in Italy they are documented as early as the sixth century— but they achieved a new status. They defined standards of work, controlled prices and salaries, and protected workers and their families.

In mercantile fourteenth-century Florence, guilds had considerable political influence and played an important role in commissioning works of art. There were seven major guilds, the *arti maggiori,* and fourteen lesser guilds, the *arti minori,* which created a balance of power between the professional and artisanal classes. The *arti maggiori* included guilds representing judges and lawyers (*giudici e notai*), cloth manufacturers (*arte della lana*)—who helped finance the construction of Florence Cathedral—wool refiners (*calimala*), silk workers (*seta*), bankers and money changers (*cambio*), furriers (*pellicai*), and doctors and apothecaries (*medici e speziali*). Painters, including Giotto, belonged to the latter because their pigments fell into the category of chemical substances and drugs. Goldsmiths and sculptors in bronze were members of the Silk Workers' Guild, and sculptors in stone belonged to the Stone and Wood Carvers' Guild, one of the *arti minori.*

ceived and tried to brush off the fly. Giotto's fame in having surpassed Cimabue was immortalized by Dante: "O empty glory of human powers! How short the time its green endures at its peak, if it be not overtaken by crude ages! Cimabue thought to hold the field in painting, and

now Giotto has the cry, so that the fame of the former is obscured."[3]

In the sixteenth century, Vasari would recall Dante's lines and include their message in his life of Cimabue. "Giotto," he wrote, "truly obscured his [Cimabue's] fame not otherwise than as a great light does the splendour of one much less."[4] Clearly, then, Giotto's reputation for having ushered in a new era in the visual arts endured throughout the Renaissance. To a large extent, this is still Giotto's reputation today.

NOTES

1. Petrarch, "The Ascent of Mount Ventoux," in Francesco Petrarca, *Familiares* IV.i. *Rerum familiarium Libri* IV, 1, ed. V. Rossi in Francesco Petrarca, *Le Familiari* I, Florence, 1933, pp. 11, 15, trans. M. Musa, *Petrarch,* Oxford. For this reference, I am indebted to Nicholas Mann, director of The Warburg Institute, London.

2. Giorgio Vasari, *Lives of the Most Eminent Painters, Sculptors, and Architects,* trans. Gaston du C. de Vere, New York, 1979, vol. 1, p. 98.

3. Dante, *Purgatory* 11, 91–96. Cited by Millard Meiss, *Painting in Florence and Siena After the Black Death,* Princeton, 1951, p. 5.

4. Vasari, *Lives,* vol. 1, p. 48.

Key Monuments of Fourteenth-Century Painting

The key monuments of fourteenth-century Italy begin with Giotto and the shift from Cimabue's Late Byzantine style to Early Renaissance style. Vasari describes Cimabue as the last great Byzantine artist, who occupied a transitional role between the "dark" past and the "enlightenment" of the Renaissance. In his reputed role as Giotto's teacher, Cimabue was seen as a kind of midwife to the *rinascità*.

Cimabue and Giotto

A comparison of two monumental paintings, the *Madonna Enthroned*, by Cimabue and Giotto will serve to highlight the latter's departure from Byzantine tradition. Both works were commissioned for high altars of churches in Florence—Cimabue's of about 1285 [1.1] for the Church of Santa Trinità, Giotto's version of around 1310 [1.2] for the Ognissanti Church. Both were executed in **tempera**, confronting worshipers with monumental, imposing images of Mary and Christ enthroned against gold backgrounds and flanked by angels.

Cimabue's Byzantine-style throne rises in the picture space, elevating Mary above the material world of the viewer. The resulting verticality of the image reinforces the impression of towering divinity conveyed by the Virgin and Christ. Beside the throne, elongated angels also rise, one behind the other, until the wings of the uppermost angels are cropped by the diagonal edge of the picture plane. Below the elevated throne are Abraham (the patriarch), David (the ancestor of Mary), and the prophets Jeremiah and Isaiah. Each holds a scroll denoting prophecy and, in the context of this altarpiece, foreknowledge of Christ. Mary's right hand gestures toward the infant Christ on her lap, informing viewers that her son is the fulfillment of Old Testament prophecy and the Savior.

Both altarpieces depict central Christian images, and their original contexts, each over the high altar of a church, reflect their association with the Eucharist. This cele-

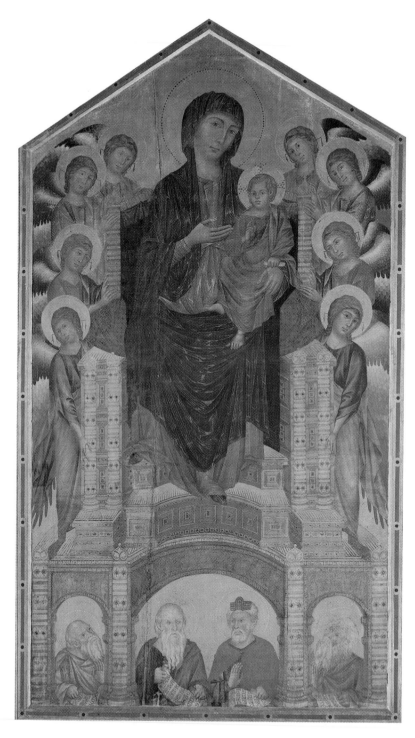

1.1 Cimabue, *Madonna Enthroned* (for Santa Trinità), 1280s. Tempera on wood.
Galleria degli Uffizi, Florence. (Scala/Art Resource)

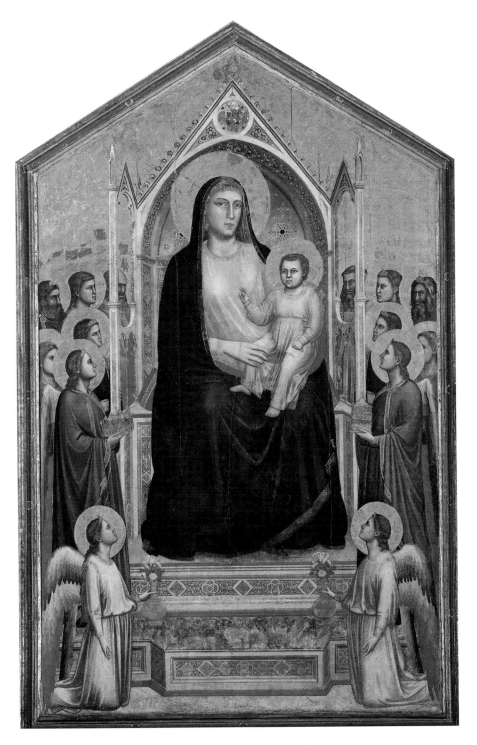

1.2 Giotto, *Madonna Enthroned* (*Ognissanti Madonna*), c. 1310. Tempera on wood. Galleria degli Uffizi, Florence. (Scala/Art Resource)

bration of Christ's role as Savior through death and resurrection, his simultaneously human and divine nature, and his ultimate triumph as King of Heaven is contained in the **iconography** of both works.

The iconography of Giotto's *Madonna Enthroned* is similar to Cimabue's, but the treatment of form and space is more sculptural. The Gothic throne does not rise but rather seems to bear the weight of its occupants. It is set solidly on a horizontal floor and is approached by a sequence of logical planes—the floor itself and the projecting step. In the horizontal arrangement of the top six figures on either side of the throne, Giotto revives the Classical convention of **isocephaly**, in which heads are aligned horizontally, reinforcing the sense of a horizontal ground plane. Kneeling before the throne are two angels who anchor the image, grounding it with their volumetric form. Like the figures flanking the throne, they gaze on Mary and Christ. In contrast, Cimabue's angels turn in various directions and do not create the intense psychological focus on Mary and Christ that characterizes Giotto's image.

Giotto's Madonna is larger and more massive than Cimabue's. She, like her throne, obeys gravity and sits solidly on the cushioned seat. Cimabue's figure, conversely, seems to rise along with the throne. In contrast to Cimabue's Mary, Giotto's holds Christ with both hands, indicating his physical weight on her lap. Giotto's Christ is more naturally babylike; he has visible rolls of fat around his wrists and neck, and his head is larger in proportion to the size of his body. This aspect of Giotto's *Madonna Enthroned* reflects the growing observation and depiction of

Tempera

Tempera was one of three main materials (media) used by Renaissance painters. It is a water-based paint made by mixing pigments ground from vegetable or mineral extracts with water and egg yolk. During the Middle Ages and Renaissance, tempera was applied to wooden panels typically used for altarpieces. The panel required careful preparation to avoid warping and to provide a durable support for the painting. It had to be sanded, **sized** (by a process of sealing), and covered with layers of **gesso** (an absorbent mixture of water, chalk, and glue). Tempera allowed artists to paint precisely, using small, animal-hair brushes. Although the paint itself dries fairly quickly, tempera panels were set aside to age for up to a year and then were varnished.

childhood reality that was part of the Renaissance interest in nature.

The emphasis on physical reality in Giotto's painting is also striking. His draperies are heavy and solid, defining the figures' weight and form. Mary's *contrapposto* (the twist at the waist), for example, is defined by the curves of her white undergarment. The void between her knees is as defined as the solid forms, here by the V shapes of the drapery folds. The relative naturalism of Giotto's figures and of the space they occupy enhances the viewer's ability to identify with them. Similarly, the focused gaze of the angels draws viewers into the painted space and engages them dramatically with the mother-son image. The picture plane thus replicates the "fourth wall" of the stage, possibly reflect-

ing both the revival of Classical theater in the early fourteenth century and the prevalence of Christian mystery plays. It is this very combination of physical and dramatic identification with the scene that exemplifies the new synthesis of mind and body and corresponds to Renaissance notions of human dignity.

Giotto depicts both solid form and voids through gradual changes in light and dark, which Renaissance authors referred to as **chiaroscuro**. He thus represents the natural **shading** that identifies form and indicates that light enters the picture from slightly to the right of center. This creates the transparent quality of Christ's drapery, which appears to filter light. Such is not the case in Cimabue's picture; there the shading is rudimentary, and the illusion of drapery folds is created by elegant, linear gold surface patterns.

Giotto's reputation for having brought painting out of darkness into light was consistent with his formal innovations. For through his use of *chiaroscuro* rather than lines and outlines, Giotto punctured the two-dimensional picture space of the Byzantine painters. He achieved an illusion of three-dimensional space that is more consistent with the experience of nature. He also created characters of psychological depth with whom viewers identify. In this mind-body synthesis and combination of physical with psychological and spiritual qualities, Giotto unified form and iconography.

From its inception in the fourth century, Christian iconography had represented the idea of Christ as "newborn King" with the image of a miraculous little man, or homunculus. Both Cimabue and Giotto have represented Christ in this way, combining adult and infantile features. The infants are small and sit on Mary's lap; she, in turn, functions formally, iconographically, and psychologically as her child's throne. Christ is regal in pose and gesture. He is also intelligent beyond his years, for the scroll in his left hand allies him with the divine foreknowledge of the prophets.

Giotto as well as Cimabue has continued the traditional Christian opposition of right and left. In both altarpieces, Christ's scroll, held in his left hand, is the **attribute** of Old Testament prophets; with his right hand, he makes the gesture of benediction. The latter denotes his role as the new King, and the formal transition from his left to his right hand echoes the historical change from the Old to the New.

Although the persistence of such conventions would have facilitated worshipers' reading of the imagery, Giotto added iconographic elements that reinforce his formal innovations. For example, by darkening the transparent drapery, Giotto draws attention to Christ's genitals, which would become a sign of his humanity in Renaissance painting.[1] Likewise, the solid physicality of Mary's grasp on Christ, in contrast to the fully covered, suspended Christ of Cimabue, shows that she is his earthly mother, responsible for his physical and emotional support. The configuration in which Christ's right arm curves around in front of Mary's rounded breast emphasizes her role as the source of maternal nourishment. At the same time, however, in extending his blessing arm across Mary, Giotto's Christ projects a more assertive character than Cimabue's. The latter restrains his right arm, leaving space for Mary's right hand as the central gesture.

The assertiveness of Giotto's Christ, together with his solid, blocklike form, endows him with a new air of self-confidence.

Compared with Cimabue and his medieval predecessors, Giotto conveys a more humanist conception of time. The Christian revision of history, called **typology**, read events and personages before Christ as prefigurations of what followed his birth. What followed was thus a fulfillment of what had come before, relating past and future to the present. The Renaissance view of history did not discard the typological system but combined it with the chronological time of the human life span. This combination is evident in the naturalism of Giotto's depiction of the mother-child relationship, as well as in iconographic details that evoke past or future time. The kneeling angels, for example, hold vases of roses and lilies, both of which symbolize the Virgin.

In scenes of the Annunciation, lilies denote Mary's purity and passion; their presence here thus denotes the conception of Christ. As such, they refer to a time before the time represented in the altarpiece, just as they precede Mary and Christ spatially on the step of the throne. The roses refer to Mary as the Madonna of the Rose and her aspect as a rose without thorns—an allusion to the legend that roses grew without thorns before the Fall. Mary's typological role as the new Eve and as the redeemer of Eve's sins is thus reinforced by the motif of the rose.

The standing angel at the right holds a cylindrical jar that resembles the ointment jar of Mary Magdalen, who anointed Christ's feet at his death. This, then, refers to a future time and reinforces the notion that Christ, like the Madonna, had foreknowledge of the Crucifixion and accepted it as part of his earthly mission. The crown held by the angel in green at the left refers to a time after the Crucifixion, when Christ takes his place as King of Heaven. There he will crown Mary Queen of Heaven, and mother and son, fulfilling the universal Oedipal fantasy, will be reunited in a timeless, mystical marriage.

Cimabue's depiction of time, like the formal organization of his image, is arranged in a vertical alignment. This conforms to Christian convention, in which what is higher is more holy than what is lower—heaven, for example, is always above hell. It is also consistent with the formal verticality of Byzantine style as compared with the more three-dimensional space of the Renaissance. The figures below the throne, therefore, belong to the past, whereas those above the throne belong to present and future.

In Giotto's image, figures of different ages and male and female saints in addition to angels are reproduced. There is thus a greater variety of human types in the *Ognissanti Madonna* than in Cimabue's picture. Giotto has also placed four elderly, bearded men in the last row, possibly merging them with space and correlating age with distance.

Duccio di Buoninsegna

Although Florence was the most progressive mercantile city in fourteenth-century Italy, art production was also thriving in the Tuscan city of Siena. Sienese painting retained traces of the Byzantine taste for elegant, curvilinear design and gold back-

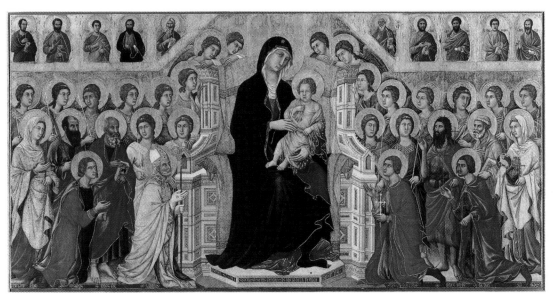

1.3 Duccio, *Madonna Enthroned* from the front of the *Maestà,* 1308–1311. Tempera on panel. Museo dell' Opera del Duomo, Siena. (Scala/Art Resource)

grounds that emphasize the two-dimensional reality of the picture plane.

In the fourteenth century, Siena was a republic with the Virgin Mary as its patron saint. She was also the object of a growing cult, and Siena was called *vetusta civitas virginis*—"ancient city of the Virgin." Thus when the city's leading painter, Duccio di Buoninsegna (active 1278–1318/19), completed the *Maestà* (*Virgin in Majesty*), the high altarpiece of the cathedral, in 1308, he inscribed the base of the throne, *"MATER SANCTA DEI SIS CAUSA SENIS REQUIEI SIS DUCIO VITA TE QUIA PINXIT ITA"*—"Holy Mother of God, give peace to Siena and life to Duccio, who painted thee in this way." This inscription reflects the combined civic and religious significance of the work.

The altarpiece, painted on the front and back, was placed under a **baldachin** below

the dome of the cathedral. On the front was a large image of the enthroned Mary and Christ, surrounded by saints and angels [1.3]. The four patron saints of Siena, identified by inscriptions, kneel in supplication before Mary. In so doing, they act on behalf of the city itself, praying for her intercession as Duccio has done on his own behalf in the inscription. Above Mary and Christ is a row of waist-length apostles surmounted by scenes from the life of Mary; below are **predella** panels illustrating the early life of Christ. The back of the altarpiece is decorated with scenes of Christ's Ministry and Passion, reinforcing the relationship of the altarpiece with the Mass performed at the high altar. The pinnacles depict events after Christ's death

The horizontal composition of Duccio's central image minimizes the verticality of

Cimabue's altarpiece and suggests the presence of a logical "floor." Parallel to Duccio's "floor" are the seat and platform of the white marble throne, a solid structure that seems to obey the laws of gravity. Likewise, the bulk of Mary's drapery is rendered in *chiaroscuro,* with the brightest areas of light falling on her knees. The figures are also shaded, so that their forms appear organically structured—for example, Christ's left shoulder and **foreshortened** left foot.

Despite Duccio's use of certain of Giotto's innovations, his taste for linear patterning, curvilinear form, and rich color predominates. The draperies of Duccio's saints and angels are far more elaborate, with their rich brocades, chromatic variety, and abundance of gold, than those in Giotto's *Madonna Enthroned.* Likewise, Mary's red undergarment and the green cushion of her throne retain the gold rhythms that characterize Cimabue's draperies. Nor is Mary's form rendered with the blocklike, sculptural bulk of Giotto's figure. The drapery of Duccio's Christ resembles the simplicity of the plain pink-and-white garment worn by Giotto's Christ, but Duccio has added a patterned, flowing, transparent robe edged with gold.

Duccio's Christ is more babylike than Cimabue's—with rolls of fat around his wrists and ankles and a chubby face—but less so than Giotto's. Nor does he sit on Mary's lap with the same volumetric force as Giotto's Christ. Mary's left hand does not firmly grasp his flesh as it does in Giotto's image but rather seems to rest lightly on his leg. Duccio's Christ, who neither holds a scroll nor engages the viewer with a gesture of blessing, is less assertive than Giotto's Christ. Here, he withdraws, as

if deferring to Mary's central role in the civic and religious life of Siena.

Spatially, too, Duccio's organization is somewhat flatter than Giotto's, despite the horizontality of the floor. The sides of the throne are expansive rather than foreshortened in the manner of Giotto. They seem to open out, creating a visual metaphor for both Mary and the Church, whose arms embrace the faithful. In contrast to Cimabue's Madonna, who towers above the viewer, and Giotto's Madonna, who is set back in space, Duccio's figure appears closer to both the actual picture plane and the painted floor. Her resulting accessibility to the viewer is a feature of her position in Sienese culture. Formally reinforcing this aspect of Mary is the finely woven gold cloth at the back of the throne, which flattens the space by its virtual blending with the gold background. The feet and robes of the four kneeling foreground saints overlap the edge of the painted floor, advancing them toward the viewer's space.

Duccio's attention to patterning and texture rather than volume engages the viewer with surface detail. His angels and saints, like those of Cimabue, occasionally turn from Mary and Christ and thus do not create the powerful focused gaze of Giotto's figures. As a result, neither Cimabue nor Duccio produces the dramatic psychological effects that evoke the viewer's identification with form and space that characterizes Giotto's paintings. In the work of Cimabue and Duccio, it is with the richness of color and linear rhythms that viewers identify.

Duccio completed the *Maestà* in 1311. June 9 of that year was declared a public

holiday in Siena, and the altarpiece was carried to the cathedral in a citywide procession. According to a contemporary account, priests, the aristocratic members of the ruling council known as the Nine, government officials, and citizens accompanied the *Maestà*. Some held lighted candles while bells rang throughout the city and musicians played bagpipes and trumpets.

Ambrogio Lorenzetti

The two main sources of artistic patronage in Siena were the cathedral and the Palazzo Pubblico, or town hall. In the latter, Ambrogio Lorenzetti's (active 1319–1348) monumental frescoes—depicting allegories of good and bad government—reflect the new attitudes toward nature and our place in it. The commission came from the Nine, who met in the Sala della Pace (Hall of Peace) where the frescoes would be located. As a total iconographic **program**, the pictures are exemplary in nature. They warn of the dangers of bad government, which leads to disorder, crime, rebellion, and war. They also show that when man-made institutions, such as government and other civic organizations, are justly run, the result is prosperity in the town as well as the countryside.

Illustrated here [1.4] are the better-preserved scenes of the *Effects of Good Government in the City* and *Effects of Good Government in the Country*. As they are arranged on the wall, the two scenes appear unified in time and place. The hunting party, with dogs and hawks, rides toward the country through the medieval, **crenellated** walls of the city. Within the walls, men arrive with horses and mules carrying produce from the country, and at the lower right a goatherd prods his flock toward the city gate.

In the country, farmers work in the foreground and middle ground; the background is a panorama of rolling, plowed fields extending to the horizon. The parallel with Petrarch's view of the invigorating effects of nature is enriched through economic prosperity, as the expanse of landscape, cut off only by the limits of the wall at the right, seems to continue indefinitely. By this juxtaposition, Lorenzetti shows that in times of peace there is free travel between city and country, which work together in a harmonious way. What is cultivated in the country is sold in the city, creating a stable, ongoing economy.

In the city, people go about their daily lives. Merchants sell their wares, and artisans ply their trades. In the center is a shoemaker's shop, and to the right of the shoemaker a class is in progress. Next to the classroom a merchant displays pottery, and beyond him a weaver operates a loom. The centrality of the school in this painting is significant, for a new view of education and a new curriculum—and eventually an increase in the literacy rate—are part of what defines the Renaissance.

Lorenzetti's city is also a place in which art and architecture flourish. In addition to the potters and weavers, masons and other workers are engaged in construction along the rooftops. In the city square at the lower left, dancing and music-making figures celebrate the leisure that is part of a balanced view of life. The circular configuration of the dancers recalls images on ancient Greek vase paintings, which the artist probably

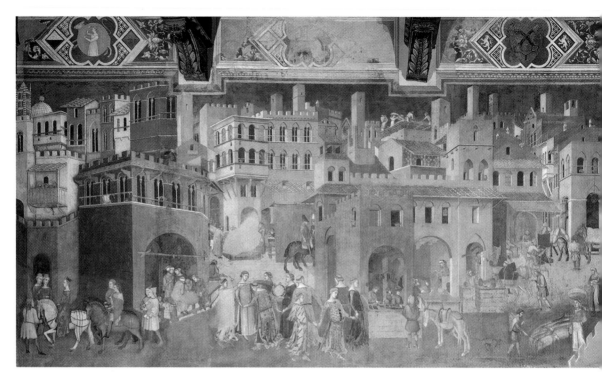

1.4 Ambrogio Lorenzetti, detail of *Allegory of Good Government: The Effects of Good Government in the City and the Country,* 1338–1339. Fresco. Sala della Pace, Palazzo Pubblico, Siena. (Scala/Art Resource)

knew and which reflect his interest in Classical antiquity. Also referring to antiquity is the statue of the she-wolf suckling Romulus and Remus that projects toward the countryside from the crenellated tower. Their descendants, according to legend, founded Siena, thereby linking it, like Florence, to ancient Rome.

Lorenzetti's stylistic affinities with the *rinascità* are evident in his organic depiction of figures and three-dimensional space. His attraction to nature is apparent in the first known landscape of its kind in Western art. In contrast to the three altarpieces discussed above, this is primarily a civic image. Its function is not to engage the viewer with the Madonna and Christ or evoke the grand Christian scheme of time and the universe. In Vasari's short life of Ambrogio Lorenzetti, the artist is credited with "great invention in groups and placing his figures thoughtfully in historical scenes."[2] Although the *Effects of Good Government* is not, strictly speaking, a history painting, it conveys a sense of secular life in contemporary Siena. As such, it is identifiable with a particular time and place in history.

Lorenzetti's image also has a political point to make. The Nine, who commis-

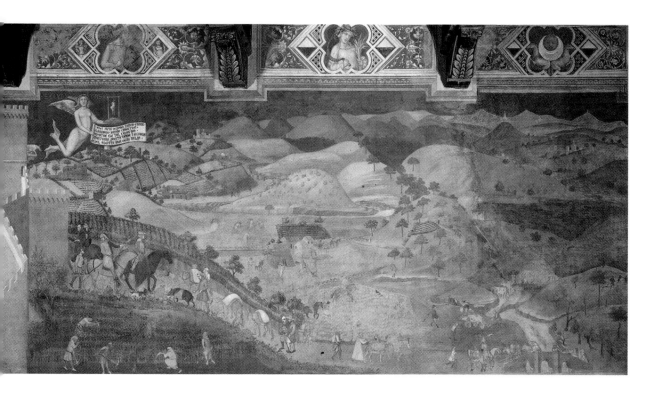

sioned the work, had a vested interest in the message that peace and prosperity resulted from their good government. On the one hand, cropping both city and country by the architectural limits of the wall suggests that there is prosperity as far as the eye can see. But on the other hand, this state of well-being carries with it a warning, which Ambrogio depicts in the allegorical winged figure of *Securitas* (Security). She hovers over the countryside holding an inscription and a small gallows. The warning is particularly weighty as it is expressed both verbally and by example—the implication being that whoever disrupts the

order of the established state faces a death sentence.

By 1339, when Lorenzetti completed his Palazzo Pubblico frescoes, Giotto had been dead for two years. Giotto's impact on Lorenzetti and Duccio is apparent, although both developed independent styles. It is also likely that all three artists were influenced by Roman painters and sculptors of the thirteenth and early fourteenth centuries.

The artists who followed Giotto are referred to as the "Giotteschi," a term that reflects their dependence on his style. These

include Taddeo Gaddi and his son Agnolo, to whom the author of *The Craftsman's Handbook,* Cennino Cennini, referred around 1390. Cennino's comments show that by the end of the fourteenth century Giotto's reputation as a great innovator was still strong. Anticipating Vasari's biographical approach to artists and his habit of situating them in a historical continuum, Cennino established an artistic genealogy of his own. He wrote that he was a student of Agnolo Gaddi, the son of Taddeo Gaddi, who "was christened under Giotto" and that Giotto "changed the profession of painting from Greek [i.e., Byzantine] back to Latin [i.e., Roman naturalism], and brought it up to date; and he had more finished craftsmanship than anyone has had since."[3]

Over a century after Cennino's account, Michelangelo studied and made copies of Giotto's frescoes, a further tribute to his lasting influence. Giotto died in 1337. Eleven years later Europe was devastated by bubonic plague, which killed a third of its population, including some 40,000 residents of Florence. Other disasters—poor crops and bank failures—occurred around the same time. Europe then underwent a process of recovery that lasted several decades. This process included the visual arts, and not until the early years of the fifteenth century, primarily in Florence, were the innovations of Giotto taken up and developed by the most original artists of the period.

NOTES

1. See Leo Steinberg, *The Sexuality of Christ in Renaissance Art and in Modern Oblivion,* 2nd ed., Chicago, 1996.

2. Giorgio Vasari, *Lives of the Most Eminent Painters, Sculptors, and Architects,* trans. Gaston du C. de Vere, New York, 1979, vol. 1, p. 170.

3. Cennino d'Andrea Cennini, *The Craftsman's Handbook,* trans. Daniel V. Thompson, Jr., New York, 1960, p. 2.

The Florentine Renaissance: 1400–1440s

By the year 1400, Florence was the principal center of Renaissance culture in Italy. It was in the best position economically and intellectually to build on the innovations of the trecento, and artists who worked there produced a remarkable number of key monuments in the early decades of the new century. The chancellor, Coluccio Salutati (1331–1406), was a Latin scholar and friend of Petrarch's. He was dedicated to civic humanism and the defense of the city's independence from the expansionist ambitions of the Milanese tyrant Giangaleazzo Visconti.

Dominating the central square of the city, its enormous walls faced with green and white marble, was the medieval Cathedral of Santa Maria del Fiore [2.1 and 2.2]. The bell tower, attributed to Giotto, stood to the south of the façade. Opposite the cathedral's entrance was the Romanesque Baptistry, mistakenly believed to have been a Roman temple of Mars. The cathedral itself was domeless because no one had been able to span a space the size of the cathedral's octagonal **crossing** since the con-

struction of the Pantheon in Rome in the second century A.D.

In 1401, as Florence was about to face a new attack by the Visconti, the Board of Works of the Baptistry announced a competition for a new pair of doors on the north side of the building. They were to consist of gilded bronze reliefs illustrating scenes from the Old Testament. The competition, supervised by the Wool Refiners' Guild, exemplifies the new civic spirit and the increasing participation of the laity in patronage. Florence resisted the Milanese troops until Giangaleazzo's death from plague the following year. At that point, the enemy withdrew, and Florence experienced a resurgence of confidence in the republic. This was reflected in the choice of the Sacrifice of Isaac as the subject for the competition reliefs.

Two submissions survive—one by the twenty-three-year-old artist Lorenzo Ghiberti (1378–1455) and the other by the architect and sculptor Filippo Brunelleschi (1377–1446). Both represent the moment in Genesis 22 when an angel intervenes to save Isaac from his father's knife [2.3 and 2.4].

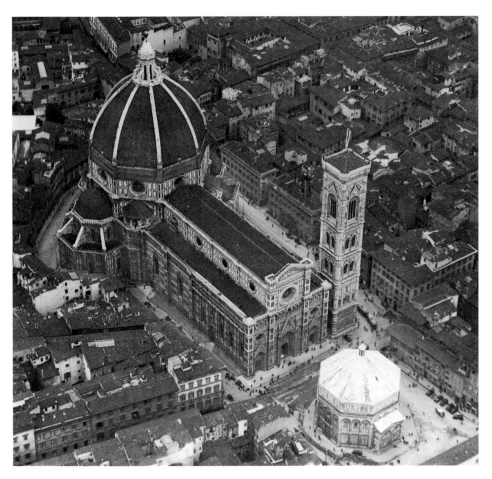

2.1 View of Florence Cathedral and Baptistry. (Alinari/Art Resource)

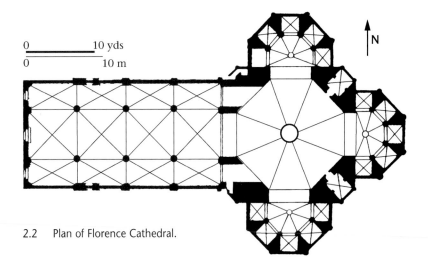

2.2 Plan of Florence Cathedral.

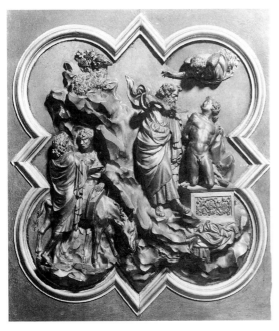

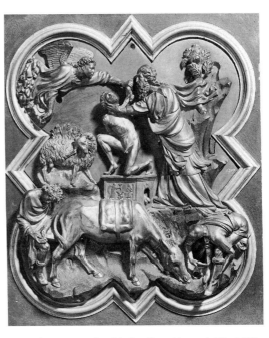

2.3 Lorenzo Ghiberti, *Sacrifice of Isaac,* 1401–1403. Gilt bronze. Museo Nazionale del Bargello, Florence. (Alinari/Art Resource)

2.4 Filippo Brunelleschi, *Sacrifice of Isaac,* 1401–1403. Gilt bronze. Museo Nazionale del Bargello, Florence. (Alinari/Art Resource)

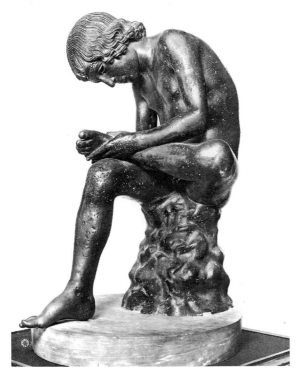

2.5 (left) *The Thorn Puller,* c. first century B.C. Bronze. Palazzo dei Conservatori, Rome. (Anderson/Art Resource)

The Florentines, on the eve of their own liberation from the threat of Milan, could readily identify with Isaac's divine rescue, as well as with Abraham's faith in God.

Although Ghiberti and Brunelleschi retained Gothic **quatrefoil** frames, their reliefs reflect the interest in three-dimensional space and naturalistic form. The altars, for example, are set in landscape and placed at oblique angles, appearing to recede in space. The Classical influence, evident particularly in Ghiberti's nude Isaac, indicates that Greek and Roman sculpture, as well as Classical texts, had become objects of serious study by 1401. Brunelleschi's relief includes a specific quotation from antiquity in the seated boy at the lower left. This figure, based on the *Spinario* (*The Thorn Puller*) [2.5], is shown removing a thorn from his foot at the very moment that Isaac is saved from the knife. Brunelleschi's version of the *Spinario* breaks out of the plane of the relief, reflecting his more expansive, dynamic style as compared with Ghiberti's.

Despite the Greek quality of Ghiberti's Isaac, with his graceful *contrapposto* and convincing organic form, the relief emphasizes elegant surface design in drapery and landscape. In Brunelleschi's more "modern" version, human and animal figures predominate. They are engaged in the forceful physical confrontation between Abraham and the angel. As with Giotto's figures, those of Brunelleschi focus unrelentingly on the central event and enhance its dramatic power. Furthermore, his relief deviates from the biblical text, in which the angel calls out to Abraham but does not intervene physically.

Thirty-four judges, consisting of clergymen, private citizens, and guild members,

Bronze Casting

Bronze casting of large-scale sculpture in fifteenth-century Italy was by the **lost-wax** method, which had also been used in ancient Greece. The artist began by making a clay or plaster model of the work and covering it with a layer of wax, including wax rods protruding from the model. A second coat of plaster was superimposed on the wax and attached with pins. When the plaster dried, the whole thing was heated, causing the wax to melt and flow out of the mold through the holes left by the melted wax rods. Molten bronze was then poured into the mold. When the bronze dried, the plaster was cut away.

Now the bronze had to be finished. This entailed filing down the rough spots, engraving or embossing (known as **chasing**) the surface with details, and polishing. For Ghiberti's doors, the surface was gilded (coated with gold leaf).

awarded the commission to Ghiberti. According to a late-fifteenth-century biography of Brunelleschi, the competition was declared a tie, but Ghiberti insisted that he had won hands down. The judges' discussions are not recorded, but they may have been drawn to Ghiberti's more lyrical style. His doors would also have been less expensive to produce, since he was able to cast his relief in a single piece.

Ghiberti worked on the doors—the subject of the reliefs was changed to New Testament scenes—until 1424, and Brunelleschi left Florence to study the ancient monuments of Rome. According to Vasari, Brunelleschi reacted to his defeat by re-

nouncing sculpture altogether, but he would later emerge as the leading architect of his time.

Or San Michele: Ghiberti, Donatello, and Nanni di Banco

Following the Baptistry competition, the unusual building known as Or San Michele, located a few blocks south of the Baptistry, became the site of several important sculptures. In 1337 it had been a rectangular **tabernacle** enclosing a painting of the Virgin and Christ that was believed capable of producing miracles. Surrounding the tabernacle was an open **loggia**. After the Black Death of 1348, the structure was renovated for storing grain as a hedge against famine. Because Or San Michele was financed by the guilds, it was designated a guild church. The exterior niches were owned by the guilds, which in 1406 were given ten years by the ruling body of Florence (the *Signoria*) to fill them with statues of their patron saints. As a result, the building and its decoration, as well as its patronage, reflected the interdisciplinary spirit of public art in Florence.

Two niche statues, probably commissioned around 1411–1413, illustrate the difference between Ghiberti and the most innovative sculptor of the early fifteenth century, Donato di Niccolò di Betto Bardi, known as Donatello (1386–1466). The Linen Weavers' Guild *(Arte dei Linaiuoli)* commissioned Donatello to carve a marble figure of Saint Mark [2.6], and the Wool Refiners' Guild commissioned a bronze statue of Saint John the Baptist [2.7] from Ghiberti. Both saints occupy Gothic niches,

from which they gaze down at the street below. The *Saint Mark* stands in a relaxed *contrapposto* pose carrying his Gospel, as does his apocalyptic symbol, the little winged lion in the relief below.

The *John the Baptist* carries a long, thin cross and a scroll, reflecting his transitional position between the Old and New Dispensations. The scroll and its placement in his left hand associate John with the Old Testament prophets. The cross denotes John's biblical role as the one who announces Christ's coming to the multitudes in the New Testament. At the top of John's robe, his hair shirt is visible, the sign of his ascetic life in the desert. The hem is inscribed with Ghiberti's signature: *"opus laur[e]ntii"* ("the work of Lorenzo").

The right knee of the *John the Baptist* is bent, the thick drapery masking the underlying form. In contrast, the drapery of Donatello's *Saint Mark* is in the tradition of Giotto, falling in response to gravity and defining organic structure. The vertical folds of the right leg suggest the **flutes** of a Classical column—revealing the artist's humanist inclinations. John's drapery, in contrast, sweeps upward in a series of broad, massive arcs, similar in conception to the more Gothic, curvilinear style of Abraham's robe in Ghiberti's competition relief. The head of the *Saint Mark* seems weighty, resembling that of a Roman senator, and the expression is pensive; his powerful, energetic hands allude to the power of his writings. In comparison, the arms and head of the *Saint John* are longer and thinner, endowing the figure with a more Gothic flavor.

Around the time that Donatello completed his *Saint Mark,* another promising sculptor, Nanni di Banco (c. 1384–1421),

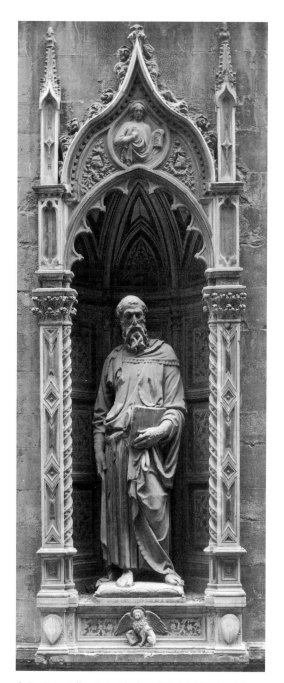

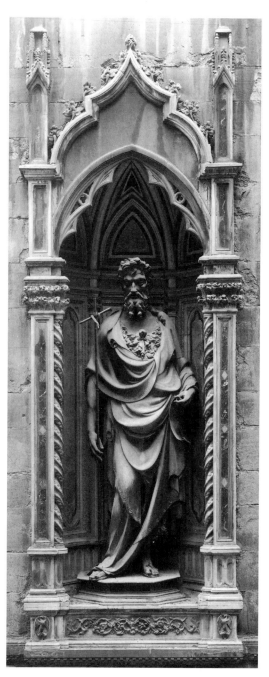

2.6 Donatello, *Saint Mark,* c. 1411–1413. Marble. South wall, Or San Michele, Florence. (Alinari/Art Resource)

2.7 Lorenzo Ghiberti, *Saint John the Baptist,* c. 1412–1417. Bronze. East wall, Or San Michele, Florence. (Alinari/Art Resource)

was commissioned by the Stone and Wood Carvers' Guild *(Arte dei Maestri di Pietra e Legname)* to carve the so-called *Quattro Coronati* for their niche on the north wall of Or San Michele [2.8]. The *Coronati* were four Christian artists martyred by the Roman emperor Diocletian (ruled 284–305) for refusing to create a statue of a pagan god. They later became the patron saints of stone carvers

Nanni's figures are arranged in a semicircle, harmonized with the curved architectural setting. The formal unity conforms to the saints' unity of purpose in defying the emperor. But they are also rendered as distinct individuals whose gestures suggest that they are deep in conversation. The organic, monumental forms ally them with the Renaissance approach to sculpture. The relief at the bottom of the niche showing sculptors and builders at work illustrates the activities of the guild, whereas the nudity of one of the works-in-progress reflects the Classicism of Nanni, whose early death cut short his career.

Brunelleschi: Foundations of a New Architecture

Hospital of the Innocents

When Brunelleschi returned to Florence, his first architectural project was the Hospital of the Innocents, an orphanage located in the Piazza della Santissima Annunziata [2.9 and 2.10], begun in 1419. The project was financed by the guild representing silk merchants and goldsmiths, of which Brunelleschi was a member, and by the powerful banker Giovanni di Bicci de' Medici. Al-

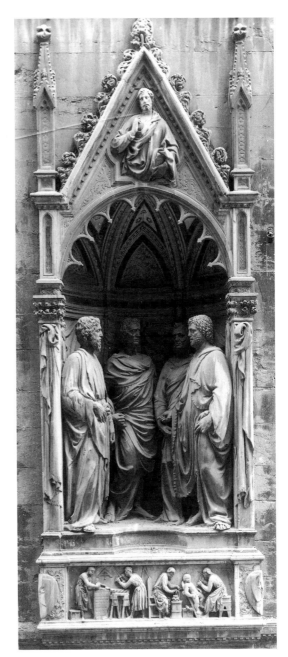

2.8 Nanni di Banco, *Four Crowned Saints (Quattro Coronati)*, c. 1414–1416. Marble. North wall, Or San Michele, Florence. (Alinari/Art Resource)

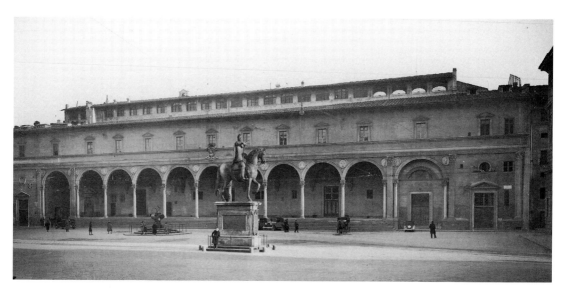

2.9 (above) Filippo Brunelleschi, Hospital of the
Innocents, begun c. 1419. Piazza della Santissima
Annunziata, Florence. (Alinari/Art Resource)

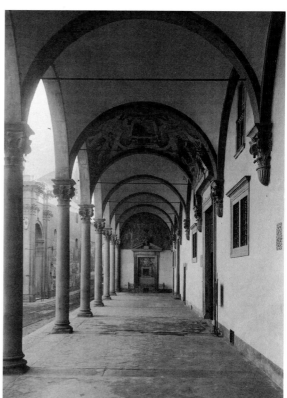

2.10 (right) View of the Hospital showing the
space between the colonnade and the solid wall.
(Alinari/Art Resource)

The Orders of Architecture

Shown in Figure 2.11 are the **Orders of architecture** known in the Renaissance. Reading from left to right, they are the Doric, Ionic, Corinthian, Tuscan, and Composite. Doric, which first appeared in mainland Greece around 600 B.C., was the earliest. Ionic, slightly later than Doric, was a more eastern Order (from the Ionian Islands and western Turkey); it is more graceful and elongated, having a round base and a **volute** (scroll-shaped) capital. The Corinthian Order was probably derived from metalwork in Corinth. The Tuscan and Composite Orders were developed later in the Roman period.

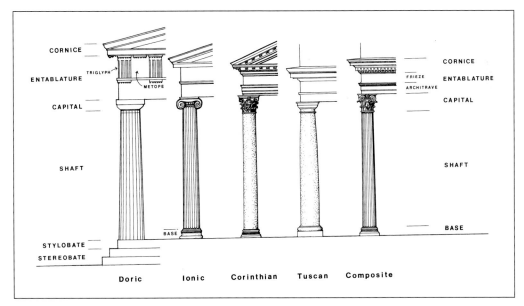

2.11 The five Orders of architecture. From Leland M. Roth, *Understanding Architecture,* New York, 1993.

though foundling hospitals had existed in the Middle Ages, the decision to award the commission to a prominent architect reflects the integration of the arts with social concerns in fifteenth-century Florence. It also exemplifies the Medici custom of contributing to the artistic embellishment of the city by paying for works of art.

The exterior **arcaded** loggia is constructed in a series of round arches supported by slender, smooth-shafted Corinthian columns. Between the columns and the ground-floor exterior wall are small domes supported by **corbels** attached to the wall and by the columns themselves. Stretching over the columns is the horizontal **entablature**, with a slightly projecting **cornice**. Visually, the cornice serves as a platform for the second story, whose windows, each surmounted by a small Classical triangular **pediment**, are located over the center of each arch. The upper story was added later and is not part of Brunelleschi's original design.

In the loggia, Brunelleschi's commitment to an architecture relating form and space

to human proportions is very much in evidence. The simplicity of the circle and square, the hemisphere and cube, constitutes a rejection of the more varied formal combinations of medieval architecture. Brunelleschi's preference for symmetry, as well as for regular rhythmic arrangements of form and space, was achieved by a proportional system in which the height of the columns was equal to the distance between them and to the distance separating them from the solid wall. The repetition of cubed modules in space reflects Brunelleschi's definition of air space as solid form, just as Giotto had defined painted cubic voids.

Decorating the outer loggia wall are **tondos** above each column containing relief sculptures of swaddled infants. These are the work of Andrea Della Robbia (1435–1525), whose family workshop, under his uncle Luca, was credited with the invention of durable vitreous **glazes** used to color **terracotta** sculptures. The round frames of Andrea's reliefs contribute to the harmony of the exterior, for they repeat the curvilinear rhythms of the arches. The babylike appearance of the figures indicates that Andrea had assimilated Classically inspired taste for naturalism and organic form, as well as the new interest in observing children.

The Dome of Florence Cathedral

Brunelleschi left the foundling hospital unfinished when he received the commission—together with his old rival Ghiberti—to design a dome for the cathedral. Construction began on August 7, 1420, and by August 1, 1436, the dome (although not

the **lantern**) was complete. According to Vasari, the early years of the project were fraught with rivalry between the two artists. Finally, Brunelleschi set out to prove that his, and not Ghiberti's, was the true mind behind the dome. According to Vasari,

> One morning Filippo did not appear at the work, but bound up his head and went to bed, and caused plates and cloth to be heated with great solicitude, groaning continually and pretending to be suffering from colic. . . . Many of the master-masons went to see him and asked him repeatedly to tell them what they were to do. And he replied, "You have Lorenzo [Ghiberti], let him do something." . . . The Warden came to see Brunelleschi and was also told to consult Ghiberti. To which the Warden said, "He will do naught without thee"; and Filippo retorted, "But I could do well without him."[1]

In 1425 Ghiberti was dismissed from the project but allowed to keep his salary. Never particularly modest, Ghiberti took a different view of the matter. He wrote that "few things of importance were made in our city that were not designed or devised by my hand. And especially in the building of the dome, Filippo and I were competitors for eighteen years at the same salary; thus we executed the said dome. We [meaning Ghiberti himself] shall write a treatise on architecture and deal with the matter."[2]

Brunelleschi faced two major problems in constructing the dome. First, it could not be centered on timber over the nearly 140-foot opening of the octagonal drum,

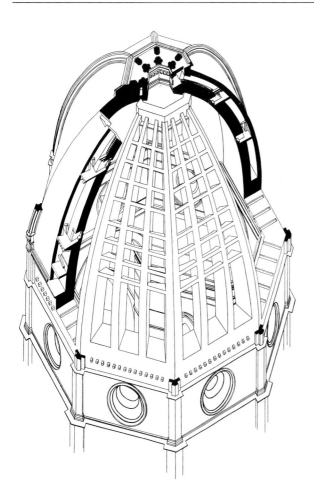

2.12 Axonometric section of the dome of Florence Cathedral.

because trees of that size were unavailable. Second, since an octagonal drum was already in place, he was unable to erect a hemispherical dome. His solution, illustrated in Figure 2.12, was to build a skeleton of eight large **ribs** extending from the angles of the octagon to the base of the lantern. These alternated with eight pairs of thinner ribs. Nine sets of horizontal ties connect both sets of ribs and absorb the thrust that they exert on the curved wall of the dome. A new feature of Brunelleschi's dome was the placement of two shells around the skeleton for support. The thin-

ner ribs are hidden between the two shells, leaving only the larger white stone ribs visible from the exterior. They provide accents of light, curved rhythms against the darker surface of the dome.

By 1425 the dome had attained about a third of its final height. To ensure its support, in addition to choosing brick, which is not as heavy as stone, Brunelleschi constructed the remainder of the dome one ring at a time, making certain that the lower ring could support the next one. In 1436, when the dome was finally finished, it ended in an open circle (the **oculus**). At

this point, another problem emerged: The ribs had to be locked in place or they would spring outward and burst open the wall. Recognizing that a new element would be necessary to solve this last problem, the cathedral's Board of Works held yet another competition, for a crowning lantern. This time Brunelleschi won entirely on his own, but he died before executing his design. Nevertheless, constructed by the sculptor and architect Michelozzo di Bartolomeo (1396–1472), the final lantern is Brunelleschi's conception. Supporting the lantern and connected to the ribs of the dome are small external **buttresses**.

The history of Florence Cathedral can be seen as a metaphor for the dynamic but gradual transition from the Middle Ages to the Renaissance in that city. It was essentially a Gothic structure, with a triple entrance on the façade, pointed arches, enormous height, and complex exterior surfaces. Giotto's bell tower was its major fourteenth-century legacy. Early in the fifteenth century, the cathedral, like Or San Michele, became a focus of sculptural activity as an emerging generation of important young artists produced monumental statues for its exterior niches.

Brunelleschi's Perspective System

Brunelleschi's influence on Renaissance art was considerable. He is credited with the invention of a system that would allow painters to produce mathematically the illusion of depth on the flat picture plane. Interest in this problem was not new, for Giotto and other fourteenth-century painters had represented three-dimen-sional space. Accounts of Greek and Roman art, as well as surviving vase paintings, indicate that techniques for creating depth in painting had also been used in antiquity. But Brunelleschi's theory of perspective was entirely new.

Figure 2.13 shows Brunelleschi's diagram of the distance from Florence Cathedral to the Baptistry. Lines of sight radiate from the viewer (A), through a vertical axis (B), to various points on the Baptistry and surrounding buildings. The eye of Brunelleschi's viewer thus corresponds to the eye of the artist.

Brunelleschi used this system mainly for architectural purposes. The small size of a person relative to a building resulted in a low point for the eye, which in reality looks up at the architecture. Brunelleschi's construction was transformed into a system of **linear perspective** by painters and sculptors of reliefs. The surface plane of a picture or relief was thought of as the equivalent of a window through which the viewer sees the depicted image. The picture space—that is, the view through the imaginary window—was conceived of as a box-like construction, in which floors and ceilings are parallel to each other and perpendicular to the walls. A particular point, whether on the horizon or elsewhere, was chosen as the **vanishing point**, where lines of sight converged. The latter were aligned with the edges of buildings or other forms demonstrably perpendicular to the picture plane. These imaginary perpendicular lines, called **orthogonals**, control the gaze of the observer by leading from the eye to the vanishing point (Figure 2.14 illustrates Alberti's diagram, which was used by painters and sculptors of reliefs).

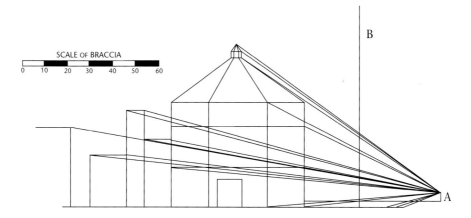

2.13 Brunelleschi's perspective construction, Piazza del Duomo. From Richard Krautheimer, *Lorenzo Ghiberti,* Princeton, 1970.

The main difference between Brunelleschi's theory and subsequent pictorial practice was in the fixing of the viewer's eye. Brunelleschi established this point at the relatively low level of a real viewer in relation to actual architecture. The painting of the 1420s that most completely assimilated this theory was, appropriately, by the most innovative painter then working in Florence.

Masaccio

Tommaso di Ser Giovanni di Mone Cassai (1401–c. 1428) was nicknamed Masaccio— meaning "Hulking Tom" or "Big Tom"— whether as a reference to his own appearance or to the simple monumentality of his painted figures is not certain. In his short lifetime, he assimilated Giotto's innovations and Brunelleschi's perspective system to become the preeminent Italian painter of the early fifteenth century. Vasari wrote

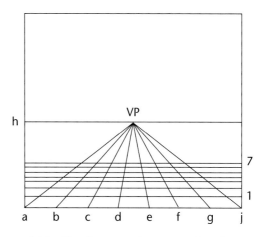

2.14 Alberti's perspective construction. This was a later diagram based on the principles of Brunelleschi. From Richard Krautheimer, *Lorenzo Ghiberti,* Princeton, 1970.

Fresco

Fresco was used primarily for wall paintings during the Italian Renaissance. In *buon* (or "true") fresco, pigments are mixed with water and applied to fresh, damp lime plaster; they are absorbed into the wall as the plaster dries. Because plaster dries in a day, the artist had to prepare the wall according to his day's work—the *giornata*—and paint quickly within the allotted time.

Like tempera, fresco required lengthy surface preparation, beginning with the placement of a layer of rough plaster (the **arriccio**) over the wall. This held the smooth layer to which the paint was applied. Brush drawings (called **sinopie,** after the red earth color of Sinope on the Black Sea) sketched out the general plan of the composition, the disposition of the figures, and certain details on the *arriccio*. The artist then added the **intonaco,** the final smooth plaster layer, and to this he applied the pigments while the plaster was still damp. Some colors, such as blue, reacted adversely to lime and so were applied when the *intonaco* was dry—a technique referred to as *secco* (meaning "dry"). As a result, *secco* is less durable than true fresco and is more likely to wear away over time.

Fresco is a broader technique than tempera, less conducive to small details. Sometimes, therefore, fresco painters added details in tempera. Tempera also produces richer colors than fresco because of the addition of egg yolk to the pigments.

and vivacity, and to a certain relief truly characteristic and natural; which no painter up to his time had ever done."[3]

The *Trinity*

Masaccio painted his great fresco of the *Trinity* [2.15] on the left aisle wall of the Church of Santa Maria Novella in Florence. It is depicted as a fictive chapel extending beyond the wall, where a sacred drama is enacted. Kneeling on the outer projecting step are the two **donors,** probably members of the politically influential Lenzi family who commissioned the work. The inclusion of donor portraits as an integral part of a painting, along with sacred figures belonging to an earlier historical moment, became a characteristic of Renaissance art. It is interesting that in Masaccio's *Trinity* the female donor is given a prominence nearly equal to that of her husband. She occupies the same projecting step, although her subordinate position is denoted by her placement to Christ's left (the viewer's right). Her blue robe, visually related to that of the Virgin, is nonspecific, whereas Lenzi wears the costume of a *gonfaloniere,* or chief magistrate.

The foreground location of the donors, combined with their focus on the Trinity, creates a link between the actual public space of the church nave and the painted interior space. The plane occupied by the Lenzi forms the base of a combined triangle and pyramid. The apex of both is the head of God the Father, who stands on a ledge projecting from the back wall of the painted room. Vertically aligned with God's head are the white dove of the Holy

that Masaccio had learned "so much that he can be numbered among the first who cleared away, in a great measure, the hardness, the imperfections, and the difficulties of the art, and that he gave a beginning to beautiful attitudes, movements, liveliness,

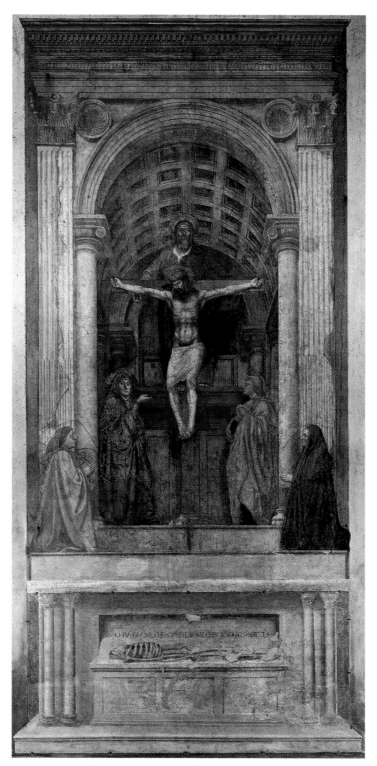

2.15 Masaccio, *The Trinity*, c. 1425–1428. Fresco. Santa Maria Novella, Florence. (Scala/Art Resource)

Ghost and the crucified Christ. Christ inclines his head toward Mary on his right, who gazes at the viewer while gesturing toward her son. Opposite Mary stands the young apostle John gazing raptly at Christ. By this formal interplay of pose, gesture, and gaze, Masaccio creates a tight unity among the painted figures and between the painted figures and the viewer. The unity between the triangular-pyramidal organization of the figural group and the three persons of the Trinity (Father, Son, and Holy Ghost) synthesizes form with content.

Masaccio uses color as well as form to unify the composition. The reds and blues of the simple, massive robes relate the drapery chromatically with the architecture. In contrast, the central figure of Christ wears only a transparent white tunic. Masaccio has rendered him as an organic nude, whose drapery defines his form, just as the *chiaroscuro* of his flesh defines the underlying anatomical structure. Masaccio's Christ obeys gravity as his elongated arms are stretched thin by his weight. Illuminated against a darker background, which is defined by God's cloak and the gray wall, Christ is depicted as the Light of the World.

The painted context of Masaccio's scene reflects Brunelleschi's architecture. Corinthian **pilasters** support an entablature with a projecting cornice. Slightly behind the pilasters are Ionic columns, which, like those of Brunelleschi, have a smooth shaft and support a round arch. The **roundels** between the capitals and the arch contain a scallop-shell design—a traditional Christian motif of rebirth and resurrection.

The receding lines of the **coffers** in the **barrel vault** are the most prominent orthogonals in the painting. They are parallel

Women in the Renaissance

Renaissance women were defined primarily by their biological roles—daughter, sister, mother, wife, grandmother. They had few other options, aside from entering a convent. The dangers of childbirth were continual, and women were expected to produce sons. Daughters were chips in the business of marriage and could be used for the political and financial benefit of a family. A woman's dowry was her primary financial asset, which she brought with her into her husband's family. In 1424 the *monte delle doti* (a bank fund in which fathers could invest to build up a dowry) was established, and this was an advantage to many women who were not from wealthy families. The role of the average Renaissance woman, once married, was to manage the household and please her husband.

A few women received a humanist education, particularly the daughters of the elite. Some were able to rule their husbands' territory in their absence. When Piero de' Medici died, his wife, Lucrezia Tornabuoni, became active in business and regularly advised her son, Lorenzo the Magnificent, on political matters.

to each other, to the sides of the square **abacus** on the Ionic capitals, and to the nails piercing Christ's hands. The extension of these orthogonals leads to the vanishing point located at the center of the step below the donors, which corresponds to the eye level of the average person. As such, Masaccio's viewpoint conforms to Brunelleschi's perspective theory.

Masaccio's vanishing point also has symbolic meaning. Directly above it is an abbreviated rock of Golgotha, where Christ

was crucified. This is one of several elements in the *Trinity* that condense time and space in a new way. The donors, wearing contemporary dress, gaze on the Crucifixion, creating a transition not only from public to sacred space but also from the present to the past. At the same time, through Mary's gaze and gesture directed at the worshiper and the frontality of God, who looks out of the picture plane, Masaccio makes the past live in the present.

The future tense is also part of the significance of the *Trinity,* referring to resurrection after death. In the context of the painted sacred space, the rock of Golgotha denotes the Church itself as the Rock of Ages. It is the visual foundation of the Cross in the picture and the symbolic foundation of the Church—alluding to Christ's future as head of the Church and to the "rock" on which he instructed Saint Peter (whose name comes from the Greek *petros,* meaning "rock") to build the Church. The durability of rock implies the durability of the Church and the continuation of both to the end of time.

The play with tense recurs in the image below the *Trinity*. This consists of a skeleton laid out on the top of a **sarcophagus** flanked by pairs of small Corinthian columns. Above the skeleton in a recessed rectangle is an inscription that reads, "I was what you are now, and I am also what you will be." The tenses ("was," "are," and "will be") in the written statement, like Masaccio's image, combine past, present, and future. By juxtaposing the skeleton with the living Trinity, Masaccio contrasts the physical decay of death with the promise of salvation through the illuminated image of Christ.

It is likely that in the fifteenth century an altar stood before the fresco and that Mass

was performed there. Documents indicate that members of the Lenzi family were buried under the floor of Santa Maria Novella, directly in front of the fresco. One of the innovative aspects of the *Trinity* is thus the way it interacts with actual events taking place around it. The illusionism of the painted chapel, the humanist character of the figures, and the relationship of fiction to reality and of word to image place the work at the forefront of its time. Masaccio's illusionistic play with the boundaries of what is real and what is painted resonates with Vasari's assertion that he "perceived that painting is nothing but the counterfeiting of all the things of nature, vividly and simply, with drawing and with colours."[4]

The *Tribute Money*

In the monumental fresco of the *Tribute Money* [2.16], Masaccio more than fulfilled Vasari's account of his genius. The *Tribute Money* is the most imposing image in the fresco cycle, which illustrates the life of Saint Peter. It was commissioned for the Brancacci Chapel in the Carmelite Church of Santa Maria del Carmine. The cycle's patron is assumed to have been Felice Brancacci, a prominent citizen of Florence whose fourteenth-century ancestor, Pietro Brancacci, had financed the construction of the chapel. Hence the choice of Saint Peter, Pietro's patron saint, as the subject of the frescoes.

Before Masaccio was hired, the older artist Masolino had begun the cycle, and it was not until some sixty years after Masaccio's death that the frescoes were finally completed by Filippino Lippi. The *Tribute Money* is the largest fresco entirely by Masaccio's

2.16 Masaccio, *The Tribute Money*, c. 1427. Fresco. Brancacci Chapel, Santa Maria del Carmine, Florence. (Scala/Art Resource)

hand. It illustrates an event briefly described in the Gospel of Matthew (17:24–27): When Christ and his apostles arrive in Capernaum, he is asked to pay a tax owed to the Temple in Jerusalem. Not wishing to offend but without funds, Christ instructs Peter to go to the Sea of Galilee and extract the money from the mouth of a fish.

Masaccio's pictorial elaboration of this rarely represented story has been interpreted in different ways. One explanation points to the institution in Florence, in 1427, of the first graduated tax in Europe (the *catasto*). Another argues that Felice Brancacci, who was on the Board of Maritime Consuls, had a special interest in maritime commerce—hence a narrative in which a miracle is produced from the sea. A third theory attributes the commission to Felice's connections with the papacy, because in 1423 Pope Martin V decided to tax the Church in Florence. Whatever influence these actual financial events exerted on Masaccio's fresco, it is certain that money and tribute are important themes.

Masaccio's Brancacci Chapel frescoes are a foundation of Renaissance style. The dramatic placement of the figures, their monumental forms and significant gestures make Masaccio a worthy successor to Giotto's new approach to painting. As in the *Trinity*, there is a dissolution of architecture that creates a synthesis of time and space. The *Tribute Money* consists of three scenes and is arranged as a **triptych** without intervening frames. Instead, Masaccio separates the scenes by painted architecture—on the right—and natural forms—the receding trees on the left. He thus encloses three episodes, combining three different times in a single space. He also creates a system of

illumination that unites the *Tribute Money*—as well as the other frescoes in the cycle—by making the painted light source conform to the actual light source of the chapel window.

The large central scene is the first episode: The tax collector, seen in back view and wearing a short tunic, extends his hand toward Christ. Christ stands at the center of the Twelve Apostles, whose individualized, sculpturesque head types suggest the influence of Roman portrait busts. He turns and points to the left, where the radically foreshortened figure of Peter kneels by the shore. In the central scene, Peter responds to Christ's instruction with ambivalence. He simultaneously echoes Christ's gesture, pointing in the same direction with his right hand, and pulling back with his left. His angry expression reflects his confusion.

The apostles around Christ form a three-dimensional semicircle, which, as in the pyramidal arrangement of the *Trinity*, fuses form with content. Christ's position at the center is a visual echo of the configuration in which the Crucifix stands on the altar within a semicircular apse.[5] The massive, simple robes that define and monumentalize the figures and their isocephalic arrangement are accentuated by foreshortened haloes.

By the use of linear perspective, Masaccio focuses the viewer on Christ's formal and psychological centrality. The picture is framed at each end by painted composite pilasters, whose *abaci* and bases form orthogonals leading to the vanishing point at Christ's head. Additional orthogonals appear in the building at the right and in the three steps at the lower right corner. The

greater architectural weight on the right is counterbalanced by the spatial thrust into distant landscape on the left. At that point, Masaccio's use of **aerial**, or **atmospheric**, **perspective** becomes evident, for the mountains diminish in clarity rather than in scale. In fact, however, he combines linear with aerial perspective, since the trees and the figure of Peter diminish in size.

The second episode, which takes place in the distance, shows Peter retrieving the coin from the fish's mouth. He has removed his yellow robe, which lies in a heap on the ground, his awkward pose conveying the difficulty of his unlikely task. Peter's placement contributes to the narrative unity of the composition, for it indicates that he has to leave the central group and go some distance, both psychologically and geographically, in order to accept and carry out Christ's unusual request.

Once Peter finds the coin, he shifts to the right foreground and pays the tax collector. The latter is the most foregrounded figure in the *Tribute Money,* which denotes his pivotal role in the narrative. His is the demand that sets in motion the depicted events, and his position in relation to Christ and the apostles replicates that of the viewer. The tension evident in his hunched shoulders, animated gestures, and twisted right leg reflect the urgency of his insistence on the tax. His bent left arm seems to unleash a sequence of gestures—the right arms of Christ and Peter become increasingly extended—that lead one's gaze from the central confrontation to the episode at the Sea of Galilee.

The scene on the right concludes the narrative. The round arch of the porch frames Peter as an architectural halo and also echoes the curves of his heavy draperies.

More stolid, and manifestly less holy than Peter, the tax collector is set against the plain, rectangular wall that contains three square windows. The corner of the building repeats the triangular space created by the extended arms of the two figures. There is thus a formal interplay between figures and architecture in this episode, in which the curved, haloesque arches denote Peter's saintliness; the squares and rectangle refer to the stolid, boorish character of the tax collector; and the diagonals echo the physical gestures of their financial transaction. The painted building also marks the boundary between the sacred space defined by the presence of Christ and his apostles and the material world to which the tax collector will shortly return.

Gentile da Fabriano's
Adoration of the Magi

The simple monumentality of Masaccio's style reflected only one trend—although certainly the most "modern"—of early-fifteenth-century painting in Florence. Another important trend was the International Style, so called because of its popularity in courts throughout Europe. In contrast to the simple, massive figures of Masaccio, those painted by International Style artists are typically elegant, richly attired, and endowed with a Gothic flavor. International Style backgrounds are generally filled with decorative, colorful detail that conformed to courtly taste.

The wealthiest man in Florence and a close friend of Cosimo de' Medici, Palla Strozzi, commissioned an altarpiece for his sacristy in the Church of Santa Trinità [2.17].

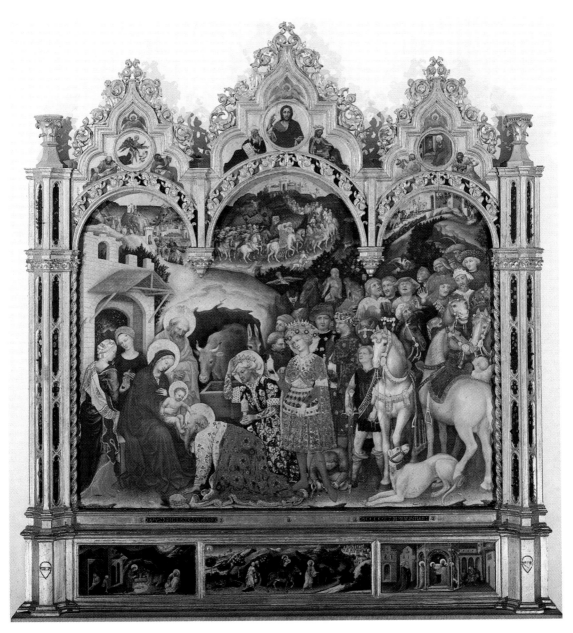

2.17 Gentile da Fabriano, *The Adoration of the Magi*, 1423. Tempera on wood. Galleria degli Uffizi, Florence. (Scala/Art Resource)

It was completed in May 1423 by Gentile da Fabriano (c. 1370–1427), an International Style painter from Fabriano, in the Marches. Gentile's reputation for luxurious textures was typical of the prevailing taste in Venice, where he had worked before coming to Florence, and appealed to patrons interested in extravagant displays of wealth. The predominance of gold in the elaborate frame and costumes guaranteed the high cost of the altarpiece. In addition, the very subject of the main panel, the Procession and Adoration of the Magi, based on the text of Matthew 2:1–12, lent itself to the qualities of International Style painting. Since the Magi were from the opulent East, their attire and that of their entourage could be lavishly rendered.

The narrative begins below the upper left arch, where the tiny figures of the three Magi gaze toward the star that will lead them to Christ. The procession passes through the arch of a crenellated wall, curving under the middle arch of the frame and moving toward a hill town. Below the right arch, it enters another walled city, possibly Jerusalem itself. The main part of the procession does an about-face and approaches the foreground. Among the crowd are exotic birds, monkeys, and leopards, together with horses decked out in elaborate trappings. The rich textures—gold leaf, furs, brocades, velvets, and silks—are contrasted with the simpler drapery of the Holy Family and their relatively plain setting.

The procession stops at the youthful king wearing red stockings; his spurs are being removed by a page. At the far right, the horse with one leg raised and the reclining animal in front of him reinforce the impression that the travelers have come to a halt at the picture plane. The three kings, arranged in order of age, focus their gaze on Christ, accentuating the irony of a wealthy crowd journeying great distances to adore a newborn infant.

The gaze of the kings directs the viewer to the climax of this lavishly depicted narrative, namely, Christ laying his hand on the head of the elderly king. He, in turn, stares at Christ's genitals, confirming his humanity.[6] Another play with the gaze occurs in the two animals traditionally present at Christ's birth. The brown ox leans forward, staring intently at Christ, while the ass pricks up his ears and looks away from Christ. Distracted by the glamorous procession, the ass fulfills his role as a Christian symbol of ignorance and sin.

Hovering above Joseph's head, reminding viewers of the divine nature of light, is the Holy Ghost surrounded by a halo. Visually, as well as iconographically, its glow alludes backward in time to the starting point of the procession—the distant star at the upper left. In contrast to Masaccio's *Trinity,* where time is condensed into an image of immobility, Gentile expands time by the unfolding narrative of the procession. The past is represented by the smaller forms denoting distance at the top of the picture, whereas the present is indicated by the arrested movement of larger figures in the foreground. Linking past to present is the spiral plane of the procession, which creates the illusion of extended space and also seems to extend time.

Gentile's altarpiece was the greatest single artistic commission of Palla Strozzi. Palla's friendship with Cosimo de' Medici later turned sour, as he joined the political faction responsible for Cosimo's one-year

exile from Florence in 1433–1434. When Cosimo returned, he had the men of the Strozzi family banished from the city. The humanist Palla, a collector of Classical texts, retired permanently to Padua.

The Medici Palace

Ten years later, Cosimo hired Brunelleschi to design his family palace in Florence. The living quarters would be on the upper two floors, except for Cosimo's bedroom, which was on the ground floor, along with offices accessible from the street. In the end, however, Cosimo rejected Brunelleschi's innovative design and replaced it with a plan by the more conservative Michelozzo. According to Vasari, Brunelleschi was infuriated by this decision and smashed his model.

The construction of Renaissance palaces marked a significant departure from medieval practice. Palaces reflected the wealth of their owners and their willingness to spend money on urban *magnificentia*, or magnificence. Such patrons enjoyed the results of their expenditures while gaining the admiration of the citizens for having improved the appearance of their city. This approach to urban design was largely the inspiration of the Medici family, and they benefited the most from it.

The exterior of their palace [2.18], situated on the corner of present-day Via Cavour (originally the Via Larga), combines the appearance of a medieval fortress with Classical elements. The ground-floor masonry consists of roughly cut, massive **rusticated** stone blocks. But the upper two stories become gradually smoother and are

The Medici

The Medici were the most powerful family in fifteenth-century Florence. Their ancestors arrived in the thirteenth century, and their fortune was established by Giovanni di Bicci (1360–1429), who founded the Medici bank. By the early 1420s, the Medici were bankers to the pope and one of the richest families in Europe. Giovanni lived modestly, careful to avoid arousing the envy of his contemporaries. Nevertheless, he participated in the government of the city and was a generous patron of the arts. He belonged to the Cloth Manufacturers' Guild because of his wool factories and to the Bankers' and Money Changers' Guild because he was a banker.

Giovanni's son Cosimo (1389–1464) became known after his death as *pater patriae* ("father of the country") and was the *de facto* ruler of Florence. His grandson Piero (d. 1469) became the next head of the family, assisted by his patrician wife, Lucrezia Tornabuoni, who became a successful businesswoman after his death. Their son, Lorenzo the Magnificent (1449–1492), educated by humanist tutors, ruled Florence and patronized the arts on a vast scale.

surmounted by a projecting cornice. The horizontality of the cornice recurs in the thinner **string courses** separating the lower stories. These in turn provide a visual platform for the second and third stories, whose arched windows with Corinthian **colonnettes** reflect the influence of antiquity. The pedimented ground-floor windows were not designed until the sixteenth century by Michelangelo. The second story, or *piano nobile*, is faced with **quarry-faced**

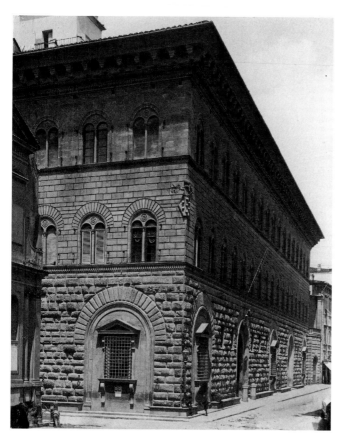

2.18 (left) Michelozzo, exterior of the Medici Palace, Florence, begun 1440s. (Brogi/Art Resource)

2.19 (right) Plan of the Medici Palace. (after Leland M. Roth)

ashlar, whose smoother surfaces and straight edges accentuate the joints. The third story is completely smooth, and the joints are barely visible from street level. By thus graduating the heaviness of the façade, Michelozzo shows the structural logic of the building: that the lower levels support the upper ones.

Dominating the corner of the *piano no-bile*, originally an open loggia that housed the Medici bank, is a relief sculpture of the Medici coat of arms, with seven balls. According to the family myth, Charlemagne granted the coat of arms for bravery when a Medici knight defeated a monstrous giant. The giant's mace had dented the knight's shield, and the dents were subsequently represented as red balls on a field of gold.[7] Other, more likely accounts derive the balls from pills used by Medici ancestors who had been pharmacists or from coins, denoting their banking interests. Coins also signified pawnbrokers, traditionally identified by three balls hanging outside their shops. The coat of arms stands for the diachronic existence of the Medici through time. It is also the patron's signature, declaring his ownership and proclaiming his *magnificentia*.

The plan of the Medici Palace [2.19] shows the disposition of rooms around a square central courtyard. Its colonnade of round arches resting on Corinthian columns with smooth shafts was inspired by Brunelleschi's architecture, but Michelozzo's proportions are not as light. Nevertheless, Michelozzo unifies the exterior of the building with a sense of structural and visual balance and with repeated details—the windows, for example—inside and outside the building.

Donatello's Bronze *David*

One of the greatest and most controversial key monuments of Renaissance art stood for decades on a pedestal in the Medici Palace courtyard and was probably—although the contract does not survive—commissioned by Cosimo himself [2.20]. Donatello's bronze statue of David is first documented as being in the courtyard in 1469, but it was completed much earlier. The most likely dates proposed for the work range from the 1420s to the 1440s, which are consistent with its innovative, humanist character. It was the first nearly life-size, bronze-cast nude sculpture since antiquity and, like Ghiberti's Isaac on the competition relief, reflects the influence of ancient Greek statuary.

Donatello's approach to the nude is more Classical than, for example, Nicola Pisano's (active c. 1258–1278) late medieval sculpture *Fortitude* [2.21] from the Pisa Baptistry. Pisano had himself been influenced by ancient art through his connections with the Classical revival at the court of Frederick II in Naples. The pose of the *Fortitude* is also derived from antiquity, and the anatomy is organically rendered. But Pisano's proportions remain medieval, particularly the large size of the head and feet. The iconography consists of the traditional lion-skin attribute, reinforcing the strength of the *Fortitude*'s powerful frame.

Donatello's *David*, in contrast, is imbued with complex iconography and an enigmatic personality. Nude except for a shepherd's hat and boots, David rests one foot on the decapitated head of Goliath, holding the stone with which he killed Goliath and the giant's sword. Goliath's head lies

2.20 Donatello, *David*, 1420s–1440s. Bronze. Museo Nazionale del Bargello, Florence. (Alinari/Art Resource)

on a laurel wreath, his helmet sprouting a large pair of naturalistic wings. A small relief on the helmet depicts a triumph of Cupids [2.22].

The genius of Donatello's *David* resides in its multiple layers of meaning and synthesis of different traditions. David was typologically paired with Christ and Goliath with Satan. David's triumph over Goliath was thus Christ's victory over evil. As the preeminent symbol of Florence, David stood for republicanism triumphant over tyranny, the latter associated with the physical might and intellectual inferiority of Goliath. In the context of Florentine humanism, the *David* could also allude to political metaphors extolling Florence as a new Athens. Plato's praise of love between men as inspiring bravery in soldiers and his view that such lovers are protected by Eros were known to fifteenth-century humanists. His assertion that democratic states permit and even value homosexuality, whereas tyrants discourage it, was seen as another link between Florence and Athens.[8]

The biblical account of David and Goliath also contains a homosexual subtext. For whereas David is both loved and hated by King Saul, he is loved and protected by Saul's son Jonathan. Latent in the adolescent friendship of David and Jonathan is the Platonic view of male lovers, for their friendship leads them to victory over the tyrannies of Saul's madness and Goliath's might.

The formal character, as well as the iconography, of the *David* enhances its homosexual personality. The figure is slim, effete, smug, and self-absorbed—a "beautiful boy" in the Platonic sense. David's toe

2.21 Nicola Pisano, *Fortitude,* 1260. Detail of the marble pulpit in the Baptistry, Pisa. (Alinari/Art Resource)

2.22 Detail of Donatello's *David* showing the relief on Goliath's helmet. (Alinari/Art Resource)

plays with Goliath's beard, while one of the wings of Goliath's helmet rises seductively up the inside of David's leg. What is latently homosexual in the biblical story of David and Goliath, therefore, becomes manifest in the statue as a result of humanist parallels with Platonic philosophy and of Donatello's own inclinations.

Leon Battista Alberti: *On Painting*

Leon Battista Alberti (1404–1472) was the leading art theorist of fifteenth-century Florence, as well as a humanist author, artist, and architect. He embodies the notion of the Renaissance man who is highly educated and competent in many fields. His short treatise *On Painting,* which appeared in Latin in 1435 and in Italian a year later, is *the* key monument of fifteenth-century Italian art theory.[9] Its humanist character derives from the use of Classical models and from the recommendations that narratives be grounded in Greek and Roman myth and history and that compositional structure be based on Brunelleschi's perspective system.

In the prologue, Alberti recalls that he had believed that nature "no longer produced either geniuses or giants"—until he arrived in Florence and encountered Donatello, Ghiberti, Luca Della Robbia (Andrea's uncle), Masaccio, and Brunelleschi.[10] Book 1 deals with the mathematics of painting (particularly the system of one-point linear perspective [cf. 2.14]) based on the construction of a visual pyramid and derived from Brunelleschi. The square base of Alberti's pyramid is turned on its side and becomes the flat picture plane; the tip

of the pyramid is the viewer's eye. The diagonal sides—and the lines parallel to them—are lines of vision from the eye to the picture plane. By constructing lines of sight, Alberti, like Brunelleschi and the artists who used the new system, measures distance in relation to size, since an object appears smaller the farther away it is. Alberti thus takes the position that man-as-viewer is the measure of things.

For Alberti, light, shade, and color also affect form and size. Shade darkens color, and light brightens it. These elements, like size, are perceived in relation to each other. In a painting they replicate the experience of nature rather than being rendered as absolutes, as in Byzantine art. "All the accidents of things," Alberti writes, "are known through comparison to the accidents of man."[11] Alberti calls Narcissus the inventor of painting, tracing the origin of painting to a man's reflection of his own image in nature. It therefore follows that art should reflect man's place in and perception of the natural world.

In Book 2 Alberti makes his well-known claim that painting contains "a divine force which not only makes absent men present, as friendship is said to do, but moreover makes the dead seem almost alive."[12] He refers here to the power of images, which was well understood by Renaissance patrons and used to personal, political, and religious advantage. Thus, for example, when Lenzi portraits are included in Masaccio's *Trinity,* the patrons symbolically prolong their existence through their images.

For Alberti, the most important aspect of a painting was the *istoria,* an ideal synthesis of form with content, of text and narra-

tive with image. This requires that the individual elements be true to themselves and harmoniously related to the whole. In Masaccio's *Trinity,* therefore, Mary's somber mood is conveyed by her weighty, dark blue drapery. And Saint Peter's conflicted reaction to Christ's command in the *Tribute Money* is shown by contradictory gestures and an angry expression.

In Book 3 Alberti describes the ideal artist as technically skilled and well educated in the liberal arts and geometry. He is acquainted with poets and orators, from whose literary inventiveness he benefits in composing the *istoria.* Reflecting the Renaissance practice of including patrons and family members in pictures, he asks painters to reward him for his treatise by depicting his features in their works.

Alberti's treatise was, as he well knew, the first of its kind. It raised the art of painting to a new level, worthy of theoretical consideration, eroding the medieval view of painting as a handicraft. His position was borne out by the most innovative early-fifteenth-century artists. Many were financially successful. They either were well educated themselves or worked with educated patrons and clergy, with whom they discussed the programs of their work.

Ghiberti's "Gates of Paradise"

From 1401 Ghiberti worked on the north doors of the Florence Baptistry. In 1424 he finished the first pair and in 1425 was relieved of his duties on the dome of the cathedral. In the meantime, he was commissioned by the Wool Refiners' Guild to produce a second set of doors on the east

side of the Baptistry, facing the cathedral entrance [2.23]. Called the "Gates of Paradise" after the area between a cathedral and a Baptistry known as the *paradiso* (often a burial space), the doors occupied Ghiberti until 1452. They consist of ten Old Testament scenes in the square Renaissance frames that conform to Alberti's view of paintings and reliefs as windows onto nature. They also show that Ghiberti had absorbed the principles of Alberti's art theory.

The main scenes begin with the Creation at the upper left and conclude with the Meeting of Solomon and Sheba [2.24] at the lower right. Ghiberti used two perspective techniques in the reliefs. One is Alberti's system, in which diminishing size indicates increasing distance, as illustrated in Figure 2.25. The other is a system devised by Donatello for reliefs, in which the degree of relief diminishes with increasing distance. Both techniques are evident in the *Meeting of Solomon and Sheba,* where the foreground figures and architecture are both larger and rendered in deeper relief than those meant to be read as farther away. They seem closer to viewers, and relate more plastically to them, which is also a function of physical closeness in nature.

In the *Commentarii,* Ghiberti describes his perspective technique: "I strove to observe with all the scale and proportion (*misura*), and to endeavor to imitate Nature in them as much as I might be capable; . . . on the standing planes (*piani*) one sees the figures which are near appear larger, and those that are far off smaller, as reality shows it."[13] Ghiberti's penchant for autobiography, related to Alberti's recommendations in *On Painting,* is shown by his inclu-

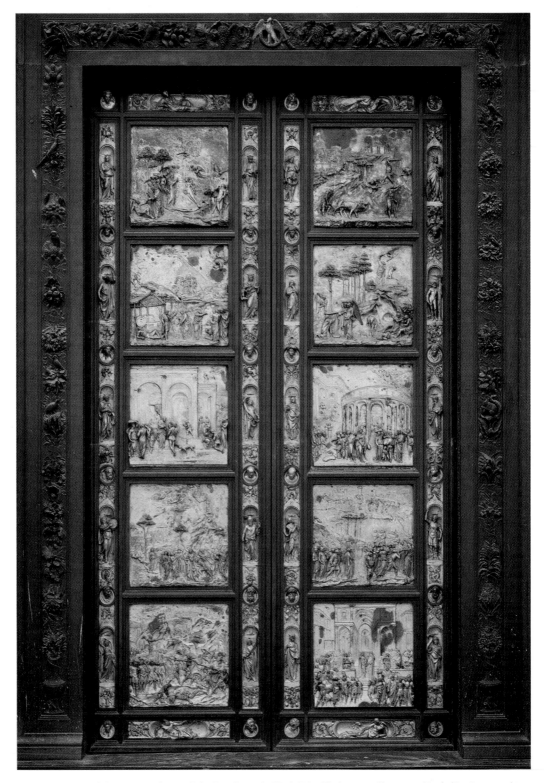

2.23 Lorenzo Ghiberti, east doors of the Baptistry, 1425–1452. Gilt bronze. Florence. (Scala/Art Resource)

2.24 Lorenzo Ghiberti, *Meeting of Solomon and Sheba* from the east door of the Baptistry, c. 1450. Gilt bronze. Florence. (Brogi/Art Resource)

2.25 Alberti's perspective system. From Leon Battista Alberti, *On Painting,* trans. John R. Spencer, New Haven and London, 1966.

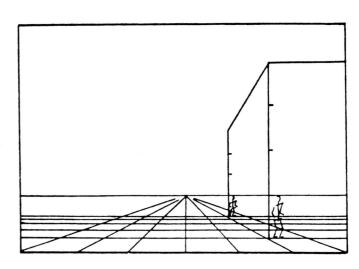

sion of his own [2.26] and his son's heads among the border figures of the Gates of Paradise. The prominence of Ghiberti's domed bald head has been read as a reference to the lifelong rivalry between the two artists. This reading is reinforced by the fact that in an earlier self-portrait on the north Baptistry door, before his problems in working with Brunelleschi on the dome, Ghiberti wears a hat.[14]

Also reflecting Alberti's theory is the symmetrical construction of the *Solomon and Sheba,* with a single vanishing point. The location of the vanishing point slightly above the royal encounter merges narrative with geometry and conforms to Alberti's notion of *istoria.* As the concluding scene of the doors, the *Solomon and Sheba* logically depicts the arrested movement that such a meeting entails. In this respect, Ghiberti's relief has affinities with Gentile's *Adoration,* whose movement stops when the kings reach the Holy Family.

Formal similarities between these two works are consistent with the traditional typological pairing of the Meeting with the Adoration. Sheba, like the Magi, traveled from Arabia, in the East, to worship a king. Ghiberti shows the respective entourages of Solomon and Sheba in corresponding Western and Eastern dress. The bridal connotations of the Meeting (denoted by Sheba's veil) were paired typologically with the Coronation of the Virgin, as well as with the Virgin's earthly marriage to Joseph. Solomon's Temple in Jerusalem, where the Meeting takes place, was a type for the Church. Ghiberti sets the Meeting at the entrance to Solomon's Temple, which is related to the relief's location on the Baptistry doors.

2.26 Lorenzo Ghiberti, self-portrait from the east door of the Baptistry. Florence. (Alinari/Art Resource)

Ghiberti's panel also had contemporary political significance. The schism between Byzantium and Rome had plagued the Church for centuries. When the Turks became a serious threat to Greek control of Byzantium in the early 1400s, the emperor of Constantinople, John VIII Paleologus (ruled 1425–1448), agreed to discuss unifying the two churches. The West demanded that the East accept the supremacy of Rome and that the emperor submit to the pope.

A council to resolve the issue was convened in Ferrara in 1438. But an outbreak of plague caused the council's transfer to Florence in 1439, and Cosimo de' Medici agreed to pay the expenses incurred by the

new venue. The excitement surrounding preparations for the council would certainly have influenced the choice of the *Meeting* as the last panel of Ghiberti's doors. The emperor, with his opulent entourage, was popularly associated with the Queen of Sheba and the three Magi. The council itself was compared with the biblical Meeting of Solomon and Sheba.

Ghiberti's representation of the royal pair on an equal footing reflects the diplomatic efforts of the council. Nevertheless, certain details denote the superiority of Solomon; Sheba bows her head slightly, whereas Solomon stands straight, his pose reinforced by the verticals of his robe and the architecture.

The efforts to unify the Church failed, but their impact persisted. The emperor made a lasting impression on fifteenth-century artists, who continued to include his portrait in their work. One of these, the painter and medalist Antonio di Puccio Pisano, known as Pisanello (c. 1395–1455), cast the first medal of the Renaissance in Italy to celebrate the council.[15]

Pisanello's Medal of John VIII Paleologus

As his name suggests, Pisanello was probably born in Pisa. He had worked in northern Italy and Rome, and his reputation as a painter in the International Gothic style was well established by the time he arrived in Florence. His medal of John VIII Paleologus [2.27] was the first of many that Renaissance rulers would use to disseminate their images for political advantage. Derived from ancient Roman coins, which Petrarch and later humanists had collected, it inspired the revival of a convenient, lightweight, and relatively inexpen-

2.27 Pisanello, medal of Emperor John VIII Paleologus, 1438–1439. Lead. Kress Collection, National Gallery of Art, Washington, D.C. (Art Resource)

sive propaganda device that could be cast in multiples.

Pisanello's medal shows the emperor on the obverse as a forceful personality, wearing his characteristic pointed hat. The reverse reflects Pisanello's International Style interest in landscape and costume detail. He conveys the notion of travel by the two horses, one on a horizontal plane and the other radically foreshortened. The encounter of Paleologus with a crucifix was intended to remind viewers of the emperor's mission to join with the Western Church. Pisanello repeats this message in the inscriptions—his own signature in

Latin and Greek, denoting the Western and Eastern Churches, respectively.

The optimistic atmosphere of early-fifteenth-century Florence was based on the centrality of man and the conviction that people could achieve fame through earthly accomplishments. These ideas were fueled by the arts, the humanist curriculum in the elite schools, the strength of a mercantile economy, and the revived interest in Greek and Roman antiquity. The next decades of the century would continue these developments, although not always without conflict.

NOTES

1. Giorgio Vasari, *Lives of the Most Eminent Painters, Sculptors, and Architects,* trans. Gaston du C. de Vere, New York, 1979, vol. 1, pp. 408–409.

2. Richard Krautheimer, *Lorenzo Ghiberti,* Princeton, 1970, p. 15.

3. Vasari, *Lives,* vol. 1, p. 382.

4. Ibid.

5. See Millard Meiss, "Masaccio and the Early Renaissance: The Circular Plan," in Meiss, *The Painter's Choice,* New York, 1976, ch. 4.

6. See Leo Steinberg, *The Sexuality of Christ in Renaissance Art and in Modern Oblivion,* 2nd ed., Chicago, 1996.

7. Christopher Hibbert, *The House of Medici: Its Rise and Fall,* New York, 1980, p. 30.

8. See Laurie Schneider, "Donatello's Bronze David," *Art Bulletin,* 55, 2 (June 1973), pp. 213–216.

9. See Leon Battista Alberti, *On Painting,* trans. John R. Spencer, New Haven and London, 1966, p. 15.

10. Ibid., p. 39.

11. Ibid., p. 55.

12. Ibid., p. 63.

13. Cited in Krautheimer, *Lorenzo Ghiberti,* p. 14.

14. See Paul Watson, "The Cement of Fiction: Giovanni Boccaccio and the Painters of Florence," *Modern Language Notes,* 99, 1 (January 1984).

15. See Roberto Weiss, *Pisanello's Medallion of the Emperor John VIII Paleologus,* London, 1966, p. 10.

The Middle Decades
of the Quattrocento

The middle of the quattrocento consolidated the foundations laid earlier in the century. Alberti's theories continued to influence artists; his ideas informed the first example of Renaissance urban planning, undertaken by Bernardo Rossellino for the humanist pope Pius II. Rossellino also executed the first humanist tomb. Alberti himself wrote a treatise on architecture and became a practicing architect. Castagno, Uccello, and Piero della Francesca painted in the monumental tradition of Giotto and Masaccio, whereas Fra Angelico combined Renaissance naturalism with Dominican ideas to convey a new sense of spirituality in art.

Leonardo Bruni and the Humanist Tomb

In 1427 Leonardo Bruni, the republican-minded historian who had coined the term *humanism* and hailed Florence as the new Athens, became chancellor of the city.

When Bruni died in 1444, his funeral was planned on the model of antiquity. Florence commissioned the sculptor and architect Bernardo Rossellino (1409–1464) to design his tomb. Located on the right nave wall of the Church of Santa Croce [3.1], Bruni's tomb would set the standard for humanist tombs in fifteenth-century Italy. Its iconography combines Classical and Christian motifs with allusions to Bruni's biography and specifically to his position as chancellor.

Bruni lies in effigy on a bier, holding his *History of the Florentine People* and turning as if toward the citizens of Florence. The laurel wreath on his head, together with the *History,* refers to the Renaissance ideal of achieving immortality through fame. Supporting the bier are two eagles, which were imbued with a rich iconographic tradition. They were attributes of Zeus and Jupiter, emblems of the ancient Roman legions, and images of power and kingship. The Roman practice of releasing eagles at an emperor's funeral, signifying the ascent

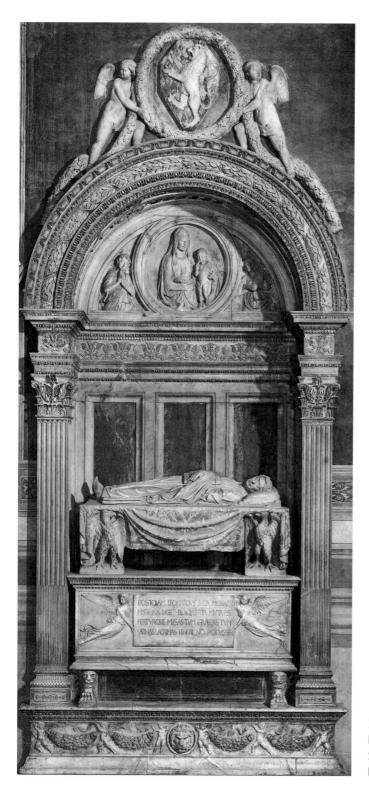

3.1 Bernardo Rossellino, Tomb of
Leonardo Bruni, begun 1444. Marble.
Santa Croce, Florence. (Alinari/Art
Resource)

of his soul to heaven, was another reference to immortality. For Bruni, the eagle was a link to Rome and therefore a reminder of the origins of Florentine republicanism.

Two winged Victories carry the inscription on Bruni's sarcophagus, which states that with his death "history mourns and eloquence is mute, and neither the Greek nor the Latin Muses can hold back their tears." Supporting the sarcophagus are two lion heads on lion paws, which also have ancient associations. Because of the legend that lions never sleep, they are traditional guardian figures; in ancient Egypt, as here, they watch over sacred spaces. In the context of Bruni's tomb, they echo the name of the deceased, Leonardo (*leo* being Latin for "lion").

The tomb's architecture corresponds to Brunelleschian and Albertian theory. It is symmetrical, with Corinthian pilasters supporting a round arch. Below the arch, the Virgin and Christ gaze forlornly from a tondo and are flanked by praying figures. Christ leans on a ledge, assuming the relaxed, *contrapposto* pose inspired by Classical statuary. He inclines his head toward his right hand, a gesture derived from Classical scenes of mourning. Even Christ, it would seem, mourns Bruni's death. At the top of the tomb, two winged putti hold the *Marzocco,* the lion symbol of Florence, in a tondo framed with laurel. On the base, six lively putti hold four swags; in the center, vertically aligned with the *Marzocco,* is the frontal head of another lion projecting from a small circle.

The repetition of leonine imagery on Bruni's tomb, like the eagles, was a link to antiquity. But the lion also had contemporary political relevance as the symbol of

Leonardo Bruni

Leonardo Bruni (1370–1444) wrote extensively about the history of Florence, always with Classical models in mind. He translated from Greek into Latin the *Ethics* and *Politics* of Aristotle as well as a number of Plato's *Dialogues.* His *Panegyric to the City of Florence* was inspired by ancient works praising Athens, and his *History of the Florentine People,* begun in 1415, was influenced by Livy's *History of Rome* as well as by Thucydides. Bruni's *History* was the first work of the Renaissance that used available documentary sources to present the historical process as a development of human cultures. It opens with the birth of Florence and continues until 1402, the year of Giangaleazzo Visconti's death. Bruni defended civic humanism and drew parallels between the government of Florence and that of the Roman republic.

Florence. Leonardo Bruni, himself an intellectual and political lion, was identified with the Florentine republic as its chancellor and historian. Just as he had written the historical "biography" of Florence, so the Florentines "lionized" him with a state funeral and a monumental humanist tomb.

Castagno's *Last Supper*

Three years after Rossellino's commission for Bruni's tomb, the Benedictine convent of Sant' Apollonia in Florence hired the monumental artist Andrea del Castagno (1419–1457) to paint the north wall of the refectory [3.2]. The scenes from Christ's Passion on the upper section are badly

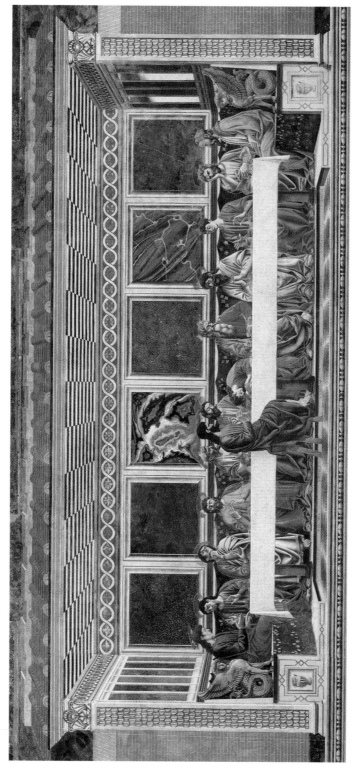

3.2 Andrea del Castagno, *The Last Supper*, c. 1450. Fresco. Cenacolo di Sant' Apollonia, Florence. (Scala/Art Resource)

damaged. In contrast, the large fresco of the Last Supper has been well preserved and cleaned three times since 1950. Influenced by Alberti's system of perspective and his rules for painting *istoria,* Castagno's version of the event takes place in a painted room whose roof of Tuscan tiles and side walls seem to project from the actual wall. Its purpose was to evoke the nuns' identification with Christ's Last Supper during their own meals and to remind them of the Eucharist.[1]

Despite the appearance of mathematical consistency, the *Last Supper* departs from Albertian perspective in its uncertain spatial construction. Its degree of depth cannot be measured precisely, and the shape of the room could be either square or rectangular.[2] The six foreshortened square panels on the left wall, matching those on the back wall, suggest that the room is square. But the back wall has a horizontal row of thirty-three and two-thirds interlaces, whereas the side wall has only seventeen. The spatial ambiguity, as well as the absence of a single viewpoint, allowed the nuns to move about and observe the work from various angles. Thus, although Castagno did not adhere to the fixed viewpoint of Brunelleschi's perspective system, he nevertheless organized the painted space to correspond to the reality of the nuns occupying the natural space of the refectory.

The back and left wall panels are painted to simulate marble, porphyry, and carnelian; painted windows on the right wall appear to illuminate the interior from the right. Stone wall panels resembling those on the Bruni tomb were typically used to denote death. In the context of the *Last Supper,* they refer to the Crucifixion as well as the apostles' martyrdoms. They also reflect Castagno's aesthetic affinity for the textures of stone and conform to the sculptural character of his figures.

Seated around the table from left to right are Matthew, Philip, Thomas, James, Peter, Christ, John, Andrew, Bartholomew, Thaddeus, Simon, and James the Less. Judas is separated from the group by his traditional placement on the viewer's side of the table. His markedly satanic features—the pointed nose and ears, sharp black beard, and dark costume—reinforce his association with the Jews, who fail to see the light of Christianity. As Christ's betrayer, he is the only apostle not identified by an inscription. Without a name, he is literally written out of existence, unworthy of identity and salvation.

Each of Castagno's apostles reacts in an individual way to Christ's announcement that one of them will betray him: "He that eateth bread with me hath lifted up his heel against me" (John 13:18). Christ identifies his betrayer further, saying, "He it is, to whom I shall give a sop, when I have dipped it. And when he had dipped the sop, he gave it to Judas Iscariot, the son of Simon. And after the sop Satan entered into him" (John 13:22–27). In Castagno's image, Judas holds the sop in his right hand, ironically juxtaposed with John's halo and Christ's blessing hand.

Castagno paints the narrative in the manner of Alberti's *istoria,* for the apostles are represented according to their biblical characterization. At the far left, Matthew and Philip engage in serious discussion, indicated by their somber expressions and animated gestures. Thomas the doubter

leans back in thought, as if speculating on the truth of Christ's statement. Saint James is the only completely frontal figure. The wine glass he contemplates and his halo accentuate his head—a foreshadowing of his martyrdom by decapitation.

At the far right, James the Less spreads his hands in a sign of helpless questioning. Simon leans on his hand in the traditional gesture of mourning—an allusion to Christ's death as well as his own. Thaddeus's gesture reverses that of James the Less. His youthful physiognomy heightens the surprise revealed by his startled gesture as compared to the more resigned, passive reaction of the elderly James. Bartholomew is next to Thaddeus, exchanging a glance with Andrew; his praying hands echo the shape of the tau cross on which Andrew, the brother of Peter, will be crucified. Andrew in turn grasps a knife, the instrument of Bartholomew's flaying.

Castagno's taste for stone, evident in the wall panels, the rugged features of the apostles, and the hewn appearance of draperies, contributes to the formal and psychological unity of the *Last Supper*. Both the draperies and the personalities of the apostles resonate with the color and design of the stone backdrops. Doubt and contemplation, for example, characterize Thomas and James and match the quiet, dark reds of their robes and the panel behind them. The second panel from the right is filled with veins of reds, greens, and grays that echo the robes and more animated gestures of Thaddeus and Andrew. At each end of the back wall, the prominence of blue anchors and frames the space and repeats the blue in the cloth on the side benches.

The center of the back wall is bisected symmetrically by the vertical of the marble frame, which directs the viewer's gaze to the crossed hands of John, who has fainted on hearing Christ's announcement. Located just below John is the vanishing point, at which the ceiling orthogonals converge, evoking the Crucifixion by its proximity to his crossed hands.

John's curved form attracts the gaze of Christ, who leans toward him so that his head is parallel to John's halo. With Judas and Peter, Christ and John fit in the space below the animated carnelian panel. Its swirling veins and sharp contrasts reflect the emotional agitation of the four figures. Peter's expression reveals his conflict, and the reversal of his left and right hands—an iconographic symbol of fraud—denotes his deceit in denying Christ three times.

In his biography of Castagno, Vasari reports a version of the story in which Cimabue discovers the young Giotto drawing a sheep on a rock. The young Castagno, according to Vasari, liked to draw animals on walls, and his talent came to the attention of a member of the Medici family, who brought him to Florence for training.[3] Medici patronage of Castagno is not documented, nor is there any record of the *Last Supper*'s commission contract. But the abbess of Sant' Apollonia was related to the chief magistrate of Florence, who had recalled Cosimo de' Medici from exile.[4] Furthermore, the humanist motifs in Castagno's iconography, notably the fanciful sphinxes and the *amphorae* (Greek wine jars), as well as the perspective construction, would be consistent with the nature of Cosimo's patronage. The *amphorae* also allude to wine, creating a link with the blood of Christ and thus with

Transubstantiation as celebrated in the Eucharist.

Fra Angelico's *Transfiguration*

In contrast to Castagno's monumental, sculpturesque style, Fra Angelico's work is endowed with a more manifest spirituality. His paintings exemplify a mystical trend in the quattrocento that can be associated with Dominican patronage.

In 1436 the headquarters of the reform Observant Dominican Order was transferred from Fiesole, the hill-town overlooking Florence, to the run-down convent of San Marco. Plans for its renovation involved three of the most important figures of the mid-fifteenth century in Italy—Cosimo de' Medici, Pope Eugenius IV, and Antonio Pierozzo (1389–1459), later Saint Antoninus. Eugenius had been expelled from Rome in 1433 and was supported by Cosimo during his stay in Florence. Antoninus was the Dominican Superior of San Marco in 1439, Archbishop of Florence from 1446, and a close friend of Cosimo's.

Cosimo hired Michelozzo to redesign San Marco, and the building was consecrated in 1442. Two years later Michelozzo completed the convent's library, the first modern public library in Europe. It originally housed Cosimo's collection of books, and he financed new acquisitions throughout his life. Figure 3.3 is a view of the library; its round arches on Ionic columns, clean white walls illuminated by outdoor light, and simple Classical elegance reflect the architectural principles of Brunelleschi and Alberti

The artist in charge of San Marco's paintings was Guido di Pietro (active c. 1418, d.

Dominicans and Franciscans

The Dominicans and Franciscans comprised the two great Orders of mendicant friars, who preached the ideals of poverty and the simple life. Saint Dominic (1170–1221), who was born in Spain, founded the Dominican Order; Saint Francis (1182–1226) of Assisi—in Umbria—founded the Franciscan Order. Despite their ideal of poverty, both Orders established churches and commissioned artists to decorate them. In general, the Dominicans encouraged the representation of spiritual and mystical qualities in art, whereas the Franciscans were more apt to hire monumental humanist artists.

1455). Like Giotto, he was born in the Mugello; by 1417 he was working in a **scriptorium**, where he **illuminated manuscripts**, and sometime between 1418 and 1423 he entered the Dominican convent in Fiesole. Nicknamed the "angelic painter" by a fellow Dominican, Guido became known as Fra (meaning "brother," from the Italian *frate* or *fratello*) Angelico. By the 1430s, he was running a prosperous workshop and receiving commissions from the most important guilds, including the Linen Weavers' Guild.

According to Vasari, Guido's piety led him to choose the religious life. He "could have lived in the world with the greatest comfort," Vasari wrote, "yet resolved . . . to take the vows of the Order of Preaching Friars."[5] Although Fra Angelico's spiritual style was influenced by the delicate forms of manuscript illumination, his work also reflects the new interest in naturalism and a command of one-point, linear perspective.

3.3 Michelozzo, library of San Marco, 1442–1444. Florence. (Alinari/Art Resource)

At San Marco between 1438 and 1445, Fra Angelico painted the high altarpiece, numerous other panel paintings, and forty-five frescoes. The majority of the frescoes are located in cells occupied by individual friars, and generally there is one fresco about 6 feet high in each cell. Like Castagno's *Last Supper,* which was seen exclusively by the nuns of Sant' Apollonia, Fra Angelico's cell frescoes were rarely, if ever, seen by the public. Their function was private, spiritual, and meditative.

One of Fra Angelico's most powerful images at San Marco is the fresco of Christ's *Transfiguration* [3.4], when Christ, Peter, James, and John ascend Mount Tabor to pray. There, according to the Gospel of Matthew (17:2), Christ "was transfigured before them: and his face did shine as the sun, and his raiment was white as the light." The apostles see Christ in the presence of Moses and Elijah—the latter considered the greatest Hebrew prophet. Peter proposes constructing three tabernacles, at which point

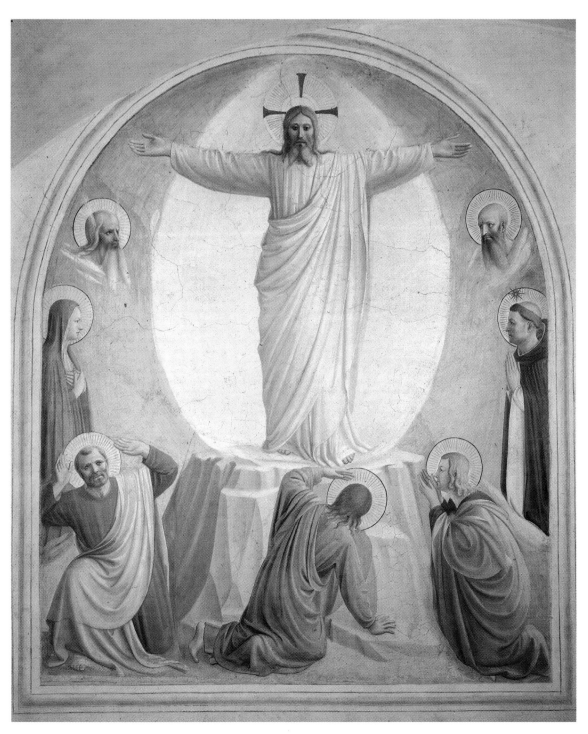

3.4 Fra Angelico, *The Transfiguration*, 1438–1445. Fresco. Museo de San Marco, Florence. (Scala/Art Resource)

"a bright cloud overshadowed them: and behold a voice out of the cloud, which said, 'This is my beloved Son, in whom I am well pleased; hear ye him.' And when the disciples heard it, they fell on their face, and were sore afraid" (Matthew 17:5–6).

In the central figures, Fra Angelico is faithful to the biblical text, but he endows the scene with an iconic quality. A monumental, haloed Christ in a white robe is surrounded by a white, oval **mandorla** of light. He stands on the rock representing Mount Tabor, flanked by the heads of Moses (on his right) and Elijah (on his left). The apostles are awestruck, for they recognize the revelation of Christ's divinity as the Son of God, and they hear God's voice. James shields his eyes from the light, John cups his hands in prayer, and Peter turns toward the viewer.

The power of Fra Angelico's image resides in its revelatory character. Christ's divinity is indicated by traditional visual signs—a monumental, towering form, a frontal pose, and light. He looms above the smaller apostles and dominates the image. The head of Moses, with small rays of light denoting his communication with God on Mount Sinai, prefigures Christ's divinity, here made manifest. The New Law is implicitly depicted as having superseded the Old Law of Moses in fulfillment of Elijah's prophecy. Christ's gesture simultaneously embraces all of humanity and is a visual echo of the Crucifixion. Signifying the site of the Crucifixion on Golgotha is the prominent rock, which, as in Masaccio's *Trinity,* alludes to the Church as the Rock of Ages.

Fra Angelico emphasizes the relationship between Christ and Saint Peter, to whom the building of the Church is entrusted— "Thou art Peter, and upon this rock I will build my church" (Matthew 16:18)—by a combination of pose, gesture, and color. Although Peter turns from Christ, his agitation reflected in his expression, he repeats Christ's gesture, revealing his identification with him. The orange of Peter's drapery combines the red and yellow of Christ's halo, the hint of orange in the mandorla, and the deeper orange of the background. The relatively darker hues of Peter's drapery reinforce his state of mind, which is in conflict, as compared with Christ's divine purity, denoted by the white of his robe. Peter's identification with the Church is shown by the curve of drapery nearly paralleling the curve of the rock.

At the far edges of the picture plane are the Virgin Mary on the left and Saint Dominic on the right. Mary's crossed hands are another allusion to the Crucifixion, whereas the image of Saint Dominic implies that he has evoked the scene of the Transfiguration through meditation. Imagining thus becomes imaging, and the actual time span separating past from present is collapsed. This is the desired effect of the spiritual identification with Christ as well as the power of prayer that was encouraged by the Dominican Order.

The friars at San Marco lived according to the liturgical calendar. Since the liturgy is cyclical and recommences each year, it does not follow the rules of sequential narrative. It is out of historical time and consistent with a communal existence removed from everyday life. This temporal system differs from the Renaissance emphasis on human history, and it is thus not

surprising that the Observants were generally unsympathetic to humanism. Fra Angelico himself satisfied Dominican ideology, but even in his most powerfully spiritual paintings, such as the *Transfiguration,* he also respects Alberti's *istoria* in showing the human reactions of the apostles.

After completing the San Marco frescoes, Fra Angelico remained on good terms with Eugenius IV, who returned to Rome. Around 1445, Eugenius called the artist to the Vatican, where he painted frescoes for both Eugenius and his successor, Pope Nicholas V.

Uccello's *Battle of San Romano*

Cosimo de' Medici employed spiritual as well as humanist artists. And he paid for works not only to adorn public and sacred places but also to decorate the interior of his palace. It is generally thought that he (or his son Piero) commissioned the artist Paolo di Dono (1397–1473), known as Uccello, to paint three large battle scenes for the bedroom wall. Nearly 35 feet long end to end and connected by gold frames, the paintings constitute a perspectival *tour de force.* Uccello was well known among his contemporaries for his virtuoso displays of perspective. His drawing of a chalice that seems to spin around three-dimensionally [3.5] exemplifies his reputation; it is a study in form created by perspective.

In contrast to the work of Fra Angelico, who subordinated geometrical structure to the effects of spirituality, Uccello's work is overtly driven by mathematics. This is evi-

3.5 Paolo Uccello, *Perspective Study of a Chalice,* c. 1430–1440. Pen and ink on paper. Gabinetto dei Disegni e Stampe, Galleria degli Uffizi, Florence. (Alinari/Art Resource)

dent in the three battle scenes. They celebrate the military victory of 1432, when the *condottiere* (mercenary commander) Niccolò da Tolentino led Florentine troops against Siena at the Battle of San Romano near Pisa. Today Uccello's three paintings are lodged in separate museums; the one illustrated here is in the National Gallery in London [3.6].

Consistent with the horizontal planes of the picture space, Uccello divides the com-

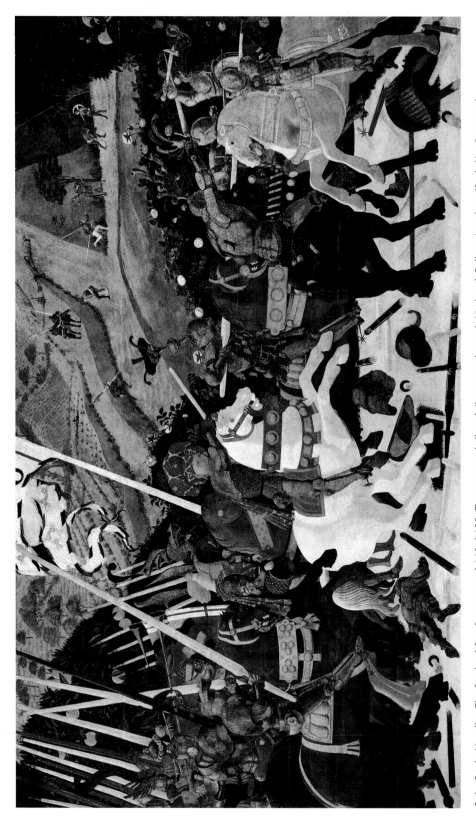

3.6 Paolo Uccello, *The Battle of San Romano*, c. 1445–1455. Tempera and silver foil on wood panel. National Gallery, London. (Scala/Art Resource)

position into three horizontal levels. Niccolò da Tolentino, on a rearing white horse, dominates the foreground. His red and yellow brocade hat is supported by a *mazzocchio,* the armature made of wicker and wood that was fashionable in fifteenth-century Florentine haberdashery. Its geometric form resembles the rim of the chalice, reflecting Uccello's taste for the visual humor of mathematics and geometry. Also characteristic of Uccello is the geometric quality of the horses, whose abrupt shifts from light to dark make them seem wooden rather than organically contoured. Their somewhat stilted appearance recurs in the stagelike platform on which the battle rages. It is strewn with broken lances, pieces of armor, and a radically foreshortened fallen soldier at the left, all of which have conveniently landed in a configuration of simulated orthogonals.

The middle plane is composed of a horizontal row of trees bearing the *mala medicea,* or "medicinal apple" (actually a kind of orange), which is a play on the Medici name. Like the coat of arms at the corner of the Medici Palace, it signals the patron's presence. But whereas the coat of arms asserts ownership and lineage, the oranges in the *Battle of San Romano* denote the family's political importance. The spheres of the oranges are repeated in the gold balls on the horse trappings; on the black horse at the left, the balls are arranged in sets of three—the mark of the pawnshop and a reference to Medici moneylending. In the background, the mountainous expanse and tiny soldiers define an abrupt thrust into distant space. Despite the naturalistic rendering of trees and plowed fields, the angularity of the hills,

like the planar shifts on the horses' bodies, have a nonorganic, wooden quality.

Renaissance assessments of Uccello's virtuosity were mixed. Vasari praises his excellence in perspective, saying that "he reduced to perfection the method of drawing perspectives from the ground-plans of houses and from the profiles of buildings, carried right up to the summits of the cornices and the roofs, by means of intersecting lines, making them foreshortened and diminishing towards the center, after having first fixed the eye-level either high or low, according to his pleasure."[6] At the same time, however, Vasari believed that Uccello went too far, that he wasted time—and therefore money—on his obsession with perspective at the expense of naturalistic figures. "Consuming his time in these researches," Vasari wrote, "he remained throughout his whole life more poor than famous; wherefore the sculptor Donatello, who was very much his friend, said to him very often . . . —'Ah, Paolo, this perspective of thine makes thee abandon the substance for the shadow.'"[7]

Vasari concludes his life of Uccello with the assertion that the artist neglected his family, as well as his reputation and his financial security, for perspective studies. When he died, according to his biographer, Uccello left behind a daughter who had learned to draw and a wife "who was wont to say that Paolo would stay in his study all night, seeking to solve the problems of perspective, and that when she called him to come to bed, he would say: 'Oh, what a sweet thing is this perspective!'"[8] The essence of Vasari's account is confirmed by Uccello's tax declaration of August 9, 1469, in which he reported that his wife was ill

and he himself was old, impoverished, and unable to work.

Piero della Francesca:
The Resurrection

The influence of Alberti permeates the work of Piero della Francesca (1406/20–1492), the most important painter from central Italy in the mid-fifteenth century. Piero wrote treatises on perspective (*De prospectiva pingendi*) and mathematics (*De quinque corporibus regularibus*) that deal with the scientific aspects of painting. All his work is infused with a geometric conception of form, but his figures and landscapes do not have the wooden quality of Uccello's. His figures have the monumentality of those by Giotto, Masaccio, and Castagno, which, along with the complexity of his iconography, places him among the leading humanists and most innovative artistic minds of his time.

Piero was born in Borgo San Sepolcro (literally, "the village of the Holy Sepulchre") in Tuscany. He came from a financially comfortable family of wool dyers, and he himself invested in land. His interest in money and the accurate gauging of volume for assessing value in the marketplace, as well as for three-dimensional pictorial space, is evident from his *De abaco*, a "handbook for merchants."[9] Piero had studied ancient ruins and worked in Florence during the Council of Churches in 1439. His patrons ruled some of the most powerful fifteenth-century courts—Ferrara, Rimini, and Urbino—but the Medici were apparently not among them.

In Arezzo Piero painted a remarkable fresco cycle illustrating the medieval legend of the True Cross for the Church of San Francesco. Its recent cleaning has revealed Piero's variety of techniques, using tempera and oil for rich chromatic effects. Perhaps his greatest single fresco is the monumental *Resurrection* [3.7], commissioned by Borgo's chief magistrates for the town hall. Generally dated to the latter years of the 1450s, it combined political with religious significance. Florence had taken control of Borgo's government in 1441 but later ceded some power back to local officials. They, in turn, renovated new quarters for themselves and decided to decorate the main state room with Piero's fresco.

As a religious image, the *Resurrection* celebrates relics of the Holy Sepulchre in Borgo and is a forceful expression of the power of Christ's will. In contrast to Fra Angelico's awe-inspiring, mystical *Transfiguration* [3.4], Piero's painting emphasizes the physicality of Christ's determined rise from his tomb. He steps up, leaning on the staff of his banner, and with his left hand pulls up his drapery. The placement of the reds exemplifies the Christian condensation of time, for the same color defines the stigmata and the banner's cross. The former refer to the Crucifixion and the latter to the triumph over death and the Crusades fought in the name of the Cross; the red robe denotes royalty and Christ's future role as King of Heaven.

Like Masaccio's *Trinity* [2.15], Piero's *Resurrection* is a tightly organized unity of structure and iconography as well as color. The strong vertical of Christ's architectonic form is repeated in the trees: Those on the left are bare, whereas those on the right are green. This standard opposition traditionally associates the dead trees with Christ's Death and

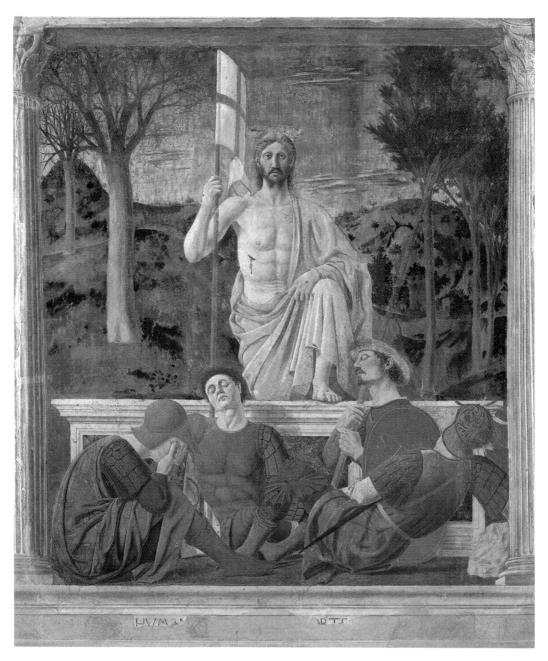

3.7 Piero della Francesca, *The Resurrection,* c. 1452. Fresco and tempera. Museo Civico, Borgo San Sepolcro. (Scala/Art Resource)

the living trees with his Resurrection—another instance of temporal condensation.

The four Roman soldiers radiate from a central point in the narrow space before the tomb. This arrangement, with Christ rising above the center, has the same symbolic meaning as in Masaccio's *Tribute Money* (see Chapter 2). Here, however, in addition to geometric allusions to the curved apse (the soldiers) and the vertical of the Crucifix (Christ himself), the horizontal tomb becomes a symbolic altar.

The entire conception of the *Resurrection,* in fact, contains multiple layers of meaning, which is characteristic of Piero's formal and iconographic complexity. Raised slightly above eye level, the fresco's viewpoint is from below, which enhances Christ's towering presence in the official state room. This effect is reinforced by the cultivated Tuscan hills (now faded because Piero applied details *a secco*) that rise in the background and the projecting illusionistic cornice below the soldiers. The image was originally framed as a tabernacle, with Corinthian columns supporting a thin entablature. This accentuates the Albertian metaphor, in which painting is a window, for the wall seems to open onto a vision of Christ outdoors in the local landscape. That the painting is bathed in Piero's characteristic white light, which is from the left, conforming to the actual light source of the state room windows, would—as in the Brancacci Chapel—have enriched the illusion. The original Holy Sepulchre is thus merged with the Tuscan village of the Holy Sepulchre, making the image a metaphor of Borgo San Sepolcro.

One of Vasari's undocumented assertions is that the soldier with his back to the tomb is the artist's self-portrait. His claim is supported by the attention to the figure's distinctive physiognomy. The soldier leans against Christ's banner, as if alignment with the Savior might gain him salvation. An even more telling autobiographical detail is the rock at the lower right corner of the picture, just behind the base of the column. In iconographical terms, it could refer to the rock of Golgotha and to the Church as the Rock of Ages, but in linguistic terms it denotes the artist—the Greek *petros* meaning "rock" and also being the word from which the name *Peter* (*Piero* or *Pietro* in Italian) is derived.

Alberti on Architecture: The Rucellai Palace

Although Piero della Francesca apparently did not work for the Medici family, his painted architecture and interest in the mathematics of perspective indicate that he was well acquainted with Alberti's theories. By the 1440s, Alberti had begun his architectural treatise, *De re aedificatoria,* in which he advocated assimilating Classical with Renaissance features. He also conformed to Brunelleschi's taste for basic, regular geometric shapes. Like Plato and Pythagoras, Alberti believed that architectural harmony resided in ideal proportions and formal unity, that no single part could be altered or removed without disrupting the whole. To achieve this, as well as to paint a good picture, he argued, the artist had to be educated and able to arrange forms in a pleasing manner. That Piero della Francesca shared this aesthetic is clear from the regular geometry of Christ's

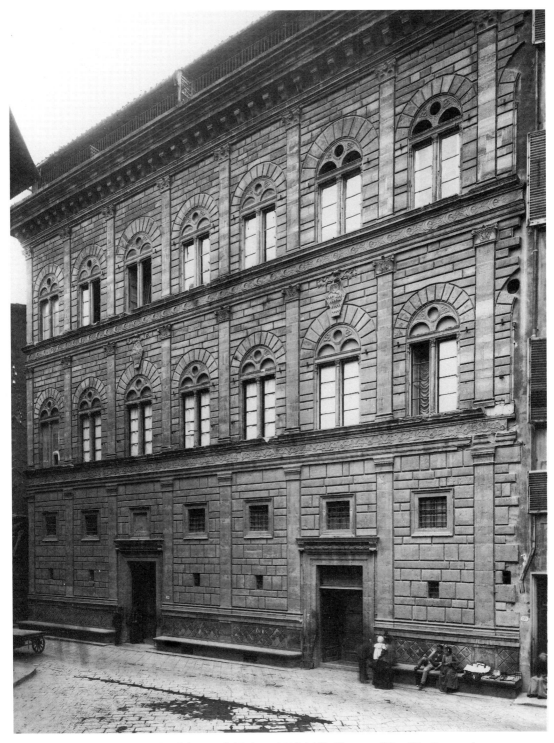

3.8 Leon Battista Alberti, façade of the Rucellai Palace, 1446–1451. Florence. (Alinari/Art Resource)

anatomy in the *Resurrection*. The "architectural" character of the figure is also emphasized by its formal relationship to the Corinthian columns.

Alberti's view of architecture had social and civic implications as well as formal requirements. For Alberti, buildings reflected a city's philosophy and expressed a patron's wishes. In the 1440s, Alberti had designed the Rucellai Palace on the Via della Vigna Nuova, in Florence, which was executed according to his plans by Bernardo Rossellino [3.8]. The Rucellai had amassed a fortune manufacturing a red dye known as *oricello,* from which their name was derived. Giovanni Rucellai subsequently spent a large amount of money on art and architecture.

The design of the Rucellai Palace conforms to Alberti's preference for Classical regularity and symmetry. Its three stories are equal in height and extend horizontally in a pattern of formal rhythms divided into **bays** (the sections framed by engaged pilasters). The central bays containing the entrances are slightly larger than the two bays at each end—the last bay at the right was not completed—which provides a visual frame for the façade.

The architectural Order of the pilasters, as in the Roman Colosseum, differs on each floor, creating variety within the unified whole. The pilasters on the first and second stories support horizontal entablatures, whose cornices seem to provide platforms for the second- and third-story windows. The heavy Tuscan Order on the first floor conveys the impression of support, even though it serves a purely decorative function. The second-floor bays are divided by Composite pilasters and those on the third floor by Corinthian pilasters.

Other variations on the severe rectilinear structure of the Rucellai Palace façade include the windows and the rustication. The windows on the first floor are small and elevated for reasons of security. The remainder are taller, separated by a colonnette supporting a miniature Classical entablature. Above each lintel, a curved arch consisting of wedge-shaped stones frames a smaller double arch and a single round window. Crowning the windows over the doors is the Rucellai coat of arms. One frieze is decorated with symbols of the Rucellai family and the other with Medici emblems. This combination reflects Giovanni Rucellai's political alliance with the Medici as well as the marriage of his son Bernardo to Piero de' Medici's daughter Nannina in 1446.[10]

The masonry, in contrast to the Medici Palace designed by Michelozzo [2.18], is smooth on all three stories and therefore less like a fortress. The ***opus reticulatum*** (diamond pattern) below the ground-floor Tuscan pilasters had been popular in ancient Roman buildings and here serves as a visual base and a structural reinforcement. It also reflects the Classical inspiration of Alberti's aesthetics. The top of the palace is crowned by a large cornice projecting over the façade. Together the base and cornice create a horizontal frame corresponding to the vertical accents formed by the pilasters at each end.

Pius II and the Town Plan of Pienza

Alberti's architectural ideas inspired the first humanist urban plan in Italy. Its patron, Aeneas Silvius Piccolomini (1405–1464), who

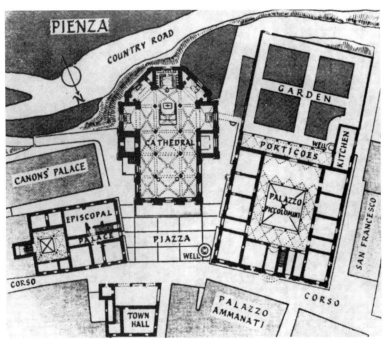

3.9 Bernardo Rossellino, plan of Piazza Pio II, 1459–1462. Pienza.

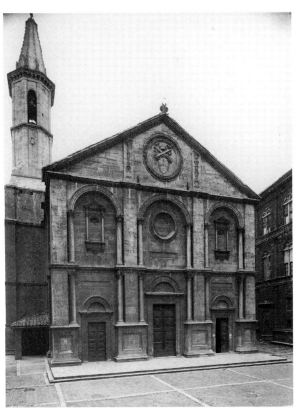

3.10 Bernardo Rossellino, Cathedral of Pienza, 1459–1462. (Alinari/Art Resource)

became Pope Pius II in 1458, was well acquainted with Albertian theory. He decided to transform his native Corsignano, near Siena, into the ideal Renaissance city and renamed it Pienza after himself.

The plan for the new city focused on the piazza, with its cathedral, town hall, bishop's palace, and Piccolomini Palace. Bernardo Rossellino executed the design [3.9 and 3.10]. The plan shows the disposition of the buildings, with the bishop's palace to the east of the cathedral and the residence of Pius to the west. Across the square, to the north, is the town hall. Each building is arranged in relation to the cathedral, and the two palaces flanking it seem to radiate diagonally from the façade.

In the spirit of Petrarch's description of Mount Ventoux, Pius planned Pienza with the Tuscan landscape in mind, specifically, the view of Monte Amiata to the south of the piazza. The southern loggia of the palace opens onto an enclosed garden, which seems to expand into landscape. The resulting integration of the urban setting into the natural environment was the first of its kind since antiquity.

The façade of the cathedral [3.10] faces the square. Its wall, like that of the Rucellai Palace, is composed of smooth blocks of stone, to which surface elements have been added. The triple arches of the ground floor—the center arch larger than the side arches—is derived from the Roman triumphal arch. Additional Classical elements include the columns and the pediments over the niches. Enclosed within the large, crowning pediment of the façade are the papal insignia of Pius II inside a circle. When he died, Pius left instructions prohibiting changes in the design of Pienza.

The *Ideal City*

The horizontal panel painting known as the *Ideal City* [3.11] of around the middle of the fifteenth century has been attributed to more than one artist. Its white light and clarity of form have affinities with the style of Piero della Francesca. Aside from the small central square of Pienza, no such urban plan was actually executed during the Early Renaissance, although both the painting and Pienza reflect Alberti's aesthetic.

The use of basic shapes in the *Ideal City*—for example, the circular and cubic buildings and the square and rectangular windows—are expressions of Albertian as well as of Brunelleschian ideas. Details such as the ground-floor loggia of round arches on the right and the colonnade on the left, the pediments, the Classical Orders, and the *opus reticulatum* at the base of a central building satisfy Alberti's recommendation that ancient forms be assimilated into contemporary architecture.

The round building at the center of the panel is also the formal and mathematical center of attention, with the vanishing point located at its door. In Alberti's view, round pagan temples were reserved for the most important deities, and the circular plan was considered ideal for Christian churches, even though few were actually built.

Accentuating the notion of centrality is the symmetrical arrangement of the cubic structures on either side of the round building, as well as their alignment with the pavement orthogonals. They also highlight its circular form. Like a deserted stage set, the painting is curiously devoid of human

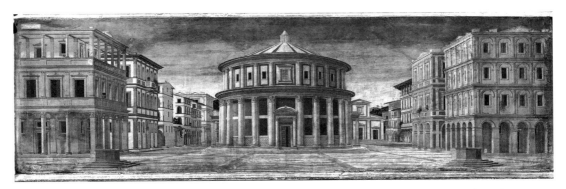

3.11 Anonymous, *An Ideal City,* mid-fifteenth century. Oil on panel. Galleria Nazionale delle Marche, Urbino. (Alinari/Art Resource)

figures. Nevertheless, the very absence of people is part of its striking impact. Aside from the sky, everything represented in the picture—the buildings, the square, and the two symmetrically placed wells in the foreground—is a product of human activity. Just as the rectangular buildings emphasize the round building, the absence of human figures highlights their creative—and civilizing—presence in the conception and construction of a city.

One of the most intriguing aspects of the *Ideal City* is the series of contrasts and juxtapositions that are essentially humanist in nature. Rather than restricting and enclosing, which would reflect medieval modes of thought, the *Ideal City,* like the philosophers of Classical antiquity, invites speculation

and opens up visual and intellectual space by presenting the viewer with unanswered questions. We are not told who built the painted buildings or why. We do not know who occupies them, where they are located, or the identity of the city or the artist.

Both the open space of the piazza and the uncanny open doors of the round building and the temple in the right background seem to beckon the viewer, just as the orthogonals draw viewers into the picture space. The effect of the *Ideal City* is thus a metaphor for the fact that things are not what they seem, that they have many layers of meaning, and that we do not know all the answers. As such, it is not only the representation of an ideal city but also the expression of the humanist intellectual ideal.

NOTES

1. Eve Borsook, *The Mural Painters of Tuscany,* 2nd ed., Oxford, 1980, p. 88.

2. John White, *The Birth and Rebirth of Pictorial Space,* London, 1967, pp. 198–199.

3. Giorgio Vasari, *Lives of the Most Eminent Painters, Sculptors, and Architects,* trans. Gaston du C. de Vere, New York, 1979, vol. 1, pp. 540–541.

4. Borsook, *Mural Painters,* p. 87.

5. Vasari, *Lives,* vol. 1, p. 478.

6. Ibid., p. 342.

7. Ibid., pp. 343–344.

8. Ibid., p. 350.

9. See Michael Baxandall, *Painting and Experience in Fifteenth Century Italy,* Oxford, 1972, p. 87.

10. I am indebted to Mark Zucker for this information.

The Renaissance Ideal of the Dignity of Man

Throughout the fifteenth century, artists continued to elaborate earlier Renaissance trends. Among these was the interest in portraiture, which appears in increasingly varied contexts. Donor portraits and self-portraits were still included in depictions of biblical events; sometimes several family members and other contemporary figures populate the scenes. The frequency and types of individual portraits—equestrian monuments and state portraits, for example—expanded as well. Altarpieces underwent considerable development and by the latter decades of the quattrocento reflected the trend toward combining secular with Christian content. In Mantegna's frescoes for the state bedroom in the Ducal Palace of Mantua, the Renaissance taste for illusionism, evident in the revival of anecdotes about Classical Greek artists that were applied to Giotto, permeates the entire work.

In the 1450s, the humanist author Gianozzo Manetti (1396–1459) published his treatise *On the Dignity of Man* for Alfonso I of Aragon (1395–1458). The Aragonese court at Naples was itself an important center of Classical revival in the quattrocento, and Manetti's work, like the writings of Bruni and Alberti, was enormously influential in fifteenth-century Italy. Manetti argued that the creation of man in God's image endowed him with a superior, creative mind. In addition to man's soul and intellect, Manetti praised the beauty of his body. This synthesis of mind and body, which distinguishes the Renaissance from the Middle Ages, reflected the conviction that man was capable of achieving the highest and most dignified state of being.

The Equestrian Portrait

Consistent with Manetti's views of the visual arts was the fifteenth-century interest in portraiture. Portraits not only preserve the features and therefore the memory of a person, as Alberti believed, but they also project a living personality. A type of image

4.1 Andrea del Castagno, *Famous Men and Women,* 1449–1451. Fresco transferred to plaster. Moved from the Villa Carducci, Legnaia, to the Galleria degli Uffizi, Florence. (Alinari/Art Resource)

that became popular in the fifteenth century is the equestrian portrait, a statue or painting showing a *condottiere* on horseback. These works celebrate the *condottiere's* intellectual achievement as a military strategist, his physical strength on the battlefield, and his loyalty, virtue, and fame. In Castagno's Villa Carducci fresco [4.1], for example, three military heroes are included among the famous men. Two of them, Pippo Spano [4.2] and Farinata degli Uberti [4.3] are shown as assertive, self-confident fighters whose statures are barely contained by their illusionistic niches. Their power is conveyed by an imposing stance, rugged energy, and prominent weapons.

Renaissance equestrian portraits had antecedents in northern Italy during the Middle Ages, when leaders on horseback were represented on tombs or above doorways. But more in tune with Renaissance taste was the equestrian monument of

Castagno's *Famous Men and Women*

Between 1449 and 1451, on the wall opposite the loggia wall of the Villa Carducci near Legnaia, on the outskirts of Florence, Castagno painted frescoes depicting famous men and women. Reading from left to right, the first three figures are Florentine soldiers—Pippo Spano, Farinata degli Uberti, and Niccolò Acciaiuoli. The central three are women: the Cumaean Sibyl, who was thought to have prophesied the coming of Christ; Queen Esther, the Old Testament liberator of her people; and Tomyris, the Tartar queen who, according to Herodotus, killed the Persian king Cyrus. At the right are the three Tuscan poets whose works were basic to the new humanist curriculum—Dante, Petrarch, and Boccaccio. Each holds a book, the sign of his literary output, just as the soldier's weapons signal their achievements on the battlefield.

4.2 Andrea del Castagno, *Pippo Spano*, from *Famous Men and Women*. (Alinari/Art Resource)

4.3 Andrea del Castagno, *Farinata degli Uberti*, from *Famous Men and Women*. (Alinari/Art Resource)

antiquity—for example, the bronze statue of Marcus Aurelius in Rome. The Stoic author of the *Meditations,* Marcus Aurelius, like Cicero, combined the contemplative life with an active political life and was a role model for Renaissance humanists.

Uccello's *Sir John Hawkwood*

In 1436 Uccello was commissioned to paint a monumental equestrian portrait of the English *condottiere* Sir John Hawkwood for the Cathedral of Florence [4.4]. Hawkwood (c. 1320–1394) had died in the service of Florence, and the city honored him with a state funeral. Uccello's fresco is essentially a picture of a statue, with the horse and rider illuminated from the left and shown in a perspective that differs from that of the pedestal. The figures are seen as if from the midpoint of the horse's legs, whereas the top of the pedestal, which resembles a sarcophagus, rests on a ledge seen from below. Such shifts reflect Uccello's penchant for perspectival play. They also solve the problem posed by a naturalistic viewpoint, which would place the observer below the horse and obscure the rider. Instead, therefore, Uccello tilts the horse and the rider toward the picture plane, creating a side view of both.

In contrast to the sculptural quality of horse and rider, the horse's trappings, Hawkwood's baton, and the background are enlivened with reds and oranges. Prominently displayed on the side of the sarcophagus is a Latin inscription extolling Hawkwood, and below, on the lintel of the pedestal's base, is Uccello's signature—"*PAULI UCIELLI OPUS*" ("the work of Paolo Uccello").

4.4 Paolo Uccello, *Portrait of Sir John Hawkwood,* 1436. Fresco transferred to canvas. North aisle of Florence Cathedral. (Alinari/Art Resource)

Castagno's *Niccolò da Tolentino*

Twenty years after Uccello received the commission for *Sir John Hawkwood,* Castagno completed the equestrian portrait of another *condottiere,* Niccolò da Tolentino [4.5], who was commemorated by Uccello in *The Battle of San Romano.* As with Hawkwood, Florence awarded Niccolò a state funeral and planned to honor him with a marble tomb, but this was changed to a painted monument paired with Uccello's *Hawkwood* on the north wall of the cathedral.

Castagno's horse and rider are composed of powerful, massive forms that fill the picture space more fully than those in Uccello's portrait. In contrast to the relatively smooth surfaces of Uccello's figures, Castagno's bulge with energy. The horse turns its broad, blocklike head toward the picture plane, thereby compressing the space and confronting the viewer. Even the tail, rolled into a swirl of curves, seems ready to spring into action compared with the more languid, graceful tail of Uccello's horse.

Niccolò da Tolentino, like his horse, is also more dynamic than the horse and rider in Uccello's fresco. His outstretched leg and arm are tensed as if he is ready to advance into battle. Reinforcing his assertive character are the sturdy armor, thick cloak, and large hat, whose folds press forward. The ribbons at the back of Niccolò's neck, like the ends of the horse trappings, fly out as they would if he were actually moving forward.

As in Uccello's fresco, Castagno's includes an inscription and coats of arms, the former proclaiming the *condottiere*'s military skill and the latter a sign of his lineage. Niccolò's arms (the knot of King Solomon) at the right are paired with the *Marzocco* at

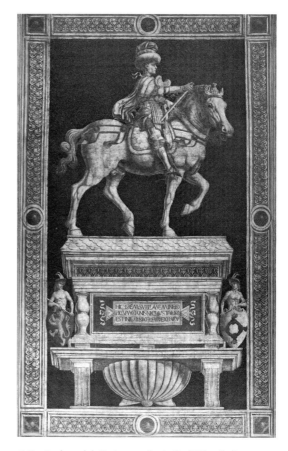

4.5 Andrea del Castagno, *Portrait of Niccolò da Tolentino,* 1456. Fresco transferred to canvas. North aisle of Florence Cathedral. (Alinari/Art Resource)

the left, identifying the hero with the Florentine republic. The prominent scallop shell below the sarcophagus signifies Niccolò's immortality through fame.

Donatello's *Gattamelata* and Verrocchio's *Colleoni*

In the Veneto, the two key equestrian monuments of the fifteenth century were large-scale bronze sculptures. The earlier, completed by 1453, celebrated the *condottiere* Erasmo da Narni (1370–1443), nicknamed "Gattamelata" (meaning "honeyed cat"). He fought for Florence and the Papal States and was appointed Captain General of the Venetian republic. Although the statue was financed by Gattamelata's family, its location just outside the Basilica of Sant' Antonio in Padua (then part of the Republic of Venice) would have required government approval.

Donatello's *Gattamelata* [4.6] sits astride a powerful war horse. Both horse and rider are tense—the horse turns slightly, resting his left foreleg on a ball. Gattamelata is upright in the saddle as he extends the baton of command. Although Donatello had never met his subject, who died an old and sick man, he has represented him in his prime. The head resembles Roman portrait busts, with a specific physiognomy [4.7]. In its combination of formal idealization and individual character with the celebration of personal achievement, the *Gattamelata* exemplifies Manetti's dignified man.

The Classical inspiration of the statue is evident in the details of the armor decoration. The winged Gorgon head on the front of Gattamelata's cuirass is a traditional protective device, symbolically turning enemies to stone. Elsewhere on the armor are

Neoplatonism and the Platonic Academy

As the revival of Plato expanded, Greek texts were brought to Italy from Constantinople and other areas of Greek influence and translated into Latin. The leading Platonic scholar was Marsilio Ficino (1433–1499), whose father had been Cosimo de' Medici's personal physician. By 1469 Ficino had translated all of Plato's *Dialogues* into Latin, largely at the request of Cosimo. Ficino's particular interest was the synthesis of Christianity with paganism.

Beginning in the early 1460s, Cosimo provided his villa at Careggi near Florence for the pursuit of Platonic studies. There humanists gathered, in the manner of Plato's informal Academy in Athens in the fourth century B.C., to debate philosophical and moral issues. In 1469 Cosimo's son, Lorenzo the Magnificent, officially founded the Platonic Academy. As tutor for his children, he hired Ficino's pupil, the Greek scholar Angelo Poliziano (1454–1492), who later composed Lorenzo's funeral oration. Among the other thinkers involved in the Academy were Cristoforo Landino (1424–1492), who wrote dialogues on the virtues of the active and the contemplative life, and Giovanni Pico della Mirandola (1463–1494), who wrote the *Oration on the Dignity of Man*.

smaller Gorgon heads and Cupids who play music and ride horseback; one carries a flaming torch—a sign of the soul's immortality on Roman sarcophagi. The detail in Figure 4.8 shows a Gorgon head derived from Etruscan temple finials and a Cupid in a provocative pose.

The iconography of the *Gattamelata*'s armor is elusive, but it is replete with references to antiquity and can be related to

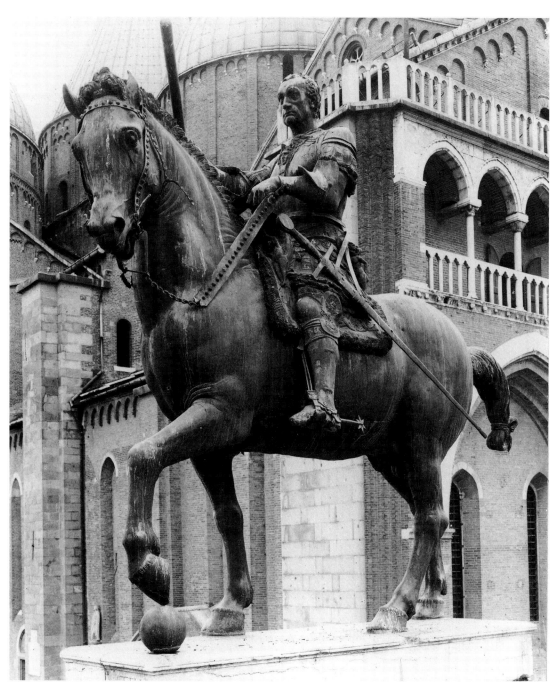

4.6 Donatello, *Gattamelata,* completed 1453. Bronze. Piazza del Santo, Padua. (Anderson/Art Resource)

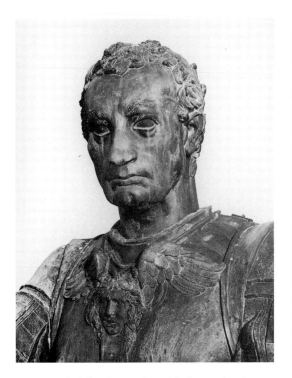

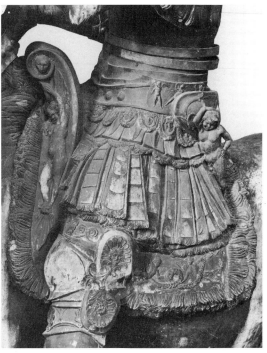

4.7　Detail of the *Gattamelata* with Gorgon head. (Anderson/Art Resource)

4.8　Detail of the *Gattamelata* with Gorgon and Cupids. (Anderson/Art Resource)

Plato's view that the ideal guardian of a state is the military (*Timaeus,* 17–18, and *Laws* I, 639). In the *Gattamelata,* as in Donatello's bronze *David* [2.20], the specificity of the iconography is probably derived from Plato's *Dialogues,* which humanists had translated. The assertion in the *Symposium* that Eros inspires and protects soldiers applies to the *Gattamelata* as well as to the *David*. In the context of the equestrian portrait, both the Gorgon heads and the Cupids function as guardians, protecting Gattamelata as he protected the state. It is possible that the commission of the *Gattamelata* was influenced by Cosimo de' Medici,[1] who was intimately associated with the fifteenth-century revival of Platonism.

The Venetian republic apparently became impatient with the length of time Donatello was taking to complete the statue. According to an anecdote recorded in a contemporary diary, Donatello responded to official pressure by smashing the *Gattamelata*'s head with a hammer. When the officials in turn proposed smashing the artist's head, Donatello replied, "That's all right with me, provided you can restore my head as I shall restore that of your Captain."[2]

Another version of this anecdote appears in Vasari's *Life of Verrocchio* (1435–1488), who cast the bronze statue of Bartolomeo Colleoni (1400–1476) [4.9 and 4.10]. According to Vasari, Verrocchio was hired to cast the horse and another artist to cast the

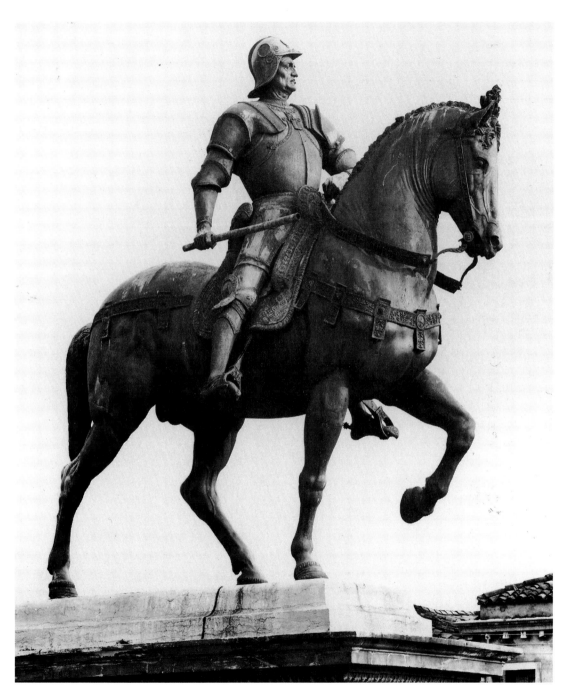

4.9 Andrea del Verrocchio, *Bartolomeo Colleoni,* c. 1481–1496. Bronze. Campo Santi Giovanni e Paolo, Venice. (Anderson/Art Resource)

condottiere. This arrangement so angered Verrocchio that he broke the head and legs of his model and returned to Florence. Venice threatened to behead the artist should he ever reappear in the city. Verrocchio replied that he would not return because a man's head could not be restored, whereas he *could* replace the head of the horse. At this Verrocchio's fee was doubled, and he went back to work.[3]

In both anecdotes, the artist is angry at his patron—Donatello because of time pressure and Verrocchio because an additional artist was hired. Both artists decapitate their figures, and the government—head of the body politic—responds to the artist's defiance in kind by threatening *his* head. It is a literal and figurative war between heads, for the patron controls the commission but finally acknowledges that only the artist can do the work. This realization on the part of the patron, along with the emergence of the artistic personality, reflects the rising status of Renaissance artists compared with the artisans and craftsmen of the Middle Ages.

The anecdotal tradition notwithstanding, documents indicate that Verrocchio won the commission for the *Colleoni* in a competition of 1480. Colleoni himself, who was from a wealthy family in Bergamo, paid for the statue and stipulated that it be located in the Piazza San Marco. But the city objected to such a prominent setting and relocated the statue to a lesser site on the Campo Santi Giovanni e Paolo.

Verrocchio's monument exudes the power of a great fighter eager for war. Colleoni rises in the saddle, tensing his legs, squaring his heavily armored shoulders, and arching his back. The sharp twist of his torso causes his breastplate to bulge forward. The

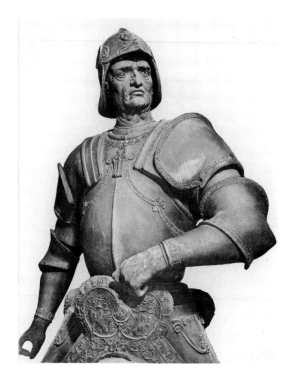

4.10 Detail of Verrocchio's *Colleoni.*

horse in turn holds his head high and raises his left foreleg, opening up the space and creating the impression that he proudly carries his rider into the fray.

In contrast to that of the *Gattamelata*, Colleoni's armor belongs to a contemporary fighter—simpler, more massive, and designed to echo the fierce energy of his physiognomy [4.10]. The *condottiere* turns his head and scowls fiercely. The repeated folds of his flesh, activated by his turn, appear tough and layered, like the plates of his armor. Whereas Gattamelata is bareheaded, Colleoni wears a large helmet that frames his face and accentuates the sense that he is in the midst of battle. Colleoni's harsh characterization is consistent with the aggressively virile self-image that he wished to

project: His name literally means "big balls," and carved in his coat of arms on the base of the pedestal is a pair of testicles.[4]

Leonardo's Equestrian Portraits

Leonardo, who was apprenticed to Verrocchio at the age of eleven, was commissioned to execute two equestrian monuments, both of which remained unfinished and are known only from drawings. The earlier was dedicated to Francesco Sforza (1401–1466) and celebrated his successful campaigns against Venice. Francesco had fought in the service of Filippo Maria Visconti, married his daughter, and succeeded him as duke of Milan in 1450. He also benefited from his friendship with Cosimo de' Medici, who recommended humanist tutors for the Sforza children.

The monument itself, popularly called the *Horse,* was commissioned in the 1470s. A drawing study for the monument [4.11] shows a rearing horse turning gracefully to create an S-shaped motion that is opposed by the counterturn of the rider. The curve of the rider's back and turn of his head echo the movement of the horse. The legs of the rider hug the horse, at once reversing and complementing the angle of the rear legs. Horse and rider move harmoniously through space, joined into a single, unified whole.

In Leonardo's study, the horse rears above a fallen warrior, a motif known from Hellenistic and Roman art. Leonardo drew many horses in motion for the Sforza project; in this drawing he experiments with the position of the legs. The rapid repetition of the lines increases the illusion of movement that the artist intended to convey in the completed monument. Eventu-

ally, however, Leonardo abandoned this type of image. His final study for the *Horse* [4.12] is more stately but also less innovative. He apparently settled on the type used by Donatello and Verrocchio. Instead of rearing, Leonardo's horse marches to the rider's command. Curves and diagonals have been subordinated to verticals and horizontals; horse and rider face the same direction and proceed in a forward motion.

Leonardo was meticulous in his studies for the *Horse*. His notebooks indicate that he began with drawings based on the observation of real horses, then created a small model in a pliable material such as clay or wax. He showed the model to his patron and also used it as a preliminary study: "In order to be able to handle the large model," he wrote on a sheet of drawings, "prepare it by making a small model."[5] For this particular monument, Leonardo had planned for some 200,000 pounds of bronze, enough to make the *Horse* over twice the size of the *Gattamelata*. But the large model was destroyed by French soldiers, and the bronze that had been set aside for the *Horse* was used to cast a cannon.

In the early years of the sixteenth century, Leonardo was commissioned to execute a second equestrian monument in Milan. Ironically, this was to be part of the tomb of Gian Giacomo Trivulzio, whose troops had destroyed the model of the *Horse*. In 1499 Trivulzio had led the French against Milan and subsequently became its governor. The Trivulzio monument never progressed beyond a few sketches, one of which indicates a much more complex arrangement than the study for the *Horse* [4.13]. It also shows that Leonardo considered returning to the dynamic original design for the Sforza monument, with a rear-

4.11 Leonardo da Vinci, *Study for the Sforza Monument*, c. 1480. Drawing. The Royal Collection. © Her Majesty Queen Elizabeth II.

4.12 Leonardo da Vinci, *Final Study for the Sforza Monument*, c. 1482. Drawing. The Royal Collection. © Her Majesty Queen Elizabeth II.

4.13 Leonardo da Vinci, *Study for the Trivulzio Monument*, 1480s–1490s. Drawing. The Royal Collection.
© Her Majesty Queen Elizabeth II.

ing horse twisting one way and the rider another. But the position of the rider's legs has changed, and they have been straightened. The horse now looks down, not only confronting the fallen warrior but also turning to the viewer below.

The State Portrait and the Ducal Palace at Urbino

Federico da Montefeltro (1422–1482) was a *condottiere* as well as the ruler of one of the most lavish courts in Italy. Lord of Urbino from 1444 and duke from 1474, he had received a humanist education and epitomized the Renaissance combination of intellect and action. During his lengthy absences as a *condottiere,* his wife, Battista Sforza of Pesaro, and his half-brother Ottaviano Ubaldini governed Urbino. Both were Classically educated humanists. Federico hired artists, architects, philosophers, poets, geographers, mathematicians, and astrologers; among the Latin, Greek, Hebrew, and Arabic texts in Federico's library was Alberti's *Books of the Family.* Federico's expenditures on artistic patronage exceeded those of any other fifteenth-century Italian court, and most of the necessary funds were raised by selling his services as a soldier of fortune.

Under Federico, the Urbino palace was rebuilt according to the harmonious proportions of Classical antiquity. Its courtyard [4.14], designed by the architects Luciano Laurana from 1466 to 1472 and Francesco di Giorgio after 1476, is a simple, rectangular space of the kind preferred by Brunelleschi and Alberti, surrounded by round arches on Classical columns. The openness of the courtyard created the impression that Federico was accessible to the citizens of Urbino, although in fact the palace was well fortified. In this, Federico conformed to Alberti's observation that a reasonable ruler who is respected by his citizens builds a palace. Tyrants, in contrast, need to be defended from their subjects as well as their enemies and thus require fortresses. The clean, clear lines of the courtyard architecture appealed to Federico's aesthetic and were consistent with the rigorous order he enforced in the daily routines of his court.

Sometime around 1472, Federico commissioned Piero della Francesca to paint a double portrait of himself and Battista [4.15]. She had recently died at the age of twenty-six from complications of childbirth. Her pallor and lifeless appearance compared to that of her husband suggest that Piero may have made her portrait from a death mask.

Both Battista and Federico are rendered in profile, facing each other as if immediately on either side of Alberti's painted "window." Accentuating this particular Albertian theory of painting, also a feature of Piero's *Resurrection* [3.7], is the literalness of the implied window, for beyond the figures extends a vast expanse of landscape. Piero uses the "windowness" of the image to construct a play on the gaze of the viewer in relation to that of the count and countess, who gaze directly at each other as if there is no frame between them. Their connection is reinforced by the stillness of their profiles and by the fact that each facial feature of the one—eyes, nose, mouth, and chin—is directly opposite that of the other. The top of Battista's necklace is on the same horizontal as Federico's collar,

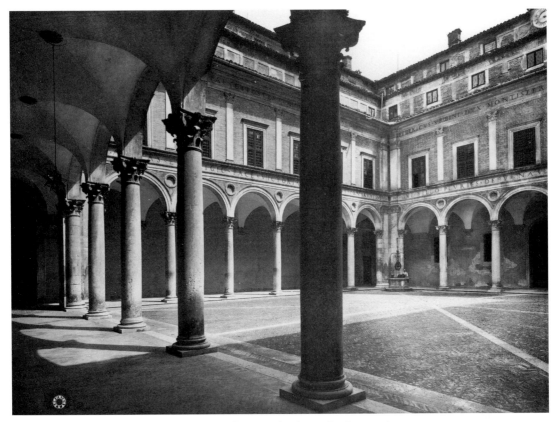

4.14 Luciano Laurana, Urbino Palace courtyard, 1470s. (Anderson/Art Resource)

and the top of her shoulder matches the level of his. The reds of their lips are identical, despite Battista's pallor, and the brooch she wears repeats and seems to reach toward the red of Federico's coat.

Their unity of purpose and emotional connection is unbroken even by death, as was confirmed by Federico's refusal to remarry. It is also, like the Urbino court, at once accessible and inaccessible, for the viewer is excluded from their gaze. At the same time, however, the viewer *is* drawn into the picture space, past the couple, toward the distance beyond them.

That the diptych is an image of rule is clear from the formal correspondences between the figures and the landscape.[6] Battista's pearls, for example, echo the white

city, and the diamond-shaped patterns of her necklace resemble those in the cultivated hillsides. The shaded triangle beneath Federico's chin repeats the triangular mountains, and the moles that dot his face repeat the pattern of dark trees against the lighter terrain. The message implied in the visual parallels between figures and landscape is that Federico and Battista rule extensive territories.

Formal parallels between the figures notwithstanding, Piero has also made clear Federico's dominance. His hat elevates him formally, and the greater bulk of his torso places him in a more forward position than Battista. He wears red—the color of the Roman emperors—and she wears pearls, which were her favorite jewels; Battista's

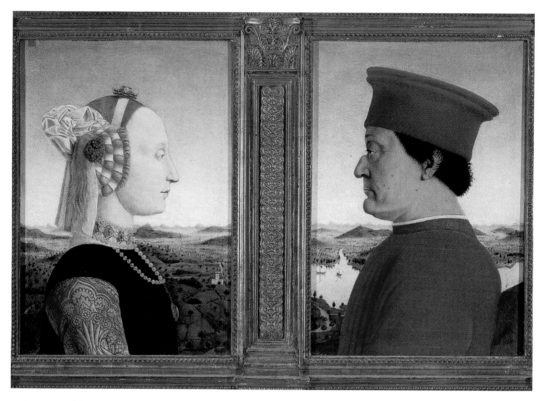

4.15 Piero della Francesca, *Federico da Montefeltro and Battista Sforza*, c. 1472. Oil and tempera on panel. Galleria degli Uffizi, Florence. (Scala/Art Resource)

pearls denote her private tastes, whereas Federico's red signifies his political power. In the portraits, therefore, they are equivalent and not equivalent, as they were in fact. Despite Battista's Classical education and skill in statecraft, Federico was Urbino's lord. The dress, as well as the scale and placement of the two figures, reflects this reality.

Iconographic and formal elements of the diptych reinforce the imagery of rule. Bust-length profiles were derived both from contemporary medals used for political propaganda and ancient coins depicting Roman emperors. The use of the "window" extends beyond Albertian theory and is related to ancient traditions associating rulers with win-

dows. In Egypt, for example, the pharaoh appeared before his subjects in a so-called Window of Appearances, seeming to rise and set like the sun, with which he was identified.[7]

Scarred by a childhood illness and having lost his right eye in a tournament, Federico is represented in left profile. This conforms to the convention of Classical Greek painters, notably Apelles, who depicted rulers from their most flattering angle. Federico's official iconography has retained only his broken nose and a few moles on the surface of his otherwise smooth flesh. This both idealizes the ruler and conveys an impression of naturalism; it also reflects Manetti's views on the dignity of man.

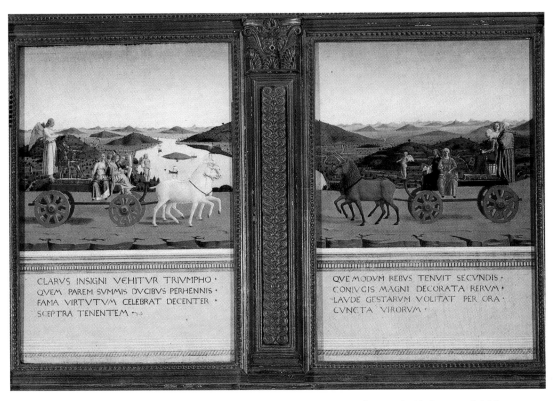

4.16　Piero della Francesca, *Triumphs of Federico da Montefeltro and Battista Sforza,* c. 1472. Reverse of 4.15.

On the reverse of the diptych, Piero has painted the triumphs of Battista and Federico [4.16].[8] Derived from the *Trionfi,* Petrarch's poems which describe triumphal processions, the iconography of the triumph was used to celebrate rulers in the manner of Roman emperors. Each chariot is driven by a Cupid facing the central frame. Pulling Federico's chariot is a pair of white horses symbolizing love, a reference to his love for Battista. Federico is armed and sits on the field stool used by Roman generals. A Victory crowns him with laurel as he, like the *Gattamelata,* extends his military baton. The four Cardinal Virtues—Justice, Prudence, Fortitude, and Temperance—are seated at the front of the chariot.

Battista's chariot is drawn by unicorns, symbols of chastity, and she is accompanied by the three Theological Virtues—Faith, Hope, and Charity (holding a pelican). A fourth figure in gray represents Time; her rendition in back view makes her anonymous, alluding to the timeless character of eternity. Battista reads a prayer book and wears red—a color of mourning as well as of imperialism. The inscription describes her as modest, praised by all, and embellished by the acclaim of Federico's deeds. She is thus clothed in his fame. Federico's inscription asserts the legitimacy of

his rule and his virtue, and declares that he is being carried in triumph to immortality.

The Gonzaga Court in Mantua and Mantegna's *Madonna della Vittoria*

By the last decade of the quattrocento, Andrea Mantegna (active 1441/45–1506) had been court painter to the humanist Gonzaga family of Mantua for nearly thirty years. He worked in the monumental tradition of Giotto and through his antiquarian interests and sculpturesque Classicism imparted an archaeological character to his pictures. In the Ducal Palace of Mantua, he elaborated illusionism beyond the individual picture plane to include the walls and ceiling of an entire room.

Born in a little village north of Padua, Mantegna was the son of a carpenter and was apprenticed to the Paduan painter Francesco Squarcione. Squarcione ran a private art school, which he called a *studium,* or university. He rejected the traditional term *bottega,* or workshop, that put artists on the same level as craftsmen, and he argued for elevating the status of painting to a liberal art. Likewise, Gianfrancesco Gonzaga had founded one of the most important humanist schools at his court, and he hired the Classical scholar Vittorino da Feltre to run it. Known as *La Giocosa,* or *La Gioiosa,* the school offered the standard humanist curriculum, including rigorous daily exercise for training the body as well as the mind. Women were educated along with men, except in the martial arts, and scholarships were offered to talented youths unable to finance their studies. Among his students, Vittorino

held Federico da Montefeltro in the highest esteem.

Mantegna's three Gonzaga patrons had all been educated at *La Gioiosa.* From the 1460s to 1474, he worked on frescoes for the so-called *Camera Picta* (Painted Room) of the Ducal Palace, later known as the *Camera degli Sposi* (Room of the Newlyweds), commissioned by Gianfrancesco Gonzaga's son Lodovico [4.17 and 4.18]. The *Camera* was actually a state bedroom, available for official business as well as Lodovico's private use.

In the *Camera,* Mantegna goes beyond the Albertian "window" and opens the walls themselves. He juxtaposes members of the family, their court, and their official visitors in the foreground with distant landscape. Illusionistic effects are enhanced by painted curtains and tapestries, which appear to have been drawn aside to reveal the exterior balcony occupied by Lodovico's family [4.17]. Lodovico himself sits on a field stool, signifying his role as a *condottiere.* He receives a letter, indicating his involvement in affairs of state, which is reinforced by the coming and going of the figures on the stairs at the right. Marquis Lodovico is also shown as a family man, wearing the Gonzaga colors—red, yellow, and white—with his dog lying contentedly beneath his chair. His wife, Barbara of Brandenburg, sits beside him facing the viewer, along with her children, courtiers, nursemaid, and a female dwarf. The Marchioness, like Battista Sforza, was a well-educated woman who was capable of governing in her husband's absence.

The ceiling of the *Camera,* with its simulated reliefs drawn from antiquity and the humorous, illusionistic oculus at the center

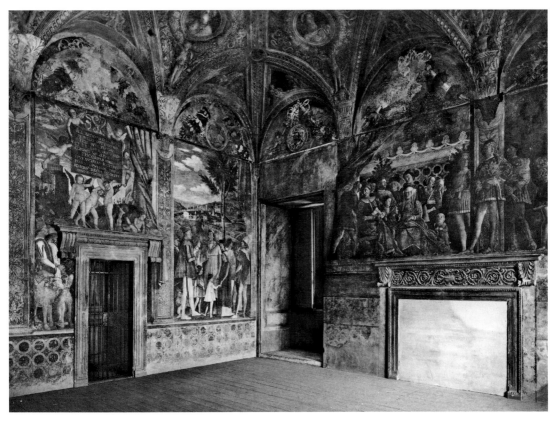

4.17 Andrea Mantegna, view of the *Camera degli Sposi (Camera Picta),* showing fireplace and entrance walls, finished 1474. Ducal Palace, Mantua. (Alinari/Art Resource)

[4.18], combines references to the grandeur of Rome with Mantegna's psychological acumen. Busts of the first eight Roman emperors (visible at the top of Figure 4.17) are depicted in **grisaille** (tones of gray used to simulate stone) on an illusionistic gold mosaic background. Each emperor is encircled by a laurel wreath supported by a single putto-caryatid, also in imitation relief. The triangular spandrels illustrate mythological scenes—six dealing with music and six illustrating the life of Hercules—chosen to enhance Lodovico's image as a humanist and a virtuous man.

The oculus contains antique elements, notably the radically foreshortened winged putti, as well as figures of contemporary women and a large bird that may have been one of Lodovico's pets. The women seem to be enjoying the possibility that a pot of flowers balanced precariously on a pole could fall at any moment. The putti behave like curious, playful children and reflect Mantegna's knowledge of child psychology. They succumb, like the women, to the voyeurism of secretly observing a bedroom, even a state bedroom. As children often do, some of the putti find that their curiosity has unexpect-

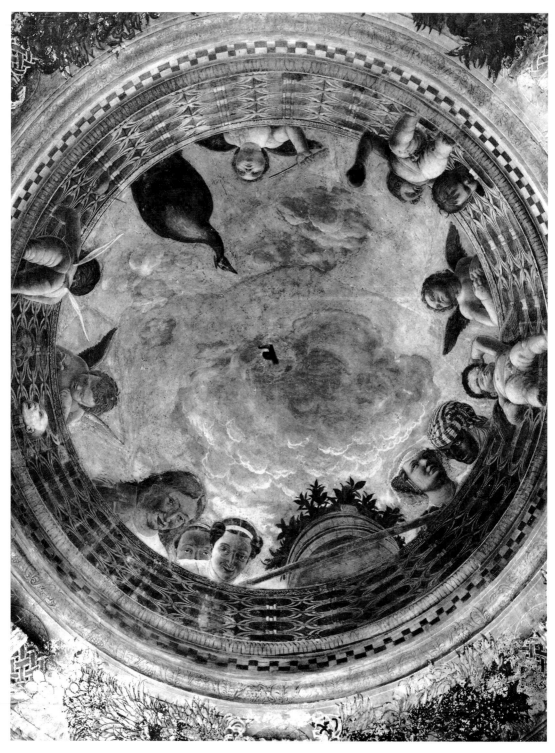

4.18 Andrea Mantegna, ceiling fresco of the *Camera degli Sposi*. (Alinari/Art Resource)

edly landed them in trouble—two are distressed because their heads have become stuck in the balustrade.

One putto seems about to drop an apple, alluding to the Fall and its sexual implications. Given the associations of winged putti with the Greek Eros and the Roman Cupid, these figures both foster romance and make fun of those engaging in it. A further play on vision and the gaze in Mantegna's oculus is the fact that just as the painted figures look down, so the occupants of the room can look up. There is thus an ongoing visual dialogue in the *Camera* between the Gonzaga and their visitors and between the people in the room and the painted images. Alberti's "window" has been transferred to the walls and ceiling of an actual room, where the Gonzaga carried on their public and private affairs. Mantegna seems to have involved the painted space and the painted figures in the daily routines of the living.

There are no surviving paintings by Mantegna for Lodovico's son Federico. His grandson Gianfrancesco II, however, commissioned the *Madonna della Vittoria* [4.19] in 1495 to commemorate his victory over the French troops of Charles VIII at Fornovo. One of Mantegna's late works, the altarpiece merges two fifteenth-century iconographic trends—the so-called *sacra conversazione* and the combination of Christian content with personal and political subtexts.

As a *sacra conversazione,* the *Madonna della Vittoria* (Madonna of Victory) transforms verbal communication into communication through pose, gaze, and gesture. But Mantegna integrates the contemporary figures with the Christian figures, just as he

had integrated fictive architecture and sculpture with actual architecture in the Ducal Palace. The primary focus of the holy figures in the altarpiece is Gianfrancesco himself, who prays at the foot of the Virgin's red marble throne. He wears the armor he wore at the time of his victory and gazes adoringly at Mary. She in turn leans toward him and extends her hand in a gesture of protection.

Kneeling opposite Gianfrancesco at the right is the aged Saint Elizabeth, patron of his wife, Isabella d'Este. Her lowly position in the painting is perhaps an allusion to Isabella's treatment by her husband, who was notoriously unfaithful. Above Elizabeth stands her infant son, John the Baptist, who holds the Cross denoting Christ's earthly mission and looks up at his second cousin. Christ completes the foreground triangle of figures as he mirrors his mother's benevolent gaze toward Gianfrancesco, his gesture of blessing echoing her protective gesture.

The viewpoint, *di sotto in sù* (from below), as in the *Camera Picta,* aligns observers with Gianfrancesco and conforms to Brunelleschi's perspective system. Gianfrancesco, like Elizabeth and John the Baptist, who also gaze upward, is protected by the Virgin's cloak. Its expansive, enveloping character alludes to Mary's role as the Madonna of Mercy, which Mantegna has incorporated into an iconography of victory. Holding the cloak are the warrior saints Michael at the left and George at the right. Saint George, the patron saint of soldiers, holds a broken lance, a reference to the broken lance that Gianfrancesco reportedly delivered to Isabella.[9]

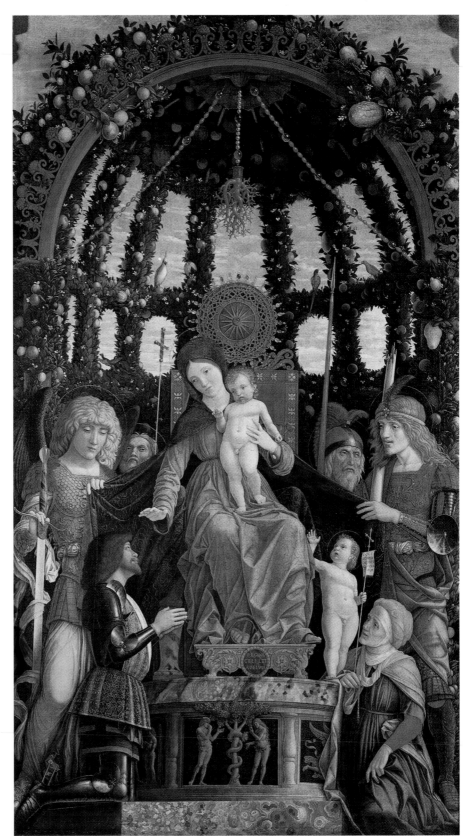

4.19 Andrea Mantegna,
Madonna of Victory,
1495–1496.
Tempera on canvas.
Musée du Louvre, Paris.
(Scala/Art Resource)

The *Studiolo* of Isabella d'Este

Isabella d'Este (1474–1539) was one of the elite Renaissance women who enjoyed the benefits of a Classical education. Her mother, Eleonora of Aragon, had been raised in the humanist court at Naples and married Ercole I d'Este of Ferrara, also a humanist center. At the age of sixteen, Isabella married Lodovico Gonzaga's son Gianfrancesco II and moved to Mantua. There she pursued her intellectual inclinations and, like other educated women, became involved in politics and diplomacy. She patronized the leading artists of the time and was the first woman to commission a *studiolo* (or private study). In this she had been preceded by Cosimo de' Medici, Federico da Montefeltro, and her uncle Leonello d'Este (d. 1450). Among the mythological paintings that decorated Isabella's *studiolo* were two by Mantegna.

The two saints in the background are Andrew, the fisherman, and Longinus, the Roman centurion who pierced Christ's side at the Crucifixion. Both were "associated with the cult of the Holy Blood, the most precious relics of the city, for it was Longinus who had brought them to Mantua and St. Andrew in whose church they were housed."[10] Alluding to Longinus's association with Christ's blood is the pronounced red of his winged helmet; his odd, watery gaze is a symptom of the eye disease that was healed by a drop of Christ's blood.

Saint Andrew holds up a long, thin Cross diagonally aligned with that of John the Baptist, reinforcing the diagonal planes of

Mary and Christ and complementing Saint Michael's sword and the lances of Saints George and Longinus. The juxtaposition of Cross and weapon and the predominance of reds throughout the painting were an attempt to link Gianfrancesco's victory over the French with the Christian faith. In his left hand Christ holds two roses, themselves symbols of his blood and of his blood miraculously transformed. The wind rose (a kind of poppy) at the top of Mary's throne, with its red inner circle and central red gem, was a Gonzaga emblem.

Above the wind rose hangs red coral, suspended from a jeweled rosary attached to the scallop shell denoting rebirth and resurrection. The coral functioned as a protective device for soldiers; the birds and fruit hanging from the Virgin's bower reflect the fertility and abundance of Christianity—and implicitly of Gonzaga rule.

Mantegna engages Mary and Christ, as well as the six saints in the altarpiece, in an image designed to celebrate and honor Gianfrancesco's victory. He occupies the same sacred space as the holy figures but is represented as a humble supplicant, kneeling beside the pedestal relief depicting the Temptation of Adam and Eve. Their fallen state is juxtaposed with Gianfrancesco's lowered position, although he, like Adam, is to the Virgin's right, whereas Elizabeth (and implicitly Gianfrancesco's wife) and Eve, in contrast, are to the Virgin's left. The Tree of Knowledge is vertically aligned with the center of the wind rose, the coral, and the scallop shell, reinforcing the typological character of the altarpiece. Visible to the right of the Temptation and Fall, just behind the folds of Saint Elizabeth's cloak, are the

wings and legs of Saint Michael driving Adam and Eve from Paradise. In the lushness of Mary's bower, therefore, Paradise is regained, as Mantegna shows Gianfrancesco praying for redemption and salvation.

A year after its completion, the *Madonna della Vittoria* was installed in the Chapel of the Victory built to house it. Mantua celebrated the installation with citywide festivities.

NOTES

1. Bonnie A. Bennett and David G. Wilkins, *Donatello,* Oxford, 1984, pp. 92–93.

2. H. W. Janson, *The Sculpture of Donatello,* Princeton, 1963, p. 154.

3. Giorgio Vasari, *Lives of the Most Eminent Painters, Sculptors, and Architects,* trans. Gaston du C. de Vere, New York, 1979, vol. 1, pp. 690–691.

4. Bruce Cole, *Italian Art, 1250–1550,* New York, 1987, p. 183.

5. Cited in Rudolf Wittkower, *Sculpture: Processes and Principles,* New York, 1977, p. 96.

6. See Henri Focillon, *Piero della Francesca,* Paris, 1952.

7. See Carla Gottlieb, *The Window in Art,* New York, 1981, pp. 18–31.

8. See Maria Grazia Pernis and Laurie Schneider Adams, *Federico da Montefeltro and Sigismondo Malatesta: The Eagle and the Elephant,* New York, 1997, esp. ch. 6.

9. Ronald Lightbown, *Mantegna,* Berkeley, 1986, p. 184.

10. Ibid., p. 179.

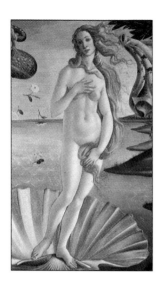

Leonardo, Botticelli, and Crosscurrents in Fifteenth-Century Florence

In the 1480s, Leonardo da Vinci (1452–1519) drew the so-called *Vitruvian Man* [5.1], based on a description in the architectural treatise *De architectura* by the first-century-B.C. Roman architect Marcus Vitruvius Pollio. Vitruvius had drawn a man framed by a square in such a way that the hands, feet, and head extended to the four sides. He wrote that if the hands and feet were to reach out symmetrically to the circumference of a circle, the navel would be located at the center. Leonardo combined Vitruvius's two images by doubling the arms and legs so that they reach both the circumference of a circle and the sides of a square; the navel falls at the center of the circle but not of the square. In this drawing, Leonardo reflects both the enthusiasm for Vitruvius among Italian Renaissance architects and the notion that the ideal measure of man is governed by regular geometric shapes.

The Ideal of the Circle and the Centrally Planned Church

For Vitruvius, as for Renaissance architects, the circle was the ideal shape for church and town plans. Drawing on antiquity, Renaissance philosophers associated the circle with divinity and the perfection of God. Although virtually no circular churches were realized during the Renaissance, centralized churches were. One of the most significant, designed by Alberti and begun around 1460, was the Church of San Sebastiano in Mantua. The building was incomplete at Alberti's death in 1472, and its present appearance [5.2] does not conform to the original plan [5.3]. Nevertheless its influence on subsequent Italian architecture was considerable.

The plan of San Sebastiano is based on the Greek cross, which has four equal arms. This solution amalgamates two traditions:

5.1 Leonardo da Vinci, *Vitruvian Man*, c. 1485. Pen and ink. Galleria dell' Academia, Venice. (Anderson/Art Resource)

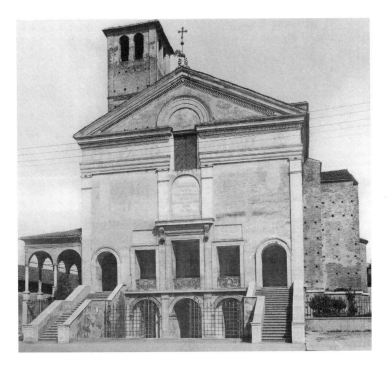

5.2 Leon Battista Alberti, Church of San Sebastiano, begun 1460. Mantua. (Alinari/Art Resource)

Early Christian and Byzantine church plans and round temples that Alberti had seen in Rome and the conviction, derived from antiquity, that such basic shapes reflect God's perfection and the harmony of the universe.

Leonardo da Vinci's Centrally Planned Church Drawings

Leonardo was deeply influenced by Alberti's ideas and, like Alberti, was a "Renaissance man." He was versed in all the known branches of science, as well as geography, art, alchemy, music, and architecture and worked as an inventor, engineer, sculptor, and painter. His literary output, typically accompanied by drawings of re-

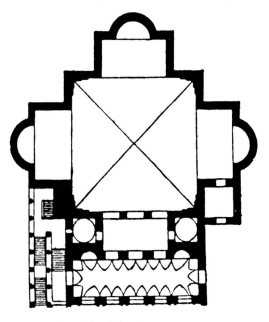

5.3 Plan of San Sebastiano.

markable skill, was prodigious; his scientific experiments were at the forefront of their time; and he produced highly original, often enigmatic paintings.

Born in the small village of Vinci to the west of Florence, Leonardo was the illegitimate son of the notary Ser Piero and a local peasant girl, Caterina. At age eleven, Leonardo was apprenticed to Verrocchio and in 1472 joined the painter's guild. He worked in Florence and Rome, in Milan he was Lodovico Sforza's military engineer, and he died in France while working as painter and engineer to Francis I.

According to Vasari, Leonardo exemplified "beauty, grace, and talent . . . united beyond measure in a single person."[1] However, Leonardo's perfectionism and obsessive research often blocked the completion of his projects. Just as Vasari believed that Uccello had wasted too much time on perspective studies, so he argued that Leonardo wasted time drawing when he should have been painting.

Leonardo completed a relatively small number of paintings but left thousands of drawings and pages of notes, which he bequeathed to his pupil Francesco Melzi. Melzi edited the text, which survives in the so-called *Notebooks,* presently located in various private and public collections. As a body of work, Leonardo's *Notebooks* constitute one of the most complex monuments of the Italian Renaissance. Even Vasari admits that drawing was the medium through which Leonardo communicated his ideas; in fact, the *Notebooks* document a lifelong dialogue between text and drawing. The dynamic character of Leonardo's line conveys the ongoing process of observation that constituted the visual evolution of his ideas.

In the *Notebooks,* Leonardo recorded architectural plans, including centralized churches that fulfilled the theoretical requirements of Brunelleschi and Alberti. As in his *Vitruvian Man,* Leonardo's plans incorporate organic form with architecture, resulting in a new sense of energy, expansion, and growth. Figure 5.4 shows a notebook page with a centralized plan based on eight units forming an octagon. The elevation drawing depicts a large dome rising over the center of the plan, with ribs and a lantern similar to those of Brunelleschi's dome in Florence.

Figure 5.5 is a page containing two drawings of churches and four plans. The three plans at the right are centralized, each based on a rhythm of eight chapels around octagons, with the two upper ones corresponding to the buildings next to them. The round plan at the left is surrounded by seven circular extensions alternating with seven squares. Reading the plans sequentially from upper right to lower left shows Leonardo's evolution toward the circle. Enhancing the dynamic nature of this process is the fluid, sketched character of Leonardo's line and the depiction of churches as three-dimensional form defined by *chiaroscuro.*

Giuliano da Sangallo's Church of Santa Maria delle Carceri

In the 1480s, the architect Giuliano da Sangallo (c. 1443–1516) designed and partly executed—but did not complete—the first

5.5 Leonardo da Vinci, plans and church views, 1490s. Pen and ink. Institut de France, Paris.

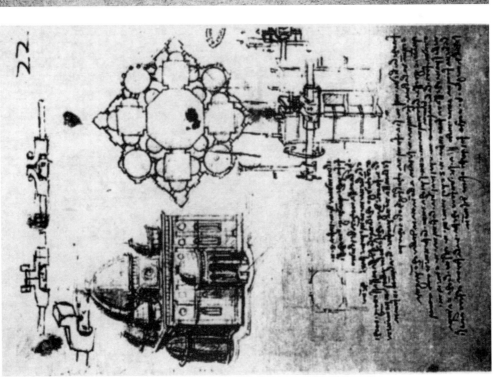

5.4 Leonardo da Vinci, drawing of a centrally planned church, 1490s. Pen and ink. Institut de France, Paris.

fifteenth-century church plan based on the Greek cross. He was influenced by the architectural ideals of Brunelleschi and Alberti and studied ancient Roman and Greek buildings. Giuliano's work appealed to the humanism of Lorenzo de' Medici, whose patronage supported the realization of some of his most innovative architecture. From 1485, in the little town of Prato just northwest of Florence, Giuliano began work on the centralized Church of Santa Maria delle Carceri, which was dedicated to the Virgin of the Prisons [5.6, 5.7, and 5.8] and celebrated a miracle in which her image on a prison wall reportedly came to life.

The plan shows the basic circle and square and simple ratios that had characterized Brunelleschi's architecture. The shapes and proportions of the individual parts of Santa Maria delle Carceri were designed to create an impression of harmonious simplicity. Surrounding the central square are four arms of equal size, whose end walls are the same width as their height, but only half as deep as they are wide. The elevation of the central square is a cube, with each arm representing half a cube. Rising above the central cubic space are **pendentives** supporting the drum of the dome, which has twelve ribs and twelve round windows. The large hemisphere of the dome, symbolizing the heavens, towers over the earthly space below. The heavenly associations of the dome, emphasized by Alberti, are reflected by its whiteness, which is intensified by outdoor light.

The exterior view [5.6] shows two of the four arms, the dome, and the lantern. Tuscan pilasters on the lower story reinforce its support function, whereas the lighter and more elegant Ionic pilasters, as in ancient Roman buildings, are used on the upper story. The two stories are in the relation of one-third (the upper story) to two-thirds (the lower story). Creating accents of dark green stone on white limestone are strict vertical and horizontal bands aligned with the rectilinear shapes of the exterior. This is broken only by the triangular pediment over the door, which echoes the pedimented top of each arm. Likewise, the tondo in the completed pediment repeats the round dome with its circular windows.

The interior view of Santa Maria delle Carceri [5.9] and the section [5.8] show its correspondence with the exterior. Wall surfaces are of plain white stucco, except for architectural accents of dark sandstone in the Corinthian pilasters and moldings at the junctions of walls and of walls and ceiling. Wrapping around the top of the first story is a frieze, whose cornice functions visually as a base for the upper story. These contrasts of light and dark reveal the structural logic of the church.

Throughout the building, squares and circles, cubes and hemispheres are arranged in rhythmic sequences that enhance the harmonious effect of the whole. Circles and curves are repeated in the four tondos at the corners below the dome, in the lunettes formed by the pendentives, and in the twelve round windows of the dome itself. In creating such formal correspondences between simple geometric shapes, as well as in assimilating the three Greek Orders, Giuliano da Sangallo de-

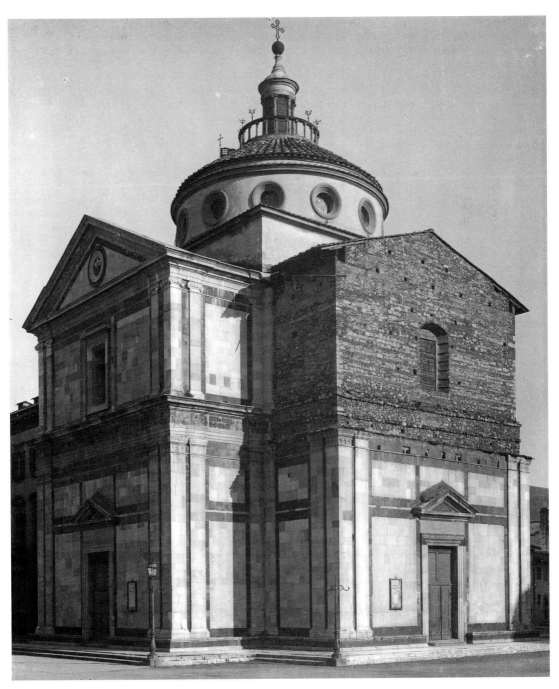

5.6 Giuliano da Sangallo, exterior of Santa Maria delle Carceri, 1485–1491. Prato. (Alinari/Art Resource)

5.7 Plan of Santa Maria delle Carceri (after Leland M. Roth).

5.9 Interior view of the dome, Santa Maria delle Carceri. (Alinari/Art Resource)

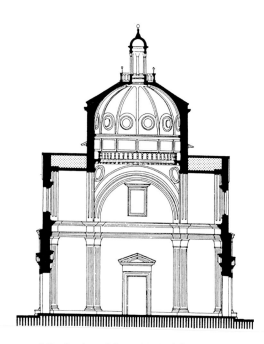

5.8 Section of Santa Maria delle Carceri (after Leland M. Roth).

signed a building that embodied humanist ideals.

The Medici Villa

Another expression of Renaissance humanism and the notion of man's dignity is found in the revival of the country villa. Petrarch's nostalgia for landscape, evident in his description of Mount Ventoux (see Introduction), as well as his conviction that it provided a healthy respite from urban life, had also been a feature of ancient Roman culture. As in Rome, Renais-

sance villas were family retreats; places of entertainment, contemplation, and study; and havens from the plagues that periodically ravaged the cities.

In the 1480s, Lorenzo de' Medici commissioned Giuliano da Sangallo to remodel the family villa at Poggio a Caiano, some 5 miles from Florence [5.10 and 5.11]. The site, like that of Pius II's palace in Pienza [cf. 3.9 and 3.10], opens onto a landscape vista that could be enjoyed from inside the villa. The symmetrical, rectangular plan of the villa [5.11] shows the disposition of rooms, conveniently arranged, like the Medici Palace in Florence, for both public and private use. The large, central hallway has a barrel-vault ceiling and functioned as an entertainment space, whereas the four corners accommodated the private apartments of the Medici family. Repeating the round arches of the barrel vaults is the exterior arcade of the ground floor.

Giuliano's design draws on antiquity for some of its formal aspects as well as its conception. The main structure, like Roman and Etruscan temples, is elevated on a base, and the entrance is modeled on the Greek temple. Supporting the entablature are four Ionic columns, framed at either end by a single pilaster. The latter, like the corner columns of Classical Greek temples, provide both a visual and structural accent, "completing" the porch in an architecturally logical and aesthetically pleasing manner. The Medici coat of arms depicted in relief dominates the center of the pediment, extending waves of ribbons to the corners. Although the subject of the frieze has not been completely identified, the im-

position of the family crest where a Greek temple would have shown gods reflects the degree to which the Renaissance had elevated human achievement.

The stamp of Giuliano's personal style can be seen in the flat, light-colored wall, against which architectural accents, as in Santa Maria delle Carceri, correspond to structure. Symmetrically disposed on the façade are rectangular windows, the two at either end belonging to the Medici apartments and those around the porch to the more public space. Accentng and framing the walls are **quoins** (corner blocks of stone). The synthesis of Classical elements with Renaissance taste evident in the villa was consistent with the wishes of Lorenzo and was at the same time characteristic of Giuliano's work in the 1480s. From a purely practical point of view, the villa, like the Medici Palace in Florence, conveyed the impression of a private residence. But it was also designed to accommodate the public space that one would expect members of a politically powerful family to require.

Botticelli and Medici Patronage

One of the artists most involved with Lorenzo de' Medici's humanist Neoplatonic circle was Sandro Botticelli (1445–1510), the son of a tanner and a Florentine by birth. He spent three years, from 1464 to 1467, as an apprentice to Fra Filippo Lippi (active c. 1432–1469), a monk who had married a nun and the father of the future painter Filippino Lippi. A comparison of Filippo's *Madonna and Child with Angels* in

5.10 Giuliano da Sangallo, exterior of the Medici Villa, 1480s. Poggio a Caiano. (Alinari/Art Resource)

PORTICO

5.11 Plan of the Medici Villa.

the Uffizi of around 1455 [5.12] with Botticelli's *Madonna of the Magnificat* [5.13], variously dated from early to late in his career, reveals the affinities between the two artists. Botticelli's is the more complex of the two works and, although somewhat repainted, it shows that he has adopted the delicate, blond figure types of Filippo. In both paintings, the figural groups are so prominently in the foreground that they appear in places to protrude from the picture plane. This effect is enhanced by the background landscapes, with spirals or zigzags that carry the space far into the distance. The artists also share a taste for curvilinear, transparent materials and elaborate gold decorative elements.

Botticelli takes these preferences farther than Lippi and increases the amount of gold. In place of the transparent halo that Mary wears in the Lippi, Botticelli depicts a star-studded gold crown held by two angels. Above the crown shines a sun, emitting rays whose gold is repeated throughout the picture. Whereas Lippi's composition consists of a pyramidal arrangement of figures against a rectangular window, Botticelli positions his figures to echo the circular plane of the tondo.

In the *Madonna of the Magnificat,* an extremely popular picture in late-fifteenth-century Florence, Christ holds a pomegranate, symbolic of rebirth and resurrection. He looks at Mary, who gazes at her quill pen. Christ's right hand rests on Mary's, and his fingertips lightly touch the words that begin the Magnificat: "My soul doth magnify the Lord" (Luke 1:46–49). Within the overall circularity of Botticelli's figures and architecture (the round arch of the window), the poses, gazes, and gestures of

Mary and Christ create a triangle. Mother and son make physical contact through their gestures, but their gazes do not meet. As a result, instead of creating an exclusive and exclusionary relationship with each other, they participate in the flowing movement of the drapery curves and the fluid poses of the angels. The left page of the book contains the Song of Zacharias, also from Luke, which praises the birth of John the Baptist, Zacharias's son and the patron saint of Florence.

It is not known who commissioned the *Madonna of the Magnificat,* which is one of Botticelli's many religious works. For a time, mainly in the 1470s and 1480s, the artist's subject matter reflected his interest in Neoplatonism and patronage by the Medici family. Around 1470, for example, Botticelli painted the so-called *Man with a Medal* [5.14], depicting an unidentified subject against a landscape background. The man holds a medal of Cosimo de' Medici, which was inserted into the wood panel; the medal is a replica in gilded stucco of an actual medal cast around 1465 to 1470.

The three-quarter view of the man, which is typical of late-fifteenth-century portraiture, enhances the sense that he purposefully displays the medal to viewers. The bony, slightly elongated physiognomy is typical of Botticelli's style, as is the combination of the pale sky with richly colored fabrics. Intense reds—the hat and ring—and the luxurious dark brown velvet cloak contrast sharply with the thinly painted blue-grays of the background.

A similar contrast is found in Botticelli's *Birth of Venus,* a key monument in late-fifteenth-century Florence [5.15]. Although

5.12 Fra Filippo Lippi, *Madonna and Child with Angels,* c. 1455. Tempera on panel. Galleria degli Uffizi, Florence. (Scala/Art Resource)

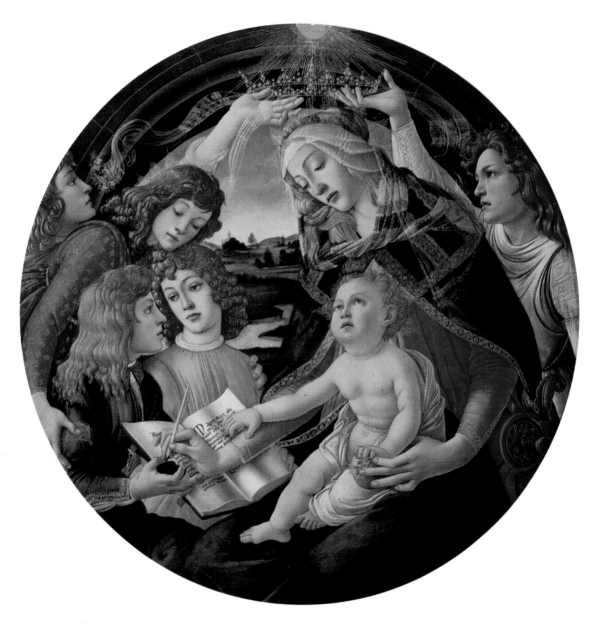

5.13 Sandro Botticelli, *Madonna of the Magnificat*, c. 1480. Tempera on panel. Galleria degli Uffizi, Florence. (Scala/Art Resource)

5.14 Sandro Botticelli, *Man with a Medal,* c. 1475. Oil on panel. Galleria degli Uffizi, Florence. (Alinari/Art Resource)

mythological scenes had been popular decorations on the panels of *cassoni* (marriage chests) and in tapestries, Botticelli's works were the first large-scale, independent mythological paintings of the Italian Renaissance.

It is generally believed that the *Venus* was commissioned by a member of the Medici family, probably a cousin of Lorenzo the Magnificent. The scene illustrates the Greek myth of Venus's birth: When the genitals of Uranos (father of the Titans) were severed and thrown into the sea, the

goddess of love and beauty sprang from the foam. She was carried ashore on a scallop shell, blown by the wind. In Botticelli's version, a wind god with puffy cheeks flies through the air carrying a personified breeze (the female). Waiting on shore for Venus is another female preparing to clothe the goddess in an elaborate pink robe. Her fluttering white dress is covered in delicate floral patterns, and she has rings of myrtle—the tree of Venus—around her neck. The draperies and long, wavy blond hair are blown by the breeze created by the winds and echo the curvilinear, translucent whitecaps of the sea.

Venus dominates the picture plane, an imposing yet modest and somewhat aloof figure. Although she is the focus of all eyes, both of the observer and of the painted figures, her own gaze remains in a separate sphere. Venus is framed by the surrounding figures, two hovering over the sea and one on land, but she is isolated from them and from the viewer. On the one hand, she relates formally to each set of figures—tilting her head toward the winds while her hair flows toward the woman with the drapery; on the other, she occupies the private space of the scallop shell. Its unnaturally large size, along with her inward gaze, endows the painting with a dreamlike quality that has never been fully explained.

Various texts have been proposed as the basis for Botticelli's iconography, among them stanzas by the humanist author Angelo Poliziano describing a virgin whose face is not human, propelled by lustful zephyrs (wind gods or breezes) and standing on a shell as the heavens rejoice. Another view re-

5.15 Sandro Botticelli, *The Birth of Venus*, c. 1470–1480. Tempera on panel. Galleria degli Uffizi, Florence. (Scala/Art Resource)

lates the iconography of the *Venus* to Ficino's more spiritual view of the goddess's birth as the birth of Beauty.[2] Like most efforts to match texts with Botticelli's imagery, these are tantalizing but not entirely convincing.

Late-Fifteenth-Century Florence

The Impact of Savonarola

The progressive character of fifteenth-century humanism and the emergence of large-scale mythological imagery inspired a latent but fervent conservative reaction that came to the fore in the 1490s. Girolamo Savonarola (1452–1498), the Dominican abbot of San Marco and a follower of Antoninus, exemplified this reaction. He was a prolific writer and preacher whose charisma drew such huge crowds that a space the size of Florence Cathedral was necessary to accommodate his congregations. He preached apocalyptic sermons against the immorality of the city, warning that the end of the world was approaching. He left his listeners in no doubt about their fate if they failed to repent.

Among Savonarola's writings was his 1495 treatise *The Compendium of Revelations,* in which he recorded a vision he had had three years earlier. He "saw a hand in heaven with a sword on which was written: 'The sword of the Lord will come upon the earth swiftly and soon.' . . . On earth war, pestilence, famine, and countless tribulations arose."[3] His predictions took on a sense of reality when the French armies of Charles VIII invaded Florence. That event, combined with the death of Lorenzo the Magnificent in 1492 and the exile of his in-

effectual son Piero (1471–1503), made it possible for Savonarola to take control of the Florentine government.

Before long, however, the tide turned against the Dominican preacher. Among his political miscalculations was an attack on the notoriously immoral behavior of the Borgia pope, Alexander IV. In 1497 Savonarola was excommunicated but refused to go to Rome. The following year he presided over the "Bonfires of the Vanities," in which elegant articles of clothing, luxurious furnishings, dice, and books and pictures of which he disapproved were publicly burned. Soon thereafter Savonarola was arrested at San Marco and hanged. Before the scaffold had finished its job, however, a fire was lit beneath his nearly dead body and he was burned as a heretic. His ashes were scattered in the Arno.

At first, by pointing out that the Medici had become autocratic, Savonarola had appealed to republican instincts, but his own autocratic style hastened his downfall. The mystical intensity of his writings also attracted some of the Neoplatonists, which contributed to the demise of Lorenzo's humanist culture. Likewise, certain important artists, among them Botticelli, seem to have been significantly affected by Savonarola's apocalyptic fervor. Botticelli's late works reflect the religious zeal of Savonarola's sermons and his bias against nudity and non-Christian subjects.

In his frenzied moralistic position, Savonarola opposed the Classical revival and humanist notions of the dignity of man. In his view, it was God, not man, who was the measure of things and the source of all beauty. Nature, he believed, was not an ideal to be grasped and conveyed by artists,

but rather a dim and imperfect mirror of God's perfection. Paintings, according to Savonarola, should teach the illiterate about the saints and the Bible. They should evoke a spiritual response rather than an identification with the humanity of their images. Finally, he recommended removing from churches all unsuitable works of art.

Savonarola, like Renaissance princes, recognized the power of images. He saw them as both a potential danger capable of corrupting the weak and a tool for swaying the masses in the direction of salvation. The more progressive counterview was reflected in the notes of Leonardo da Vinci, writing in the tradition of Alberti. For Leonardo, the power of imagery had different implications; he believed that the ultimate control of imagery lay with painters, which argued for elevating the status of painting to a liberal art.

Leonardo's *Book on Painting*

Contained in Leonardo's *Notebooks* were projects for independent treatises. One such project, preserved by Melzi and now in the *Codex Urbinas* owned by the Vatican, is entitled *Book on Painting*. Compared to Alberti's *On Painting* of 1435, Leonardo's discussion places more emphasis on technique and on elevating the intellectual status of painting. The work is divided into five main sections, which include discussions of art and science, the formal elements of painting, the depiction of the human body and nature, and specific topics related to the practice of painting.

In the section on the human body, Leonardo cites Vitruvius on the relationship of man to architectural shapes. He recommends that painters study anatomy so that their knowledge of interior structure will improve their renditions of external appearances. Like Alberti, Leonardo believed that the good painter depicts the physicality of pose and gesture, form and physiognomy to convey emotion. In this view, Leonardo conformed to a basic tenet of Alberti's *istoria,* namely, that human events are determined by the characters of the participants. According to both Leonardo and Alberti, it is the task of painters to fuse their experience of the world with technical skill and to depict figures in a convincing and truthful manner.

Leonardo, more than Alberti, compares painting to other arts, such as poetry and music, a rhetorical system known as *paragone.* Leonardo employs this strategy to demonstrate the superiority of painting over other disciplines. He argues that painting is a science because the painter uses geometry and other branches of mathematics to create the illusion of three-dimensional images on a flat surface. Furthermore, he claims, painting is the most useful science because images communicate more directly with viewers than do other forms of expression. In this, according to Leonardo, the art of painting is surpassed only by nature itself. Calling on the anecdotal tradition in which artists deceive viewers with illusionism, Leonardo describes the effect of a picture of a father "which little children tried to caress even in their swaddling clothes, and similarly the dog and cat in the same household."[4]

Leonardo points out that in contrast to poetry and music the painted image is instantaneously perceived. Reading a poem

or listening to music is sequential and requires attentiveness over time. But "painting presents its essence to you in one moment."[5] Furthermore, "hearing is less noble than sight, in that as it is born so it dies, and it is as fleeting in its death as it is in its birth."[6] Since images are more permanent than sounds, they have a lasting impact, and Leonardo thus concludes that music is the "younger sister" of painting.

According to Leonardo, painting is also superior to sculpture, for sculpture requires greater physical exertion than painting, which is a cerebral activity. Because painting is two-dimensional and sculpture three-dimensional, the painter has to create the illusion of depth. To do so demands the study of mathematics, perspective, shading, color, and light. As a result, the painter achieves a broader understanding of these elements than the sculptor. "Sculpture," Leonardo asserts, "is nothing other than it appears to be" and therefore, like music, is another "sister" of painting.[7]

Addressing the social status of the arts and those who practice them, Leonardo observes that the sculptor becomes sweaty and muddied. He looks "like a baker. . . . His house is in a mess and covered in chips and dust from the stone."[8] The painter, in contrast, "sits before his work at the greatest of ease, well dressed and applying delicate colours with his light brush, and he may dress himself in whatever clothes he pleases. His residence is clean and adorned with delightful pictures, and he often enjoys music or the company of the authors of various fine works that can be heard with great pleasure without the crashing of hammers and other confused noises."[9] The painter, in sum, is a gentleman and an intellectual, whereas the sculptor is a workman.

Leonardo concludes the first part of his *Book on Painting* with a resounding justification for raising the status of painting to a liberal art. To the prevailing view that painting is a handicraft because it is a manual art, Leonardo notes that poetry and music are also composed by hand. Draftsmanship, he says, has taught the sculptor how to perfect statues, the architect to make buildings, and the potters, goldsmiths, weavers, and embroiderers to form their images. It has given numbers to mathematicians, figures to geometricians, and the letters of the alphabet to writers.

"With justified complaints," Leonardo concludes the first part of his treatise, "painting laments that it has been excluded from the number of the liberal arts, since she is the true daughter of nature and acts through the noblest sense [i.e., sight]. Therefore it was wrong, O writers, to have left her outside the number of the liberal arts, since she embraces not only the works of nature but also an infinite number that nature never created."[10]

By the end of the fifteenth century, artists had gained in social status. The most successful tended to work directly for wealthy patrons rather than through the guild system and had become recognized as important members of the community. But it was not until the sixteenth century that artists achieved the status of gentlemen and guilds were replaced by academies.

This change in the artist's status paralleled the general rise in literacy and the dissemination of Classical learning in Italian culture during the Renaissance. By the sixteenth century, the profession of artist

would evolve from craftsmanship practiced through the guild system to academies derived from Plato's Academy. According artists the status of gentlemen and intellectuals was consistent with their increasingly humanist education, which had been advocated by Alberti as early as the 1430s.

NOTES

1. Giorgio Vasari, *Lives of the Most Eminent Painters, Sculptors, and Architects,* trans. Gaston du C. de Vere, New York, 1979, vol. 2, p. 778.

2. See Ernst Gombrich, *Symbolic Images,* New York, 1972, pp. 72–75, and Edgar Wind, *Pagan Mysteries in the Renaissance,* London, 1958, ch. 8.

3. Cited in Linnea H. Wren, ed., *Perspectives on Western Art,* New York, 1994, vol. 2, p. 39.

4. Leonardo da Vinci, *On Painting,* ed. Martin Kemp, New Haven and London, 1989, p. 19.

5. Ibid., p. 23.

6. Ibid.

7. Ibid., p. 42.

8. Ibid., pp. 38–39.

9. Ibid., p. 39.

10. Ibid., p. 46.

The High Renaissance in Florence and Rome

The turn of the sixteenth century in Italy evolved into the period known as the High Renaissance. It was a time of greatness in the visual arts, concentrated in a few major figures, each of whom was in one way or another engaged with the Classical revival. Donato Bramante (c. 1444–1514), whose innovations in reviving ancient forms and developing inexpensive materials laid the foundations of High Renaissance architecture in Rome, was the oldest. Leonardo and Raphael were primarily painters, although both made significant contributions to architecture. And Michelangelo considered himself a sculptor but also worked as a painter and architect and wrote poetry. Early in his career, Michelangelo was engaged with Neoplatonic philosophy, and his style reflected the Classicizing trends of the later fifteenth and early sixteenth centuries. By the end of his life, however, he had begun to develop in radically new directions. All of these artists continued the most original trends

of the fifteenth century, arriving at new solutions that produced the key monuments of the High Renaissance.

Michelangelo at the Turn of the Century

Michelangelo Buonarroti (1475–1564) was born on March 6 "under a . . . star," according to Vasari, his biographer and good friend. For Vasari, the celestial reference to Michelangelo's birth was more than astrological convention. It revealed his genius and heralded his future greatness. The other event of Michelangelo's childhood that has been seen as an omen of his future is the choice of his wet nurse. She was the wife of a stonecutter, and Vasari would later quote Michelangelo as having attributed "the good of [his] brain" to the pure air of Arezzo and to the "hammer and chisels" that he drank in with the milk of his wet nurse. His actual family was less fortuitous: his mother

died when he was six, and his father, a minor civil servant, was unsympathetic to Michelangelo's ambition to study sculpture.

According to Vasari, Michelangelo's father scolded and beat him for drawing in secret, but the future artist made friends with a youth who was apprenticed to the popular Florentine painter Domenico Ghirlandaio. The young man brought Michelangelo drawings by his master that only increased Michelangelo's determination to be an artist.[1] Finally, when Michelangelo was thirteen, his father apprenticed him to Ghirlandaio, possibly in the belief that the social position of a painter was higher than that of a sculptor.

Before the age of sixteen, Michelangelo had come to the attention of Lorenzo de' Medici, who gave the young sculptor access to his collection of ancient statuary and brought him into his household. There Michelangelo met the leading intellectuals, particularly the Neoplatonists, in the Medici circle. He also had works by his immediate fifteenth-century predecessors readily available for study throughout the city.

Of Michelangelo's surviving drawings from these early years, among the most impressive are copies of frescoes by Giotto and Masaccio in Florence. Not only were the simple, massive forms of these artists more congenial to Michelangelo than the elegance of Ghirlandaio, but he could identify with the conflicted personality of Saint Peter as described in the Bible and as depicted by Masaccio in the *Tribute Money* [2.16]. Just as Peter had balked at Christ's order to retrieve the tax money from the mouth of a fish and then proceeded to do exactly that, so Michelangelo's life would be characterized by continual conflicts with powerful patrons.

The *Pietà*: 1498–1500

With the expulsion of the Medici from Florence after Lorenzo's death, Michelangelo departed for Venice and Bologna. At the age of twenty-one, he went to Rome and stayed for five years. During that time, he carved the marble *Pietà* [6.1]. Completed by 1500, the work was a fitting transition to the next century and the achievements of the High Renaissance in Italy.

The *Pietà* was commissioned for the Chapel of the Kings of France in Old Saint Peter's by Cardinal Jean Bilhères de Lagraulas, the French ambassador to the Holy See. The contract specified that the *Pietà* be the most beautiful work of art in Rome, and Michelangelo accordingly searched the marble quarry at Carrara for the highest-quality stone. In keeping with the nationality of the patron, the theme chosen for the work was popular in the northern Gothic tradition: the dead Christ extended across Mary's lap. Italian sensibility, however, differed from that of the North in its affinity for idealized, Classical form.

Michelangelo's *Pietà* reflects the Classical style, yet is a new conception within that tradition. In contrast to northern depictions, Christ is not extended stiffly across his mother's lap, and angular forms are absent. Unlike Italian examples of the subject, Michelangelo's eliminates the figures of Saint John and Mary Magdalen, emphasizing the exclusive mother-child union. The figures form a pyramidal mass, which

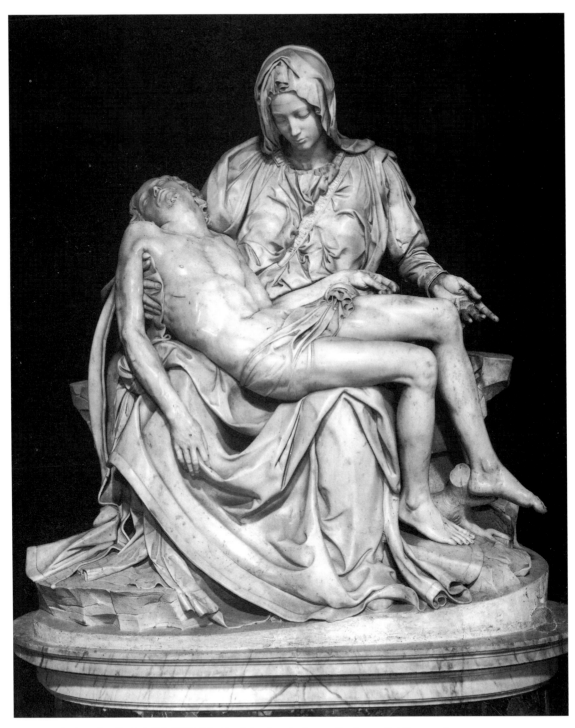

6.1 Michelangelo, *Pietà*, 1498–1500. Marble. Saint Peter's, Rome. (Anderson/Art Resource)

alludes to the Trinity, and they are set on an oval base.

Mary is posed so that her lap is Christ's actual support; she leans back, gazes downward, and turns her left hand upward in a gesture of resignation and display. She is somewhat enlarged, whereas Christ is reduced in size, though not sufficiently to disturb the idealization of the forms or disrupt the compositional unity of the work. Christ himself forms a series of curved and diagonal planes that collapse him into the space of the sculpture. Mary holds him as if he were a sleeping baby, which also collapses time by evoking images of the Enthroned Virgin and Child. Her massive drapery curves follow and echo Christ's own form—the broad curve sweeping to the ground mirrors Christ's right arm, and the shorter curve above passes between the fingers of his right hand.

The curved strap extending from Mary's shoulder, across her chest, to the figure of Christ links mother and son. It is inscribed with the only signature of Michelangelo's career. This raises the question whether, when Michelangelo designed the sculpture, he had in mind his mythic account of having imbibed the tools of his trade with the milk of his wet nurse and projected it onto the archetypal Christian Mother and Son.

According to another of Michelangelo's biographers, Ascanio Condivi, the artist was criticized for the youthfulness of Mary, who would have been in her late forties at the time of Christ's death.[2] Michelangelo allegedly replied that Mary's chasteness preserved her youth. This sentiment has been related to the Neoplatonic view that the body reflects the state of the soul, and thus if the soul is moral and pure, the body

is young and beautiful.[3] In fact, the idealization and youthfulness of both figures celebrate their heroic stature and render them timeless. Enhancing the youthfulness is the surface polish of the marble, in which Michelangelo achieved a degree of shine higher than in any of his subsequent works. Along with the dynamic drapery curves, the surface of the work contributes to the energy inherent in its formal structure despite the somber content.

Two iconographic details further the condensation of time in the *Pietà* by their reference to past and future. One is the small tree stump supporting and echoing the diagonal of Christ's left foot, and the other is the very rock that forms the base of the sculpture and the platform on which Mary sits. By virtue of her large size, Mary *is* the rock, signifying both the Church building and the eternal time of the Rock of Ages. The little stump alludes to the wood of the Cross and the Crucifixion. By this combination of motifs, Michelangelo juxtaposes the mortal time of the past—before Christ's Resurrection—and the future time of salvation and eternity, which is timeless because signifying the end of time.

The *David:* 1501–1504

In 1501 Florence elected the patrician Piero Soderini (1452–1522) *gonfaloniere* (literally "standard-bearer," but roughly "mayor") for life. It was hoped that, like a Venetian doge, he would maintain the stability of the city as a republic. Shortly after the new government of Florence had been established, Michelangelo, then twenty-six years old, received a commission from the Cloth

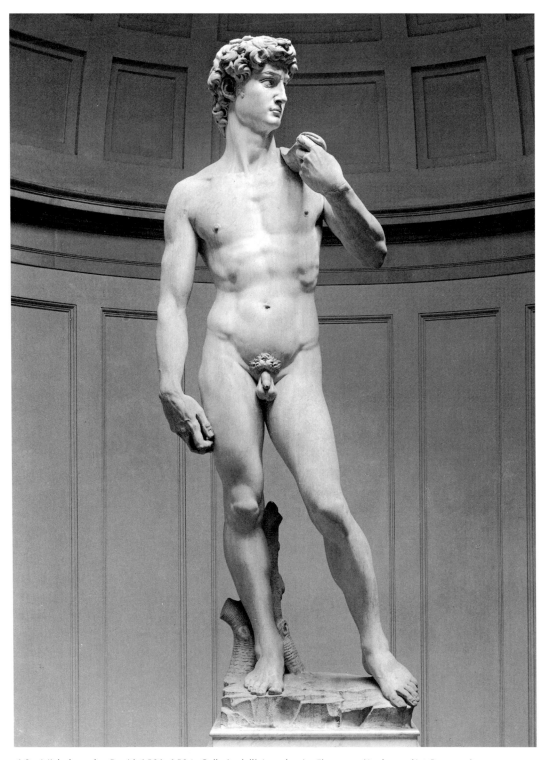

6.2 Michelangelo, *David*, 1501–1504. Galleria dell' Accademia, Florence. (Anderson/Art Resource)

Manufacturers' Guild. The guild wanted a new statue of David for the exterior of the cathedral, whose decoration and upkeep it oversaw [6.2].

By 1504, when the statue was completed, however, the guild convened a commission of artists and other citizens to consider the best location for it. Different members of the commission favored various sites, but finally it was Soderini, possibly in consultation with Michelangelo, who prevailed. He chose the most politically prominent location, just to the left entrance of the Palazzo Vecchio, seat of the *Signoria.* Instead of surveying the city from the upper reaches of the cathedral, the *David* would stand guard at the *Signoria* door. Soderini felt that, at this site, the statue would take its rightful place as the timeless defender of Florentine republicanism. Today Michelangelo's *David* is in the Accademia in Florence, where it was moved in 1873 because the soft marble was eroding.

In carving the *David,* according to a popular anecdote reported by Vasari, Michelangelo had a minor contretemps with Soderini. The latter allegedly found the nose of the statue offensively large and asked Michelangelo to make it smaller. Michelangelo obliged by climbing the scaffold and dropping some marble dust, which he pretended to chip from the nose. Soderini declared himself pleased with the reduction, saying that the statue was now more lifelike, and went away satisfied.[4]

In contrast to the anecdotes in which Donatello and Verrocchio come into conflict with the authorities in Venice (Chapter 4), Michelangelo outsmarts his patron— not by verbal wit, but by trickery and illusion. Instead of imperial clothes, the statue

seemed to get a new nose. Michelangelo pretends to obey his patron and fools him by relying on Soderini's inclination to be deceived by an image. The episode can thus be seen as a metaphor for the creative process and an audience's willing suspension of disbelief.

Michelangelo's *David,* like the *Pietà,* was a new conception of a traditional theme. It differs in several ways from earlier representations of the biblical hero. Michelangelo's was carved from a huge marble block that had been worked on by other artists and was popularly known as the "Giant." In its final form, the *David* is entirely nude, somewhat older than Donatello's bronze version, well over life-size (some 14 feet high), and does not stand over the severed head of Goliath. Instead, he carries the sling over his left shoulder, the stone in his right hand, and gazes into space.

The *David's* relaxed *contrapposto* stance, like that of Donatello's figure, is derived from Classical statuary, but the proportions are closer to Hellenistic style. The bulk of the weight is on the right, reinforced by the vertical plane of the right arm, the power of the large right hand, and the tree trunk behind the right leg. This sense of solid support at the right has been related to the medieval tradition in which the right side of a figure is seen as strong and virtuous, whereas the left side is vulnerable to evil.[5] By bending back his left arm, David symbolically exposes his left flank to the enemy, but he compensates for it by directing his eyes to that side. When the statue was placed to the left of the *Signoria* entrance, the *David* would have seemed vigilant against tyranny—and other evils such as Satan, with which Goliath was

equated—that might threaten the peace and stability of the republic.

In the Middle Ages, the symbol of Florence had been Hercules, whose strength and virtue allied him with the biblical David. Both figures were paired typologically in the fifteenth century as the pagan and Jewish prototypes of the Christian Virtue of Fortitude.[6] Hercules' lion skin also evokes the traditional leonine quality of watchfulness that had informed the iconography of Bruni's tomb. The lion itself served as a guardian symbol of Florence in the form of the *Marzocco* resting his paw on the coat of arms of the city. In the figure of *David* as conceived by Michelangelo, therefore, the strength and virtue of Hercules are conflated with the watchfulness of the lion guardian. These the artist has merged with an image of human dignity, exemplified by vigilant thoughtfulness and idealized human form.

Michelangelo's personal and artistic identification with his statue is indicated by the autograph phrase on a sheet of drawings that included a sketch of the *David*'s arm and of a small bronze version of the work: "David with his sling and I with my bow Michelangelo."[7] This has been read as meaning that as David slew Goliath with his slingshot, so Michelangelo would defeat his giant (the marble block) with his bow, a hand-drill used by sculptors both in antiquity and in fifteenth-century Florence.[8] By implicitly comparing the drill to a weapon, Michelangelo conveys the artist's struggle against his own material—much like an author having to "fight" the blank page in order to produce a text. The artist would carve a youthful, humanist David and transform the older and larger "giant," with

all its political, psychological, and artistic implications. David's conquest of Goliath, Christ's triumph over Satan, and the fortitude of the Florentine republic against tyranny were meanings that Michelangelo's contemporaries would immediately have read in the statue. Michelangelo's personal triumph was in transmuting those meanings into a timeless work of art.

Leonardo in the Early Sixteenth Century

One of the most significant distinctions between the Middle Ages and the Renaissance was the approach to human form. The Classical revival naturally led artists to the depiction of nudity in a way that would have been unthinkable in medieval art. Once drapery had been removed and the body displayed, the next logical step was the exploration of human biology. Man was now not only dignified in mind and outer appearance but also worthy of scientific study.

The Anatomy Studies

The artist who launched scientific studies of anatomy in the Renaissance was Leonardo da Vinci. At first, in the late 1480s, Leonardo dissected animals and studied the surface forms of human beings mainly as an aid to draftsmanship. Then he became interested in the science of human anatomy, which appealed to his obsessive passion for investigation.

Cadavers were hard to come by—hospitals were the main source—and, all told,

6.4 Leonardo da Vinci, drawing of a fetus, c. 1510. The Royal Collection. © Her Majesty Queen Elizabeth II.

6.3 Leonardo da Vinci, drawing of the genito-urinary system, c. 1510. The Royal Collection. © Her Majesty Queen Elizabeth II.

judging from his drawings, Leonardo's human dissections included a head and neck, a seven-month-old fetus, a two-year-old child, and an old man.[9] For the rest, he used animals, wrongly assuming, like the ancient Greek physician Galen, that human and animal anatomies were the same. For example, he studied the action of the human heart from that of an ox. But Leonardo also introduced techniques that were scientifically valid, including cross-sectioning and injecting the brain ventricles with wax to enhance the visibility of their shapes.

The text describing Leonardo's drawing of the female genito-urinary tract in Figure 6.3 reflects the medieval belief that the soul could transform the animal body into a human one.[10] In a drawing of a fetus [6.4] of around 1510, Leonardo writes that "the heart of this child does not beat nor does it breathe because it continually lies in water. If it breathed it would drown and breathing is not necessary because vivified and nourished by the life and food of the mother."[11]

From the perspective of modern knowledge, some of Leonardo's misconceptions are readily evident. Since hearts do not breathe, Leonardo must have misunderstood their function. He was correct, however, in concluding that the fetus does not breathe before birth—for there is no air in the uterus—and that the mother "vivifies" the fetus. But the heart of a fetus *does* beat, which Leonardo did not know because the circulation of blood was still undiscovered. Nor did he know how a fetus makes the transition to extrauterine life or the role of the placenta.

As regards the relationship of the body's structures to its workings, Leonardo could reason from animals to humans with a fair degree of accuracy. This was an approach he learned from Galen, and it was an important step in his acquisition of anatomical understanding.[12] The most significant step, however, came toward the end of Leonardo's last stay in Rome around 1515, when he progressed beyond Galen and arrived at the more scientific procedure of independent observation.[13]

However flawed his scientific theories, Leonardo's anatomical drawings, like his other notebook entries, are key Renaissance monuments. They reflect not only the genius of their creator but also the increasingly scientific outlook of their time. They exemplify Leonardo's personal synthesis of science and art, which is manifest in his drawings and latent in his paintings. In certain instances, especially in his unfinished paintings, it is possible to discern both the manifest and the latent elements simultaneously. The best example is the unfinished *Saint Jerome* [6.5], which illustrates Leonardo's use of flesh and drapery to reveal anatomical structure. He wrote that "as man has within himself bones as a stay and framework for the flesh, so the world has the rocks which are the supports of the earth."[14]

The *Mona Lisa*

Leonardo's metaphorical view of the human body as world is an extended image of man as the measure of things. It is philosophically related to his *Vitruvian Man* [cf. 5.1],

6.5 Leonardo da Vinci, *Saint Jerome,* early 1480s. Oil on panel. Vatican Museum, Rome. (Alinari/Art Resource)

the navel of which is located at the center of the ideal circle. And it also informs the iconography of the *Mona Lisa,* in which the figure of the woman is a landscape metaphor [6.6]. In the formal structure of the painting, the woman corresponds to the artist's descriptions comparing bones to rocks, blood to waterways, and flesh to earth.[15] She dominates the foreground, her pyramidal form echoing the shape of the distant mountains. Her sleeves and fingers repeat the spiral roadways, her veil filters light as does the background mist, and the curve of the aqueduct at the right seems to flow into the curve of her drapery. Leonardo's use of *sfumato*—the smoky subtleties of light and shade—enhances the blending of the figure with landscape. Likewise, the formal similarities between the figure and the landscape and the shifting perspective—the woman is seen from the front and the landscape from above—create a spatial ambiguity that is consistent with Mona Lisa's enigmatic character.

6.6 Leonardo da Vinci, *The Mona Lisa,* c. 1503. Oil on panel. Musée de Louvre, Paris. (Scala/ Art Resource)

Considering the enormous amount that has been written about the *Mona Lisa*, remarkably little is known about the meaning of the image. According to Vasari, the woman in the painting is one Lisa di Antonio Maria Gherardini, wife of the Florentine aristocrat Francesco del Giocondo (hence Mona Lisa's designation as *La Gioconda*), who commissioned the portrait around 1503.

Vasari says that jesters and musicians were hired to keep Mona Lisa smiling, a play on the term *giocondo,* meaning "jocund" or "merry."[16] In fact, however, the woman in the painting is not particularly cheerful and certainly not merry. There is the faintest suggestion of a smile on her very slightly upturned lips; this quality is conveyed as much by the shading that continues the upward movement at the corners of the mouth as by the lips themselves. Likewise, at the corners of the eyes Leonardo has created an upward diagonal of shading that accentuates the illusion of a smile without actually representing one. Interpretations of this figure have run the gamut of human imagination. They range from Vasari's reading of a *gioconda* to the nineteenth-century Romantic view of an aloof, cold, mysterious, ageless vampire.[17] Mona Lisa has been called smug and self-satisfied because pregnant, a self-portrait of the artist (based on computer images), and (by Freud) a memory trace of the smile of Leonardo's mother.

As a portrait in the context of its time, the *Mona Lisa* was unprecedented, and its influence on later European portraiture would be considerable. The woman sits on a balcony, whose now cropped columns serve as a frame painted within the picture.

Her pose was unusual at the time, as was her length—from the head to below the waist. Antecedents in which portraits are related to landscape exist in fifteenth-century Italy—in Piero's diptych [4.15] the message is political, whereas in the *Mona Lisa* it is metaphorical. The Albertian notion of the painting as window has additional significance in the case of a woman enigmatically gazing at viewers. As such, Mona Lisa is in the tradition of the so-called woman at the window, a motif in ancient Near Eastern iconography denoting both a goddess and a temple prostitute. This reading enriches and further complicates the enigma of Mona Lisa's character.

Whatever the truth of the *Mona Lisa,* it must have had a personal meaning for Leonardo. All of the interpretations of its mysterious power seem to derive from maternal qualities, whether positive or negative. They include the unlikely identification as a self-portrait, for nursing infants experience themselves as mirrored in the mother's gaze. Supporting the notion of the painting's autobiographical significance for Leonardo is the fact that he never delivered it to a patron. He brought it instead to the court of Francis I, king of France, and it remained in his possession until his death in 1519.

Persistence of the Circular Plan

Bramante's Tempietto

The fifteenth-century ideal of the circular plan for religious buildings persisted into the sixteenth century. The most significant turn-of-the-century round building was

6.7 Donato Bramante, Tempietto, 1500–1502. San Pietro in Montorio, Rome. (Alinari/Art Resource)

Bramante's Tempietto, located in the cloister of San Pietro in Montorio, in Rome [6.7, 6.8, 6.9]. Bramante was born to an impoverished family in Urbino, according to Vasari, and was trained as a painter. He is mainly known, however, for his innovative architecture, especially in Milan and Rome. He was influenced by Brunelleschi and Alberti and was probably acquainted with Leonardo in Milan. When the French occupied the city in 1499, Bramante went to

Rome, where Vasari says that he measured every ancient building and made a thorough study of antiquities.[18] In 1500 Ferdinand and Isabella, the king and queen of Spain, commissioned Bramante to build a **martyrium** on the traditional site of Saint Peter's crucifixion.

The Tempietto, like Leonardo's drawing in Figure 5.4, combines the small-scale, centrally planned Early Christian martyrium church with the circular temples of

6.8 Elevation and section of the Tempietto. From Sebastiano Serlio, *Il terzo libro d'architettura*, Venice, 1551.

ancient Greece and Rome. It is surmounted by a Renaissance dome and lantern (a later addition), which are supported by the drum that forms the structure's central core. The entire building was planned as a coherent whole, with harmonious proportions based on a Classically inspired conception of unity. For example, the height of the Tempietto from the ground to the base of the dome equals the width, and the ratio of the width of the colonnade to its height is the same as the ratio of width to height of the dome's drum.[19]

The original plan and elevation of the Tempietto, recorded in the sixteenth-century architectural treatise of Sebastiano Serlio [6.8 and 6.9], clarify Bramante's concep-

tion. They reflect the assimilation of both Brunelleschi's and Alberti's view that architecture be based on simple geometric shapes—in this case a circular building plan inscribed in the square of the courtyard. Also Brunelleschian are the dynamic rhythms connecting solid forms to voids visible in the plan. There were, for example, sixteen columns (no longer extant) in the courtyard and sixteen in the **peristyle**. They seem to expand organically as their size and the width between them increase in proportion to the circumference of the circles. The elevation shows the relationship of the parts of the solid wall surface; they consist of alternating rectangular and round-arched niches, anchored visually by the main door.

In the Tempietto, Bramante gave concrete form to Alberti's view that a building's harmony, based on the proportions and interrelationships of its parts to each other and to the whole, is the source of its beauty.[20] For a viewer's innate sense of harmony, according to Alberti, responds naturally to architectural beauty, which in turn reflects the unity of the human soul with the uni-

6.9 Plan of the Tempietto. From Sebastiano Serlio, *Il terzo libro d'architettura*, Venice, 1551.

verse. Alberti agreed with the Neoplatonists that such unity was ultimately a revelation of God. Ornament, whose purpose was to enhance beauty, was Alberti's other requirement for an aesthetically harmonious building, and for him the primary ornament was the column. But in his own architecture, Alberti, unlike Brunelleschi, never used freestanding columns to support a round arch. As in the Tempietto, Alberti's ideal arrangement consisted of columns supporting a horizontal entablature.

The exterior peristyle colonnade of the Tempietto is Roman Doric, each column being composed of a circular marble base and capital and a granite shaft. At the base, the building is ringed by three steps continuing around the perimeter, with an additional three steps leading to the entrance. Echoing the ring of steps is the **balustrade**, whose **balusters** are arranged so that each space between the columns corresponds to three balusters.

The **triglyphs** similarly conform to Bramante's system of architectural unity, with one triglyph over each column. The **metope** reliefs were inspired by those on the frieze of the Roman temple of Vespasian, which illustrates objects used in ancient rituals. Bramante transformed them into the ritual objects of the Christian Mass. The Tempietto as a whole, in fact, can be seen as a martyrium/temple assimilated into the idiom of the Church.

Raphael's *Sposalizio*

Two years after the design of the Tempietto, Raphael Sanzio (1483–1520) signed his monumental painting of the *Betrothal of the Virgin* (the *Sposalizio*) [6.10]. Its relationship to Bramante's architecture is readily apparent, not only in the painted building but also in the clarity of its perspective, its symmetry, and its proportions. As such, the *Sposalizio* reflects both the harmonious Classicism that characterizes Raphael's early work and the personal affinity between him and Bramante.

Like Bramante, Raphael was born in Urbino, where his father, Giovanni Santi, was the court poet and painter to the Montefeltro. There Santi and his son would have known influential humanist architects such as Luciano Laurana, who designed Federico's courtyard [cf. 4.14], and his successor, Francesco di Giorgio; painters such as Piero della Francesca; humanist poets; and Alberti. The ideas of these men had a profound effect on the young Raphael, who would come to epitomize the achievements of High Renaissance Classicism.

Raphael painted the *Sposalizio* when he was twenty-one, after he had completed his apprenticeship with Perugino, the leading Umbrian painter. It was commissioned by the Albizzini family as an altarpiece for the Church of San Francesco in Città di Castello and is now in the Brera in Milan. The chapel in San Francesco was dedicated to Saint Joseph, which is consistent with the scene of his triumph as the Virgin's suitor. The fact that Città di Castello had a relic of what was believed to be Mary's wedding ring also inspired the subject, as well as the placement of the painted ring along the center axis of the work.

The implications of the ring in the narrative include its legitimization of the New Dispensation, which begins with the birth of Christ. The cruciform shape of the

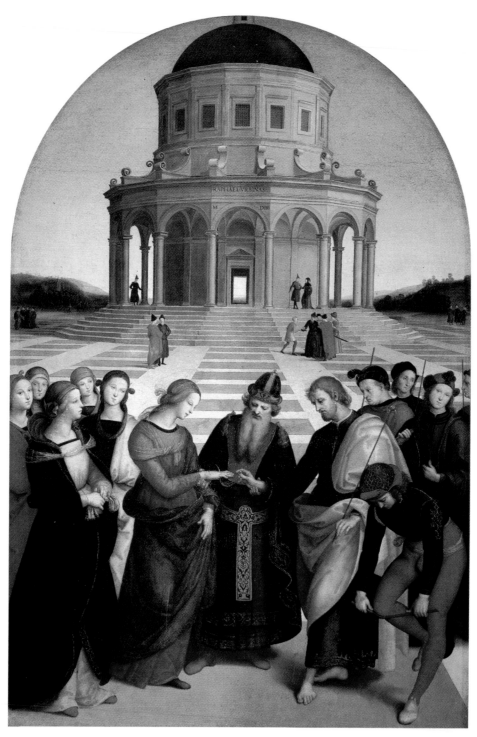

6.10 Raphael, *The Betrothal of the Virgin (Sposalizio)*, 1504. Oil on panel. Pinacoteca di Brera, Milan. (Scala/Art Resource)

priest's girdle alludes to the death of Christ, and Christ's future role as the center of the Church is implied in the positioning of the girdle at the center of the arc of the foreground figures—another reference to the Crucifix in the curved apse. The juxtaposition of past and future is thus a prominent theme in both the iconography and the formal arrangement of the *Sposalizio*.

The perspectival piazza recedes toward the round building in the upper part of the picture. In the context of the past, the building would most likely be the Temple of Solomon in Jerusalem, which Raphael apparently had in mind when designing the structure.[21] He has transformed the Temple into an ideal Renaissance church building, changing its time as well as its place. Despite differences between the two structures, Raphael's building, like Bramante's Tempietto, consists of a drum, supporting a dome and lantern, and an outer peristyle.

The imaginary nature of Raphael's building is evident in the open door, which leads not so much into an architectural interior as into a space beyond itself. That space is framed by the central round arch and its supporting columns, above which is the date, MDIIII (1504), and one of Raphael's rare signatures. The location of the signature over the open space of the doorway must have had personal meaning and seems to merge perspective with time. That is, the foreground scene refers to an earlier time than that denoted by the round building. The distant background is therefore suggestive of the future or of Raphael's view of the future as being in the distance.

In 1508, four years after completing the *Sposalizio*, Raphael went to Rome, where his artistic future was assured. The humanist Julius II, who became the patron of Raphael as well as Bramante and Michelangelo, had been elected pope in 1503. It was for Julius that Raphael would create the paintings that epitomize the Classical phase of the High Renaissance in Rome.

The New Saint Peter's

In 1504, before Raphael's arrival in Rome, Julius II appointed Bramante his papal architect. He launched a campaign to revive the ancient Roman ruins and to rebuild the Early Christian Basilica of Saint Peter. The original building was located on the traditional site of Saint Peter's burial and the apse of Constantine's basilica—the former calling for a round martyrium and the latter recalling the transition from imperial to Christian domination of Rome. It had been built on a Latin-cross plan, with a long nave, side aisles, and a transept, and was the main pilgrimage site in Europe. Despite arguments that a longitudinal plan would be more suited to the liturgy and more like the original basilica, the pope preferred a central plan that would reflect the synthesis of antiquity with Christianity. He financed the costly rebuilding project with the sale of indulgences—letters promising credit in Purgatory against one's sins.

Bramante's plan for the new Saint Peter's shows the central circle of the dome inscribed in a square at the crossing [6.11], conforming, as in the Tempietto, to Brunelleschi's preference for simple geometric shapes. At each corner of the central square is an additional domed chapel. The combination of a Greek-cross plan with

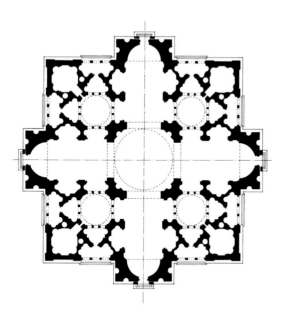

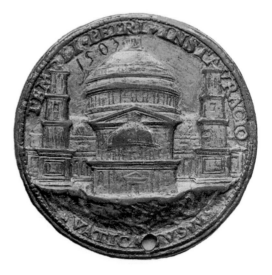

6.11 Donato Bramante, plan of Saint Peter's, 1504–1514.

6.12 Caradosso, medal showing Bramante's original design for Saint Peter's, 1506. Bronze. British Museum, London. (Art Resource)

barrel vaults and domes also reflects the influence of Leonardo's architectural drawings. Extending from the center of the plan are the four arms of the Greek cross, each with an apse at the end. In each corner, Bramante planned a smaller Greek cross, two of whose apses join the arms of the main cross. At each of the four corners of the outer walls is a tower connected to three bays by open loggias.

The elevation and section of Bramante's Saint Peter's shows the dynamic relationship of solid to void apparent in the Tempietto but on a much grander scale. The huge dome was 136 feet in diameter, only slightly less than that of the Pantheon but elevated to a greater height. Supporting the dome were four piers and pendentives,

with barrel vaults between the piers that carried the thrust of its weight.

Construction on the new Saint Peter's began in 1505 with the piers of the dome. In 1506 Julius laid the foundation stone, which was commemorated in the medal struck by Caradosso showing Bramante's original design [6.12] on one side and a portrait bust of Julius II on the other. Bramante envisioned an imposing structure, with a façade of regular alternating sections. Strict symmetry would have been maintained with the center flanked by towers reaching above the base of the dome. The central section, as seen from the view in the medal, was a series of advancing parts: the large hemisphere of the dome descends to a pedimented portico. In front of the apex of the

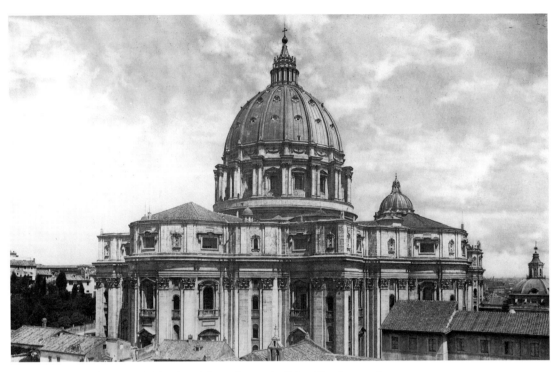

6.13 Michelangelo, view of Saint Peter's from the south. (Alinari/Art Resource)

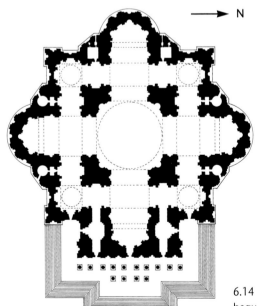

N

6.14 Michelangelo, plan of Saint Peter's, begun 1547. (After Roth)

pediment is the lantern of a smaller dome that in turn descends to the entrance. The latter, in keeping with Bramante's adherence to Albertian aesthetics, is composed of columns supporting an entablature and a pedimented door at the center.

In 1513, seven years after the foundation stone was laid, Julius II died, followed by Bramante in 1514. Although only the foundations of the large piers were in place and parts of the barrel vaults begun, Bramante's plan established the general form and dimensions of the building. According to Vasari, Bramante arranged for Raphael to succeed him as overseer of Roman antiquities and official architect of Saint Peter's. But even less of Raphael's plan was carried out. Further work was halted by the onset of the Reformation in 1517, set off by Martin Luther's protests against the sale of indulgences. Ten years later Rome was sacked by the troops of Charles V.

Artists continued to work on Saint Peter's, among them Antonio da Sangallo, whose plan was never carried out. He died in 1546, and Michelangelo, commissioned by Pope Paul III (papacy 1534–1549), took over the project in the following year.

Michelangelo's plan [6.14] creates more support for the dome than Bramante provided. It is more compact, with thicker walls to increase stability, and is no longer a purely centralized Greek cross. Attempting to arrive at a compromise between the Greek- and Latin-cross plans, Michelangelo extended the eastern side by adding a portico, thereby making a partial Latin cross. This consisted of two rows of columns, dominating the façade and the space in front of it from the height of an imposing set of steps. The first row had four columns, and the back row, stretching from one end of the east wall to the other, had ten. Within the portico façade, however, Michelangelo maintained the symmetry insisted on by his predecessor. The huge Corinthian pilasters he planned for the exterior walls are visible in Figure 6.13. But at Michelangelo's death in 1564 the building was still unfinished. It would not be completed until the Baroque period, in the seventeenth century.

NOTES

1. Giorgio Vasari, *Lives of the Most Eminent Painters, Sculptors, and Architects,* trans. Gaston du C. de Vere, New York, 1979, vol. 3, p. 1833.

2. Ascanio Condivi, *Le Vite di Michelangelo Buonarroti scritte da Giorgio Vasari e da Ascanio Condivi,* ed. K. Frey, Berlin, 1887, p. 44.

3. Charles de Tolnay, *The Youth of Michelangelo,* Princeton, 1969, p. 92.

4. See Paul Barolsky, *Michelangelo's Nose,* University Park and London, 1990.

5. De Tolnay, *The Youth of Michelangelo,* p. 95.

6. Ibid.

7. Rudolf Wittkower, *Sculpture: Processes and Principles,* New York, 1977, pp. 103–104.

8. See Charles Seymour, Jr., *Michelangelo's David,* Pittsburgh, 1967, esp. ch. 1.

9. Charles D. O'Malley and J. B. de C. M. Saunders, *Leonardo da Vinci on the Human Body,* New York, 1982, p. 27.

10. Ibid., plate 202.

11. Ibid., plate 210.

12. Ibid., p. 28.

13. Ibid., p. 27.

14. See Laurie Schneider and Jack D. Flam, "Visual Convention, Simile and Metaphor in the Mona Lisa," *Storia dell' Arte,* 29, 1977, esp. p. 18.

15. Jean Paul Richter, *The Notebooks of Leonardo da Vinci,* New York, 1970, vol. 1, p. 965.

16. See Paul Barolsky, *Why Mona Lisa Smiles and Other Tales by Vasari,* University Park and London, 1991.

17. See Walter Pater, *The Renaissance,* ed. Donald L. Hill, Berkeley, 1980, pp. 97–99.

18. Vasari, *Lives,* vol. 2, p. 821.

19. Leland M. Roth, *Understanding Architecture,* New York, 1993, p. 333.

20. See Rudolf Wittkower, *Architectural Principles in the Age of Humanism,* New York, 1971, pp. 33–37, for an extended discussion of Alberti's aesthetics.

21. Earl Rosenthal, "The Antecedents of Bramante's Tempietto," *Journal of the Society of Architectural Historians,* 23, 2 (May 1964), p. 68.

CHAPTER SEVEN

Julius II: Patron of Raphael and Michelangelo

Julius II's two most significant painting commissions of the early sixteenth century in Rome were Michelangelo's monumental frescoes in the Sistine Chapel and Raphael's *Stanza della Segnatura* in the pope's Vatican apartments. Both were contracted for and executed between 1508 and 1512. Raphael's frescoes epitomized High Renaissance Classical restraint, whereas Michelangelo's ceiling, although retaining Classical elements, exudes a new dynamic energy that looks beyond the High Renaissance. In fact, however, both artists would develop in less Classical directions following these commissions—Raphael in the *Stanza d'Eliodoro* and the *Transfiguration* and Michelangelo in the *Last Judgment*.

With the Sistine ceiling and the decoration of his apartments, Julius commemorated Pope Sixtus IV, exalted himself and his own papacy, and embellished the holy city of Rome. In building a new Rome, Julius allied himself with the Caesars of antiquity; his choice of papal name was made with the accomplishments of Julius Caesar in mind.

Julius II's identification with the Roman Caesars is apparent in the first design of his tomb, which he commissioned in 1505 from Michelangelo. The design, as reconstructed in Figure 7.1, consisted of an oval tomb chamber, entered by a version of the ancient "door of death," and enclosed by a three-story structure decorated with some forty statues. At floor level, statues of Victories were planned, along with so-called captives, which have been interpreted in a variety of ways—from references to the pope's victorious military campaigns to personifications of the liberal arts to Neoplatonic symbols of the earthly plane of existence. At the second level, there were to be statues of Moses and Saint Paul along with personifications of the Neoplatonic active and contemplative lives. Later versions show the pope's effigy on his sarcophagus, which may also have been part of the original design. The tomb underwent many revisions and was eventually completed in 1545 in a radically different form; but this first plan reflects the degree to which Julius wished to project his self-image as a new Caesar.

7.1 Michelangelo, reconstruction of the first project for the tomb of Julius II, 1505. From Charles de Tolnay, *Michelangelo,* Volume 4, Princeton, 1969.

Michelangelo and the Sistine Chapel

In 1506, when Julius called the work on the tomb to a halt, an angry Michelangelo left Rome and returned to Florence. In the same year, Julius captured Bologna and summoned the artist to cast a huge bronze portrait of himself for that city. Three years later the sculpture was destroyed by the pope's enemies. In the meantime, Julius had been planning to have the ceiling of the Sistine Chapel redecorated.

The chapel itself had been constructed under Sixtus IV, the uncle of Julius II, beginning in 1473, shortly after the Vatican had become the official papal residence. Consistent with the typological tradition, the new building conformed to the proportions of Solomon's Temple. In 1 Kings the temple's length is described as twice its height and three times its width. Sixtus also decided that where Solomon had covered the walls of the temple in gold and cedar, he would cover the Sistine Chapel walls with paintings. These, like the proportions, reflected the typological system, with Old Testament scenes on the left wall and New Testament scenes on the right. Their iconography emphasized the roles of Moses as Lawgiver to the Hebrews and Christ as creator of the New Law, passing on the authority of the New Law to the popes. The ceiling at the time depicted gold stars on a blue background.

On May 10, 1508, Michelangelo signed the contract for the frescoes. He made extensive preparations, including numerous drawings for the project, constructed the scaffolding himself, and in 1509 began painting. Julius II's patronage starts where that of Sixtus leaves off, at the level of the windows. Michelangelo's contribution is diagrammed in Figure 7.2. Originally the

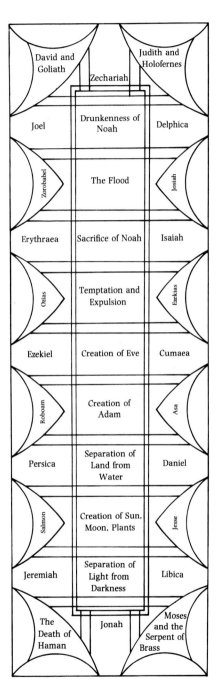

7.2 Diagram of the Sistine Ceiling, Rome. From Howard Hibbard, *Michelangelo,* New York, 1974.

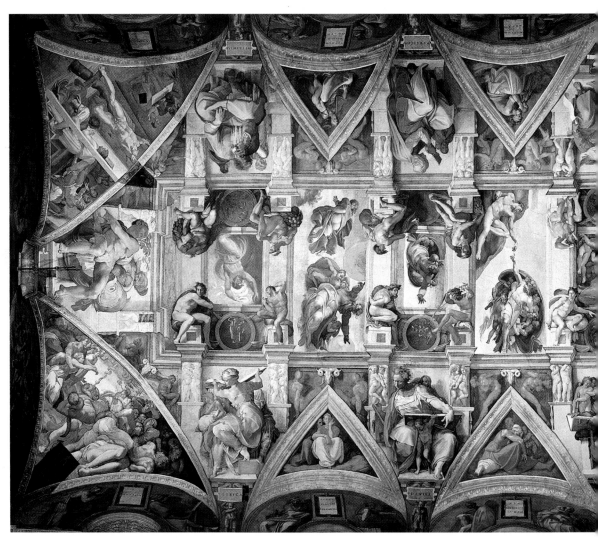

7.3 Michelangelo, Sistine Ceiling, 1508–1512. Frescoes. Rome. © Nippon Television Corporation, Tokyo.

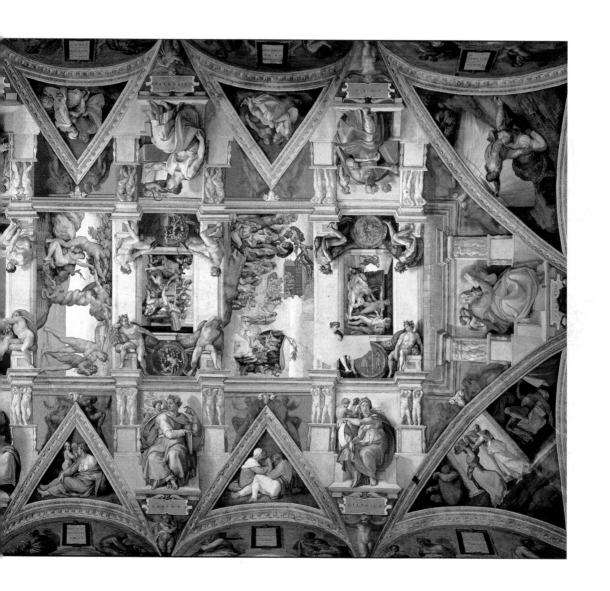

Twelve Apostles had been planned for the spaces between the windows, but this was changed to seven Old Testament prophets and five pagan sibyls. This allowed for one prophet at each end of the ceiling and for the remainder to alternate with the sibyls on the long walls. The change was in line with a late-fifteenth-century Neoplatonic belief that the significance of the Old Testament resided in the power of revelation rather than prefiguration. The prophets and sibyls were now seen as having revealed God's divine plan for human redemption.

Although typology persists in the iconography of the Sistine ceiling frescoes [7.3], the divine nature of revelation had been reflected in the mystical Neoplatonic writings of Pico della Mirandola. His *Oration on the Dignity of Man* (c. 1486) had elaborated the notion of the "divine chain of being" from God to humanity, which has been related to Michelangelo's emphasis on the Ancestors of Christ.[1] In a letter, Michelangelo claimed responsibility for the new scheme, but it would have required the agreement of Julius II and possibly the assistance of a theological adviser.

In the lunettes over the windows and in the triangular spandrels above the lunettes, Michelangelo painted the monumental, powerfully sculpturesque Ancestors of Christ cited in the genealogy that opens the Gospel of Matthew. Over the apex of each spandrel on the long wall is a ram's head, on each side of which is a nude of simulated bronze. The Ancestors in the spandrels alternate with the prophets and sibyls, thereby juxtaposing figures possessing divinely inspired foreknowledge with the human family whose biological continuity led to Christ's birth. Spatially, the

prophets and sibyls appear to project forward compared with the Ancestors, the latter more enclosed and more contained within their frames. The sibyls and prophets, who are larger and more powerful than the Ancestors, occupy stone seats flanked by caryatids painted to resemble sculptures. Below each projecting platform is an inscription identifying the seated figure.

The prophets and sibyls indicate their role as instruments of the revealed Word of God by their connection to a written text, either a book or a scroll. Two of these, Jeremiah [7.4] and Jonah, flanking one of the corner spandrels, have no such text. Instead, Jeremiah meditates, introspectively hunched forward, whereas Jonah leans expansively backward over the altar wall and gazes upward at *God Separating Light and Dark* [7.5]. The large fish signifying the whale and the green tree behind Jonah refer to his role as a prefiguration of the resurrected Christ.

All four corner spandrels depict Old Testament scenes with typological meaning. To Jonah's right and left, respectively, are the *Death of Haman* and *Moses and the Brazen Serpent*. Haman's death on a tree and his pose foreshadow the Crucifixion. The episode in which Moses lifts up the brazen serpent was compared by Christ himself to lifting up the soul of man. As a result, those who see (and understand) Moses' action are depicted as orderly, in contrast to the disordered and darkened figures who fail to see. The emphasis on seeing and not seeing in the Moses scene, as well as the allusion to the Crucifixion in Haman's *Death*, also presents viewers with a revelation of God's divine plan.

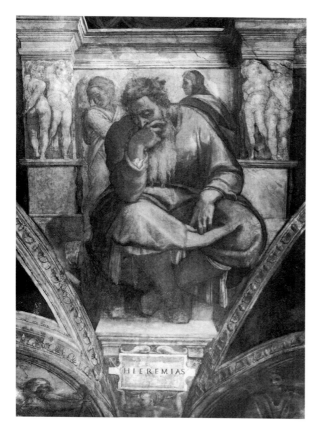

7.4 Michelangelo, *Jeremiah,* Sistine Ceiling, Rome. (Alinari/Art Resource)

Opposite Jonah, above the entrance reserved for the laity, is Zacharias, who prophesied that a man called "the Branch" would grow from the ground and build God's temple (Zacharias 6:12). Visually echoing this revelation is the green branch behind Jonah. The two corner spandrel scenes flanking Zacharias represent *Judith and Holofernes* and *David and Goliath.* In the former, Holofernes lies dead as Judith and her maidservant carry off his severed head. In the latter, David crouches over the radically foreshortened body of Goliath and raises his sword to behead him. Holofernes, like Goliath, was traditionally seen as an Old Testament counterpart of Satan and,

during the Renaissance, as an enemy of civic freedom. Judith and David, saviors of their people—as Christ was the Savior of humanity—were suitably located over the more earthly entrance to the Sistine Chapel.

The main narrative scenes are located along the central area of the ceiling, a barrel vault some 133 feet long and 44 feet wide. All together there are nine scenes, five smaller and four larger. They are framed by a painted, illusionistic cornice, parts of which appear to project from the ceiling's surface. These projections are both the lintels supported by the putti caryatids flanking the prophets and sibyls and the

bases for the platforms on which the so-called *ignudi* (male nudes) sit in contorted poses. These occupy the four corners of the smaller Genesis scenes and flank painted bronze medallions depicting Old Testament events. The *ignudi* have been interpreted in a number of ways, among them as personifying the nudity before God of the ideal Neoplatonic man. Several hold clusters of oak leaves in reference to the oak tree (*rovere* in Italian) on the coat of arms of the Della Rovere, which was the family of Julius II. In addition to being a Della Rovere device, acorns were traditional symbols of immortality in ancient Rome.[2]

The nine main narrative scenes, all events from Genesis, encompass the span of time from Creation to Noah's Drunkenness. In the first three events, God creates light and dark, the sun and moon, the earth and the waters. In the second three, he creates Adam and Eve, and they fall from grace. The third set depicts the sacrifice of Noah, the Flood, and Noah's Drunkenness. All precede the Law of Moses, which is the main theme of the scenes on the lower left wall, painted in the fifteenth century. The central scene is the *Creation of Eve*, who forms the transition from God's Creation to the era of human free will. It is through Eve's sinfulness, engendered by Satan, that Adam is induced to disobey God. Eve is thus represented in her traditional role as the instrument of the Fall.

Michelangelo painted the scenes in reverse chronological order. He began with the *Drunkenness of Noah* and ended with *God Separating Light and Dark*, placing the earliest creation scenes closest to the altar wall and the Noah scenes nearest the en-trance used by the laity. The narrative arrangement thus conforms to the hierarchy of the Church itself, and in order to see the scenes right side up, it is necessary to face the altar wall.[3]

The lay worshiper, reading the events from the vantage point of one who has just entered the chapel, begins with the Noah scenes, first confronting his human drunkenness. The figure digging in the background denotes the renewal of life after the Flood. The scene of the *Flood* itself precedes the *Sacrifice of Noah* in Genesis but follows it on the ceiling. It is a monumental vision of human panic in the face of inevitable annihilation—a cataclysm reminiscent of those foretold in the public sermons of Antoninus and Savonarola. Figures in violent *contrapposto* struggle toward shelters and high ground as the water level relentlessly rises. Michelangelo depicts the range of human response, as some battle each other to survive and others carry friends and family to temporary safety.

In the prominence of trees in the ceiling's iconography, Michelangelo refers both to the Tree of Life as the ancestor of the Cross and to the notion of a family tree implied in the Ancestors of Christ. In the *Flood,* trees are bent by the destructive force of the storm, just as the sky would grow dark at the time of the Crucifixion. In the foreground, people literally hanging onto the tree for dear life are an ironic allusion to the notion of the Tree of Life in the Garden of Eden. There the Tree serves as a structural divider between the *Temptation* and *Expulsion of Adam and Eve*. It also marks the point between their existence inside of Paradise and their entry into the world of human time and labor.

Michelangelo has used the motif of the tree in the Genesis scenes to accentuate the theme of revelation as well as of ancestry. For the tree, which grows in nature, is a marker of life and death and therefore of earthly time as opposed to eternal time. There are no trees, for example, in the first four creation scenes, before the First Man is given life. A tree first appears in the *Creation of Eve*—Adam sleeps against its trunk—signaling the future reality of human time. In each subsequent scene, either a tree or its wood is depicted.

In the *Sacrifice* and *Drunkenness of Noah*, the wood has been transformed into objects of daily life—logs for the fire, the handle of a shovel, a vat of wine. In the large scene of *God Creating the Sun and the Moon and the Planets*, Michelangelo's Creator God extends his arms in a broad, foreshortened gesture that reveals the future power of the Cross. The corner detail of green foliage, which is not yet a tree, alludes to the later trees, as well as to God's cruciform gesture, to the rebirth of humanity through Christ's Resurrection, and to eternal life.

In 1510 the first half of the ceiling was unveiled. Michelangelo periodically complained that the pope was late in paying him for the work. He also caricatured the physical discomforts of painting a ceiling in a drawing [7.5] and a sonnet:

> *I've got myself a goiter from this strain*
> *. . .*
> *My beard toward Heaven, I feel the back of my brain*
> *Upon my neck, I grow the breast of a Harpy;*
> *My brush, above my face continually,*

> *Makes it a splendid floor by dripping down . . .*
> *And I am bending like a Syrian bow.*[4]

Scholars disagree over the details of Michelangelo's progress, but it seems that by 1510 he had completed the scenes from *The Sacrifice of Noah* through the *Creation of Eve*. At this point, Michelangelo removed the scaffold and was able to view his work without obstruction. It is generally thought that he changed his approach in the last four Genesis frescoes, where the figures are larger and more monumental in conception and execution. They are also the most innovative. In the *Temptation and Expulsion of Adam and Eve*, Michelangelo merges events that had previously been represented as individual scenes and uses the Tree of Knowledge as a frame between them. The tree takes center stage in the drama of the Fall, and it also prefigures the Redemption.

The creation scenes, including the *Creation of Adam*, are new, and they seem formally and iconographically more unified than the five previously painted scenes. All four depict God as a forceful Creator,[5] intensely focused on executing his decision to bring the universe into existence. In the *Creation of Eve*, God is still powerful, but his energetic fervor has calmed. He now stands like a block of stone, a Michelangelesque version of Masaccio's Brancacci Chapel apostles, as he summons Eve into existence. In the *Creation of Adam*, God's energy is contrasted with Adam's languid passivity. Adam is shown as God's personal creation and therefore as the link between God and the human race, which evokes Pico della Mirandola's Neoplatonic notion of the "divine chain of being."

7.5 Michelangelo, detail of a sonnet and caricature of himself painting the Sistine Ceiling, 1508–1512. Pen drawing. Casa Buonarroti, Florence.

time of seasonal change, accompanied by birth, growth, aging, and death.

The reality of time is set in motion in the small opening narrative scene of the ceiling above the altar, namely, *God Separating Light and Dark* [7.6]. For here the rotations of day and night are brought into existence. In the formal organization of the scene, light and dark divide the background diagonally. The brightest light is concentrated around God's head, signifying his having had the idea to create the universe. Because the swirling motion of the celestial lights and darks echoes God's form, he becomes his own idea, which he also controls.

It would seem from Michelangelo's sonnet and caricature [7.5] that he identified with God as he separated light from dark. Both Michelangelo and God are bearded—as was Julius[6]—and tilt their heads upward, giving concrete shape to their ideas. The physical discomfort described by the artist is depicted in God's contorted, swiveling pose. His hands work the heavens in a circular motion as the hands of a potter throw pots on the wheel, giving form to what had been without form. The "Harpy" breast of which Michelangelo complained seems to appear on God's foreshortened, sculpturesque upper torso.

The primal separation of light and dark is also the beginning of seeing and therefore makes possible the art of painting. In Renaissance discussions of *chiaroscuro*, gradations of light and dark were explicitly identified as the necessary element for per-

Adam is also a visual echo of Noah in the last ceiling scene. Both are enervated, Adam because not yet alive and Noah because drunk. But both are progenitors, Adam of the original human race and Noah of humanity rescued from extinction. Noah is smaller than Adam, a sign that from the beginning he was the lesser progenitor. He belongs to the era of human time, human error, work, and mortality. Adam, at the moment of his creation, is the ideal man who is out of time. The man digging to the left of Noah and in the background denotes the consequences of the Fall. His implicit connection to agriculture takes human history forward into the real

7.6 Michelangelo, *God Separating Light and Dark*, Sistine Chapel, Rome. (Scala/Art Resource)

ceiving and creating natural form. Michelangelo concluded his creation scenes with a God caught up in the creative moment, a figure who combines the strength of Atlas, the control of time of Chronos, and the divine power and human form of Zeus.

Michelangelo's God of the *Separation of Light and Dark* is a powerful Creator who controls the universe and its time. The remaining ceiling scenes in effect are images of God's divine plan, what Charles Seymour calls "a celebration of present greatness in the form of prophecy from an imagined past and of future promise in the guise of history."[7] Once man is created, his drama is the focus of Michelangelo's narrative—in formal beauty (Adam), in error (temptation and drunkenness), in fear and panic (the Flood), and in the will to survive (Noah). With the Sistine ceiling frescoes, completed in less than four years, Michelangelo produced a powerful image of the Renaissance notion of human dignity.

Raphael and the *School of Athens*

While Michelangelo was working on the Sistine ceiling, his rival Raphael was executing another commission for Julius II. Sometime before 1509, when Raphael received the first payment, he began decorating the pope's private library [7.7]. It is known as the *Stanza della Segnatura* (Room of the Seal) after its later function as a place where Church documents were signed. The lunettes on each of the four walls were painted as part of a monumental program designed to represent the summation of

pagan and Christian knowledge. To this end Julius arranged his library of ancient and contemporary texts according to the iconography of the frescoes.[8] In so doing, he reflected the humanist view that written texts are a source of influence and power.[9]

Raphael's four lunette frescoes depict the *Disputà* (a debate or discussion over the Sacrament of the Eucharist), the *School of Athens,* the *Parnassus* (where Apollo and the Muses resided), and the *Three Cardinal Virtues* (Fortitude, Prudence, and Temperance; the fourth, Justice, appears on the ceiling above). Scholars disagree over the order in which the frescoes were painted, even though several preparatory drawings exist. It is generally assumed that Raphael worked on the scenes from 1509 to 1511, overlapping the period of Michelangelo's work on the Sistine ceiling. It is also generally believed that the iconographic program was planned with the assistance of an adviser, although some scholars attribute most of the decisions to Raphael himself.

Like the Sistine Chapel, the *School of Athens* [7.8] has from the beginning been recognized as a key monument of the period. But it is seen as even more: as a synthesis of all that was Classicizing about the Renaissance. In it Raphael has drawn on the Renaissance theme of famous men,[10] which he has transformed into a mythic vision of intellectual greatness. The manifest subjects of the fresco are philosophers and scientists of Greek antiquity—although not every one can be identified [cf. 7.9]. But the real subject is the dignity of man. In a conflation of time and space, Raphael has assembled into a unified architectural setting the men who formed the Classical foundation of Western thought.

7.7 Raphael, view of the *Stanza della Segnatura* showing the corner with the entrance and *The School of Athens*.
(Alinari/Art Resource)

7.8 Raphael, *The School of Athens*, 1509–1511. Fresco. *Stanza della Segnatura*, Vatican, Rome. (Scala/Art Resource)

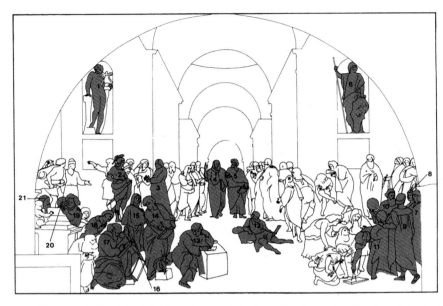

1 Apollo
2 Alcibiades or Alexander
3 Socrates
4 Plato (Leonardo)
5 Aristotle
6 Minerva
7 Sodoma
8 Raphael
9 Ptolemy
10 Zoroaster (Pietro Bembo?)
11 Euclid (Bramante)
12 Diogenes
13 Heraclitus (Michelangelo)
14 Parmenides, Xenocrates, or Aristossenus
15 Francesco Maria della Rovere
16 Telauges
17 Pythagoras
18 Averhöes
19 Epicurus
20 Federigo Gonzaga
21 Zeno

7.9 Diagram of *The School of Athens*. From Gloria Fiero, *The Humanistic Tradition,* 3rd ed., New York, 1998, vol. 3. © The McGraw-Hill Companies. With permission.

The figural arrangements are relatively symmetrical, spreading horizontally across the vast width of the picture plane. Gesture and pose, as required by the aesthetics of Alberti, conform to what is known of the characters represented and therefore are expressive of them. They also relate to the architecture,[11] so that most of the standing figures are on the top level, and most of the seated, kneeling, or bending figures are on the lower level. All are formally integrated through Raphael's harmonious synchronization of movement, at the same time maintaining figural and chromatic variety. In his use of varied color, Raphael follows the recommendations of Alberti, and in creating a sense of three-dimensional relief through the use of *chiaroscuro* he follows Leonardo.[12] Light, too, unifies the paint-ing, entering as it does consistently from the right.

At the center, on the top step, Plato and Aristotle (numbers 4 and 5 in the diagram) are framed by the distant arch, which denotes the triumph and centrality of their philosophy. That they are engaged in a discussion is indicated by their animated gestures and mutual gaze. By placing the vanishing point between their heads, Raphael also directs the viewer's gaze toward the locus of their dialogue. Plato carries the *Timaeus,* in which he outlines his myth of the cosmos and defines the circle as the perfect symbol of God.

Plato points upward, a gesture generally read as echoing his view that ideas originate in the realm of the divine. Aristotle, in contrast, stretches his hand toward the

picture plane and the space occupied by the viewer. He carries the *Ethics,* a text that, like his gesture, is directed at the human world and reflects his empirical view that by studying nature one learns truth. Likewise, the foreground group on Aristotle's side of the lunette—the viewer's right—is associated with empirical sciences such as astronomy, geography, and geometry. The bearded figure in white holding up a celestial globe is identified as the Persian Zoroaster (number 10), representing astrology and astronomy. Opposite him, in back view, is the Greek geographer Ptolemy (number 9), and bending over with a compass is the founder of Euclidian geometry (number 11). Surrounding Euclid are a group of students reacting to his discourse.

The figure in blue sprawled across the steps is Diogenes (number 12), the cynic who reportedly roamed the streets of Athens with a lantern looking for an honest man. Isolated from the figural groups, he is absorbed in a text, but his diagonal plane links the Euclid group with Plato and Aristotle. The blue of his loose drapery also connects the steel blue of Euclid's kneeling student with Aristotle's robe.

On Plato's side of the lunette—the viewer's left—and on the same level, the snub-nosed Socrates (number 3) discourses with his disciples. One of these (number 2) wears antique armor and is most likely Alcibiades, the famous general who loved Socrates. Zeno (number 21) and Epicurus (number 19) embody the opposing Stoic and Epicurean philosophies. The aged Zeno stares "stoically," with a disapproving air, past the figures grouped around Epicurus. The latter, in contrast, is engrossed in a

book that a chubby putto, probably an Eros, helps support. Epicurus wears a wreath of ivy in his hair, denoting his association with the Epicurean philosophy, in which knowledge is gained through the experience of the senses and pleasure is considered the greatest good.

Kneeling in the foreground plane, to the right of Epicurus, is the philosopher Pythagoras (number 17). Dressed in pink and white robes, he writes in a large book, observed intently by the turbaned Arabic scholar Averroës (number 18), alluding to the intellectual achievements of Islam, and a seated old man taking notes. A blond youth holds a slate with a diagram of Pythagoras's musical harmonies. "This," according to Rudolf Wittkower, "is Raphael's interpretation of the harmony of the universe which Plato had described in the *Timaeus* on the basis of Pythagoras' discovery of the ratios of musical consonances."[13] Pythagoras's view of the primacy of the number as governing the entire universe was taken up by the Neoplatonists. This notion was translated into a theory of aesthetics by Alberti, who believed in an inborn sense that responds to harmony and therefore recommended that the visual arts be structured harmoniously.[14]

Raphael conflated time not only by assembling philosophers from different eras, but also by turning the ancient figures into portraits of his contemporaries. A few of these have been identified with reasonable certainty. Plato, for example, is a likeness of Leonardo, for he resembles the well-known self-portrait drawing by the artist [7.10]. By this combination, Raphael pays homage to Leonardo as a central and seminal figure of the Italian High Renaissance.

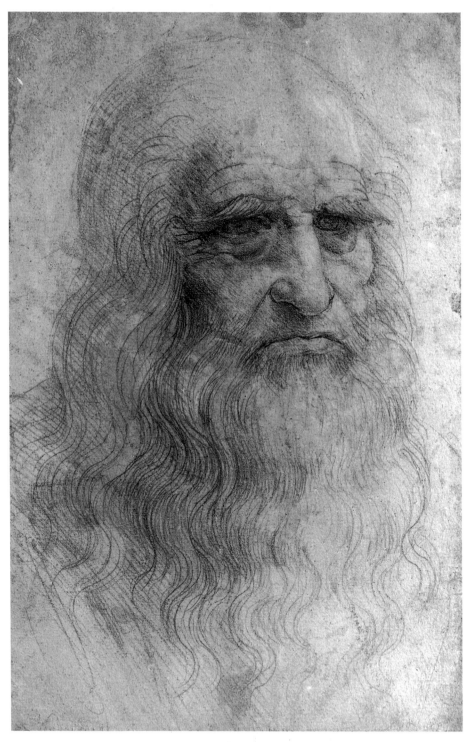

7.10 Leonardo da Vinci, *Self-Portrait,* early sixteenth century. Chalk drawing on paper. National Library, Turin. (Alinari/Art Resource)

Euclid is a portrait of Bramante, Leonardo's follower in architectural theory and Raphael's mentor in Rome. Both Leonardo and Bramante had designed centrally planned, domed buildings reflecting the circular ideal. The similarity of the painted architecture in the *School of Athens* to Bramante's architecture has been attributed to the fact that both he and Raphael studied Roman ruins, in particular the Basilica of Maxentius.[15] Raphael hired scholars to translate Vitruvius so that he could study ancient architectural techniques; he wrote to his friend the courtier Baldassare Castiglione that he hoped to recover the forms of antiquity. As he merged contemporary portraits with depictions of ancient philosophers, Raphael assimilated the architecture of Rome with the Renaissance perspective system—manifest in the floor design and the receding cornices—devised by Brunelleschi and codified by Alberti.

On a more anecdotal note, there is a visual play on the motif of the sphere in the group of figures that includes Bramante. The unseen dome that logically, although not demonstrably, crowns the space above the architectural drum behind Plato and Aristotle would echo the shape of Bramante's bald head.[16] That Bramante-as-Euclid demonstrates with a compass also alludes to the circle and allies his geometry with the Renaissance ideal building. His entire body is engaged in the demonstration, bending forward in something of an arc. As such, his action recalls the story of Giotto's *O*, in which the artist becomes his own creative instrument—in both cases, a compass.

In the receding walls of the painted architecture, niches contain marble statues. Their identity is hidden by virtue of their location, but it is likely that they represent the Greek gods. This is suggested in the two visible statues of Apollo (at the left) and Athena (at the right) facing the picture plane. The juxtaposition of the statues with the philosophers condenses time not only by their relation to the Classical past but also by the opposition of stone gods with flesh-and-blood figures. The lasting quality of stone speaks to the humanist search for antiquity, the Renaissance efforts to collect ancient statuary, and the archaeological activities in Rome under Julius II.

As the sun god, Apollo was associated with light and reason, and Athena, the goddess of wisdom (as well as war), with knowledge. Both, therefore, are consistent with the philosophical implications of Raphael's fresco. Apollo is also the god of music, hence the lyre in his left hand. He is on the side of Pythagoras, whose tablet represents the "diagrammatic design of the four strings of the ancient lyra, the whole system of the Pythagorean scale."[17] Raphael's Apollo thus presides over the harmonious synthesis of different philosophical schools of thought. As the music god, Apollo appeals to the sense of sound, whereas Athena, in her aspect as the goddess of weaving, appeals to vision and the visual arts.

In Raphael's painted statue, Athena turns her shield slightly to the right so that its gaping Gorgon head seems to scream down at the figures below. The Medusa myth, which is about the act of looking in both its dangerous and intelligent aspects, has been appropriated by Raphael and related to the art of painting. For the statue, as well as the Gorgon, looks down on the figures at the far right of the picture plane. Two of these

have been identified as painters, appropriately placed on Athena's side of the fresco. Number 7 is probably Sodoma (who had worked in the Stanza before Raphael received the commission), and number 8 is Raphael himself. Together with the astronomer and the geographer, Sodoma and Raphael create a foursome, but Raphael, in contrast to the others, gazes out of the picture. In so doing, he conforms to the convention of artists' self-portraits, communicating with the viewer rather than with his painted colleagues.

The entire conception of the *School of Athens* requires a condensation of time and conflation of personages. Alberti's request in *On Painting* that artists insert his portrait into their *istoria* was intended to keep alive his memory, and this Raphael has done with his own contemporaries. Just as Renaissance artists subscribed to the notion that an image preserves the features of an individual, so they understood that written texts are a means of recording and preserving ideas. Raphael has therefore depicted texts as well as portraits in the *School of Athens*, for he shows several philosophers and their disciples reading and writing. Both Plato and Aristotle carry texts, and at the left and right of the foreground Raphael combines image and text as principles of music and geometry are demonstrated on slate tablets. The iconography of Raphael's fresco not only assembles the ancient philosophers but also stands as a summation of the Renaissance view of history and the history of ideas.

In August 1511, the first half of the Sistine ceiling was publicly unveiled, and Raphael certainly saw it. An extant cartoon of the *School of Athens* shows that he had left room at the far right for his own figure and that of Sodoma. But there is no evidence that he had planned to include to the right of Pythagoras the brooding foreground figure (number 13), who writes without looking at his page [7.11].[18] Identified as a portrait of Michelangelo in the person of the pre-Socratic philosopher Heraclitus, this figure was a late addition to the fresco. It reflects Raphael's ability to assimilate, for which the secretive and suspicious Michelangelo accused him of having stolen his style.[19] And in fact the Heraclitus more resembles the powerful, sculpturesque figures of the Sistine ceiling than his fellow philosophers in the *School of Athens*.

Like Michelangelo's *Jeremiah* [7.4], Raphael's Michelangelo-as-Heraclitus is introspective, leaning forward in deep thought. Although he is dressed in rustic boots more suitable for a stonemason than a Classical philosopher, his character conforms to the obscurity of Heraclitus's philosophy.[20] Nevertheless, Heraclitus used the term *harmonia* to imply a dual structure of the cosmos, which evokes the Pythagorean view of cosmic harmony.[21] His emphasis on self-discovery through active thought and on language (the *logos*, or "word") to express the duality of things is consistent with the text-image duality of the *School of Athens*. It is reflected as well in the fact that in the painting he is simultaneously active and passive, literally meditating "on the one hand" while composing a text with the other hand.

By the end of October 1512, both the Sistine Chapel and the *School of Athens* had been completed. The following February Julius II died. The next pope, Leo X (papacy 1513–1521), was a Medici, the son of

7.11 Raphael, *Michelangelo-as-Heraclitus,* detail of *The School of Athens.* (Anderson/ Art Resource)

Lorenzo the Magnificent. He, too, was a devoted patron of the arts and continued his predecessor's efforts to forge Rome into a great artistic capital. But the death of Julius II and the demise of his patronage marked the end of the most Classicizing period of the Renaissance. Raphael would live another seven years, and Michelangelo would work until his death in 1564, by which time new trends in art were well under way.

Vasari on Raphael and Michelangelo

Just as the *School of Athens* is an image about texts and their authors, so Vasari's *Lives* is a text about images and the artists who created them. Both works are also about recording history, in large part through a biographical approach to those who make history. Throughout the *Lives,* Vasari interweaves the language of myth and convention with empirical observation. Michelangelo was born "under a fateful and happy star," a reference to the artist's horoscope and implicitly to the birth of Christ. He was God's gift to Florence, an "exemplar in the life, works, saintliness of character, and every action of human creatures, . . . that he might be acclaimed by us as a being rather divine than human."[22]

Raphael was born at 3 A.M. on Good Friday. He was, for Vasari, one of the immortals whose works place them in the "archives of fame" and who are destined "to enjoy in Heaven a worthy reward for their labours

and merits."[23] Because he was born into an enlightened, humanist family, Raphael's genius was fostered by his parents, especially his father. Michelangelo's genius, in contrast, was obstructed by his father.

Both artists nevertheless followed the conventional Renaissance apprenticeship to masters whom they soon surpassed—just as Giotto had surpassed Cimabue. When their paths crossed in Rome, the rivalry between Raphael and Michelangelo, which was another convention for artists in the Renaissance, intensified. Vasari records Michelangelo's accusation that Bramante secretly allowed Raphael access to the Sistine Chapel before the unveiling of 1511 and that Raphael improved his style as a result. A corollary to their rivalry was the striking difference in their natures. Vasari's

description of Michelangelo reflects his reputation for outbursts of temper and his difficulty in adapting to social propriety.

Raphael, according to Vasari, was graceful, charming, and politically adept. In the *School of Athens* Raphael depicts both himself and Michelangelo in accord with Vasari's account. Michelangelo is isolated and introspective. His powerful genius is conveyed through a monumental, sculptural form and poses and gestures that express the ambivalent duality of Heraclitus's philosophy. Raphael, in contrast, is slim, elegant, and surrounded by peers. He is one among several famous men, and he diplomatically places himself behind the lesser artist Sodoma, at the same time symbolically "signing" himself as the author through the outward direction of his gaze.

NOTES

1. Charles Seymour, Jr., ed., *Michelangelo: The Sistine Ceiling,* New York, 1972, pp. 83ff.

2. Ibid., p. 186.

3. Ibid., p. 84.

4. Howard Hibbard, *Michelangelo,* New York, 1974, p. 119.

5. On the role of wind and spirit in the *Creation of Adam* and in Botticelli's *Birth of Venus,* see Paul Barolsky, "Michelangelo and the Spirit of God," *Source: Notes in the History of Art,* 17, 4 (Summer 1998), pp. 15–17.

6. See Mark Zucker, "Raphael and the Beard of Pope Julius II," *Art Bulletin,* 59, 1977, pp. 524–533.

7. Seymour, *Michelangelo,* p. 85.

8. Marcia Hall, ed., *Raphael's "School of Athens,"* New York, 1997, pp. 6–7.

9. Ingrid D. Rowland, "The Intellectual Background of the *School of Athens*: Tracking Divine Wisdom in the Rome of Julius II," in ibid., p. 149.

10. Hall, *Raphael's "School of Athens,"* pp. 10–11.

11. Ralph Lieberman, "The Architectural Background," in ibid., p. 65.

12. Janis Bell, "Color and Chiaroscuro," in Hall, *Raphael's "School of Athens,"* p. 94.

13. Rudolf Wittkower, *Architectural Principles in the Age of Humanism,* New York, 1971, p. 125.

14. Ibid., p. 27.

15. See Lieberman, "The Architectural Background."

16. Ibid., p. 72.

17. Wittkower, *Architectural Principles,* p. 125.

18. See Hall, *Raphael's "School of Athens,"* p. 40.

19. Hibbard, *Michelangelo,* p. 144.

20. Ibid.

21. See C. H. Kahn, *The Art and Thought of Heraclitus,* Cambridge, 1979.

22. Giorgio Vasari, *Lives of the Most Eminent Painters, Sculptors, and Architects,* trans. Gaston du C. de Vere, New York, 1979, vol. 3, p. 1832.

23. Ibid., vol. 2, p. 178.

CHAPTER EIGHT

High Renaissance Painting in Venice

In Venice the two principal High Renaissance painters were Giorgione (c. 1475/77–1510), whose career was cut short by the plague, and Titian (b. late 1480s–1576), who lived well into his eighties. Both artists, according to Vasari, had studied with Giovanni Bellini (c. 1430–1516), and their work shows ample evidence of Giovanni's influence. Giovanni is generally seen as having created the transition to High Renaissance painting in Venice. The work of these artists reflects the more painterly tradition of Venice compared with that of Florence and Rome. A predilection for **oil paint** over tempera and fresco enhanced the richness of color and the subtlety of light characteristic of their work. They applied paint directly to their canvases with more emphasis on color than line, which made Vasari prefer the Florentines—especially Michelangelo—to the Venetians.

Oil Painting

Oil paint is a richer medium than either fresco or tempera; it became widely used in Italy around 1500, sooner in Venice than elsewhere. It appealed to the Venetian taste for rich textures, which was also characteristic of painting in Flanders. Oil paint is made by mixing ground pigments with oil (Renaissance artists used walnut or linseed oil), which dries more slowly than tempera and fresco and thus gives artists greater flexibility to make revisions, to model form, and to mix color. Oil is not only a richer medium, but it also allows for an expanded palette and thicker texture. Although first used as an adjunct to tempera and applied to panels, oil is more suited to a flexible canvas support. Canvas has the added advantage of a rough surface that holds the paint naturally, requiring less preparation than either wood panels or plaster walls.

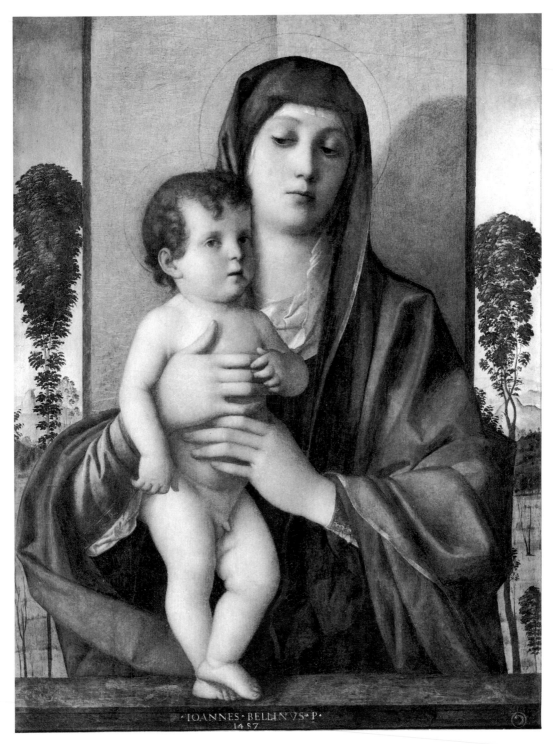

·IOANNES·BELLINVS·P·
1487

8.1 Giovanni Bellini, *Madonna degli Alberetti*, 1487. Oil on panel. Galleria dell' Accademia, Venice.
(Anderson/Art Resource)

Giovanni Bellini

Giovanni Bellini was a member of a distinguished artistic family in Venice, where the family workshop tradition was more entrenched than in either Florence or Rome during the same period. His father, Jacopo Bellini, and his brother Gentile were among the most famous artists of their time, and his brother-in-law, Mantegna, had a demonstrable influence on his style. Remarkably little is known of Giovanni's life, and few of his paintings are securely dated, but it is known that he was named painter to the republic of Venice, confirming the esteem in which he was held by his contemporaries.

The luminous quality of Venice infiltrates Bellini's paintings, which he enhanced by combining Flemish media and techniques with those used in Italy at the time. He added oil to tempera and enriched his colors with several thin layers of glaze, thereby creating the impression of light emanating from within the paint itself. His interest in atmospheric landscape was integrated into his early devotional pictures, typically representing the Madonna and Christ. In the *Madonna degli Alberetti* [8.1], dated 1487, for example, Mary holds a standing Christ in the near foreground, pushed up against the picture plane by the green cloth behind them. On either side is a dwarf tree (*alberetto*) set against misty, deep yellow and light blue mountains and sky.

The filtered landscape light seems to originate from the distance, whereas the source of the foreground light is to the left. Mary casts a shadow to the right of the green cloth, gazing mournfully at her son

The Myth of Venice

Giovanni Bellini's artistic career developed against a backdrop of political turmoil and decline in Venice. Following the fall of Constantinople to the Ottomans in 1453, Venice lost a large part of its empire in the Mediterranean and was in continual conflict with other Italian states. This culminated in the League of Cambrai, lasting from 1509 to 1517, in which the kings of Spain, the pope, the French king, and the Holy Roman Emperor united against Venice and threatened to end its 800 years of independence as a republic. But Venice prevailed against the league, and by 1529 a lasting peace restored the city to its pre-league power and gave new impetus to the so-called myth of Venice.

In the fifteenth century, the myth had drawn on the antiquity of the Venetian republic as well as its relative internal stability to convey an image of civic harmony. Reinforcing this image was the combination of a constitution, a senate composed of patricians, and a great council that included a wider spectrum of the population. Unique to Venice, according to the myth, was the moral fiber of its citizens, their readiness to participate in affairs of state, and their ability to coexist peacefully. The unique setting of Venice, a city of waterways and reflected light, and a crossroads between the Italian peninsula and Byzantium, contributed to the city's mystique.

in the recognition that his destiny is death. Her saddened expression finds a visual echo in the landscape, particularly in the indication by the relative brightness of the horizon that the sun is setting. Christ's pose, with one foot resting on the other,

8.2 Giovanni Bellini, *Madonna of the Meadow*, c. 1500–1505. Panel transferred to canvas. National Gallery, London. (Anderson/Art Resource)

also echoes his pose on the cross.[1] His own mournful gaze, together with his pose, identifies him simultaneously as Mary's infant son and the Light of the World that must set, like the sun, before resurrection is possible.

In the later *Madonna of the Meadow* [8.2], Bellini infuses the traditional Madonna of Humility (in which the Virgin sits on the ground) with new meaning. Here, too, there is a landscape background, but it in-

cludes human figures, animals, and the walls of a distant city. Life goes on, Bellini seems to be saying, while we confront the significance of a sleeping infant destined to change the world. Mary's large size—she is even closer to the picture plane than in the *Madonna degli Alberetti*—denotes the Church building, and her praying hands form a symbolic arch above Christ.

The Virgin is formally related to the landscape and the city walls, but she is spatially

distinct from them. The slope of the hill at the left, for example, continues into the slope of her right shoulder. The shoulder's diagonal then continues through Mary's tilted head and is carried to the far right by the direction of the rolling clouds. These planar connections are reinforced chromatically, for the blue of Mary's cloak and the white of her veil are repeated in more muted tones in the blues and whites of sky, distant hills, and clouds. Mary herself is thus a metaphor for both the fertile earth and the city; she is the House of God and by extension the Holy City. Likewise, in the *Madonna degli Alberetti,* her verticality, as well as that of Christ and the cloth behind them, parallels the vertical of the trees.

Bellini has merged the image of the Madonna of Humility with that of the Pietà. The sleeping Christ alludes to the dead Christ, for the twinship of the gods Sleep and Death has an ancient history. Christ's pose and position clearly refer to the Pietà, in which he lies across his mother's lap as she mourns his death.[2] Natural echoes of Christ's death occur in the dry trees at the left and the black bird, which seems too heavy for the thin branches.[3]

Bellini's *Saint Francis*

In the *Saint Francis* [8.3], variously dated from the 1470s to around 1485, Bellini created an unprecedented synthesis of the devotional image with nature and of form and light with meaning. The painting is suffused with a new emphasis on light and color as well as on details of nature, reflecting both Flemish influence and the character of Saint Francis himself. In particular, the linear

quality of the rocks and the precision of the saint's physiognomy are reminiscent of Jan van Eyck. Flemish attention to such details can be seen in a *Saint Francis Receiving the Stigmata* [8.4], showing the kneeling saint on the mountain of La Verna. He receives Christ's wounds from a crucified seraph, while Brother Leo, whose mourning pose alludes to the Crucifixion, seems oblivious to the mystical event occurring behind him. Throughout the picture, the artist has meticulously depicted flowers, rock formations, and the distant city that stands for the Heavenly Jerusalem. The green tree at the upper left is a reminder of resurrection through Christ's death on the Cross.

Bellini's *Saint Francis* differs from the Flemish version as well as from earlier Italian examples. In Giotto's depiction [8.5], both the seraph attached to a cross, who illuminates the night, and the little chapel are included. Piero della Francesca's predella panel from the Perugia altarpiece [8.6] includes Brother Leo as well. Bellini's picture is more elusive because it does not follow the accepted text of the miracle or the iconographic tradition. Brother Leo is absent, and instead of a chapel Saint Francis has availed himself of a natural cave that serves as both his abode and a reference to the Church as the Rock of Ages. In the Flemish picture, the absent chapel is also implied in the structured quality of the rock formations. With no neat explanation for Bellini's image, the description by one scholar seems particularly apt: "The Saint personifies religious rapture and his exemplary devotion is presented as a model for the beholder, who is encouraged to enter the stillness of Francis's world."[4] The painter also reminds us of his own presence

8.3 Giovanni Bellini, *Saint Francis*, c. 1470s–1485. Oil and tempera on panel. © The Frick Collection, New York.

8.4 Sometimes attributed to Jan van Eyck, *Saint Francis Receiving the Stigmata,* c. 1438–1440. Oil on panel. John G. Johnson Collection, Philadelphia Museum of Art.

by his signature—*IOANNES BELLINUS*—on a strip of paper bound to a branch at the lower left.

Like Bellini's Madonnas, his *Saint Francis* is divided into a clear foreground containing the devotional figure and a background that includes a city, a landscape, and a shepherd tending his sheep. The saint stands with outstretched arms, displaying the *stigmata* on his open palms. He gazes toward the upper left corner of the picture, where several elements indicate the presence of divine light. The yellow cloud

emits barely perceptible rays in the direction of Saint Francis, who is bathed in a different and richer light than the white light of the distant sky. That the yellow light emanates from a divine source is evident not only from its color, but also from its supernatural force in causing the laurel tree at the left to bend toward the saint.

The laurel has been associated with the Cross;[5] its ancient associations with victory might further allude to the triumph of Christ through death. Bending as it does toward Francis, the tree substitutes for the

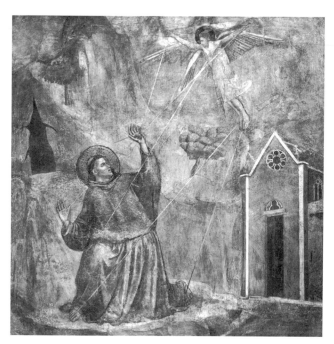

8.5 Giotto, *The Stigmatization of Saint Francis,* c. 1317. Fresco. Outer wall of the Bardi Chapel, Santa Croce, Florence. (Alinari/Art Resource)

8.6 Piero della Francesca, *The Stigmatization of Saint Francis,* c. 1469. Predella panel from the Perugia altarpiece. Oil and tempera on poplar panel. Galleria Nazionale dell' Umbria, Perugia. (Alinari/Art Resource)

more traditional iconography, in which a seraph bound to a cross emits rays that inflict the *stigmata* on the saint [cf. 8.4]. Through the intermediary of the tree-as-cross, therefore, Bellini's Saint Francis receives the divine marks of his identification with Christ. By virtue of this substitution, natural manifestations have replaced the traditional mystical apparition, which is consistent with Saint Francis's legendary powers of communion with nature.

There is, however, no generally agreed-upon identification of the precise subject matter of the painting, which is complicated by the fact that it has been trimmed slightly at the top. Over the years, various titles—including *The Ecstasy of Saint Francis, Saint Francis in the Desert, The Stigmatization of Saint Francis,* and just plain *Saint Francis*—have been assigned to the work.[6] It lacks certain conventional iconographic elements of the stigmatization, such as the wounds on Francis's feet and side.

Despite the elusiveness of Bellini's iconography, he did retain some traditional details. The skull, which is more usually associated with penitent hermit saints such as Jerome, can denote the Passion of Christ. The Bible resting on the lectern alludes to the studious, introspective character of isolated meditation on the Word of God. Grapevines growing from the latticework at the cave entrance refer to the Eucharist, and the water flowing from the stone spout at the lower left recalls Moses striking water from a rock. That Saint Francis is barefoot, his sandals casually resting under the lectern, shows that he is on holy ground, a convention found in Egyptian art as early as 3,000 B.C. as well as in fifteenth-century Flemish art.[7]

The indication that Francis is on holy ground identifies his rocky enclosure as a sacred space. On a literal, textual level, the setting is La Verna, but, as in the Flemish stigmatization, the insistence on the rocky character of the setting and the way in which it encloses the saint evoke the Church. Millard Meiss has described these rocks as having a "tidal character, ebbing and flowing as though they were impelled by the depth of his [Francis's] experience."[8] The space directly behind Saint Francis, in which the rock strikes Meiss as seeming "to melt in accommodation, forming a natural spreading niche that repeats the shape of his figure,"[9] could also be read as a natural apse. As such, it assumes a triangular (trinitarian) form, blending nature with spirituality and also allying Saint Francis with Christ and the saint's gesture with the Crucifix on the altar.

The prominence of the ass on the outcropping of rock toward the background is clearly significant, although its exact meaning is again elusive. This could be the ass that carried Saint Francis to La Verna; symbolically it can represent the people Christ leads to heaven.[10] The traditional significance of the ass as evil through ignorance notwithstanding, Bellini depicts the ass as a formal parallel to Saint Francis. Both stand on a three-quarter diagonal facing the left of the picture. The ass does not look upward as the saint does, but its ears, outspread as if listening (Francis's mouth is open, possibly singing God's praise), parallel in reverse the arms of the saint. Like the rock, therefore, the ass seems to respond formally and spiritually to the ecstatic saint, enveloped by nature and illuminated by divine light.

8.7 Giorgione, *Sleeping Venus*, before 1510. Oil on canvas. Gemäldegalerie, Dresden. (Scala/Art Resource)

An aspect of Bellini's iconography that also appears in the Flemish panel is the juxtaposition of nature with the man-made architecture of the distant city. Corresponding to this contrast is the presence of Saint Francis in a space where plants grow wild and a rabbit pokes its head through a hole in the rocks, as opposed to the shepherd with his flock and the cultivated fields of the background. To the natural cave inhabited by the saint, Bellini has added several man-made elements: the latticework, the shelf to the left of the lectern, and the masonry below the saint's hands. Francis is thus depicted as a kind of First Man, an Adamic figure through whom the rocks of La Verna, as well as the skull on the lectern, are associated with Golgotha (the hill of the skulls), the traditional site of both Adam's burial and Christ's Crucifixion.

God's palpable presence in the natural setting seems to confer new life on the saint, witnessed by the rabbit from one side and the viewer from the other. Francis has turned from the meager artifacts of human civilization to receive the benefits of God's light. The invigorating effect of God's spiritual presence in nature combines the philosophy of Saint Francis with the Flemish concept of the divine lodged in the physical presence of everyday objects. It is also consistent with the tradition of Petrarchan humanism, in which nature is imbued with God and revivifies humanity.

8.8 Titian, *Venus of Urbino,* c. 1538. Oil on canvas. Galleria degli Uffizi, Florence (Scala/Art Resource).

The Reclining Nude: Giorgione and Titian

Bellini's two famous pupils, Giorgione of Castelfranco and Titian of Pieve di Cadore, elaborated his interest in landscape, at times endowing it with mythological and secular as well as Christian meaning. Little is known of Giorgione's life. He was apparently part of the humanist circle in Venice of Cardinal Pietro Bembo, a poet and historian who knew Latin and some Greek. According to Vasari, Giorgione played the lute and sang so well that he was often hired to perform for the nobility. So great was his attraction to nature, Vasari asserts, and so faithful to life was everything represented in his paintings that he surpassed even his master, Giovanni Bellini.[11] Giorgione, Vasari informs us, was, like Leonardo, passionately convinced that painting is superior to sculpture. In order to prove this, Giorgione demonstrated the simultaneous viewpoints possible in painted images but not in sculptures, which require that viewers walk around them. He did so by painting

a naked man with his back turned, at whose feet was a most limpid pool of water, wherein he painted the reflection of the man's front. At one side was a burnished cuirass that he had taken off, which showed his left profile, since everything could be seen on the polished surface of the piece of armour; and on the other side was a mirror, which reflected the other profile of the naked figure; which was a thing of most beautiful and bizarre fancy, whereby he sought to prove that painting does in fact, with more excellence, labour, and effect, achieve more at one single view of a living figure than does sculpture.[12]

There is only one documented surviving work by Giorgione, and questions of attribution regarding other works have vexed generations of scholars. His *Sleeping Venus*, now in Dresden [8.7], is dated shortly before his death in 1510. Owned by the Venetian Girolamo Marcello and seen in his house in 1525, it may have been commissioned to celebrate his marriage in 1507. There have been many readings of this painting: a woman engaged in a pastoral, idyllic dream; a woman having an erotic dream; a woman masturbating for the explicit purpose of increasing fertility (as explicated in contemporary medical treatises); and a woman hiding the absence of a phallus (based on ancient statues of the Hermaphrodite) to allay castration fear in the presumed male viewer.[13]

None of these readings entirely excludes the others, and all have plausible features. X-rays have shown that Titian later added a Cupid holding a bird and a staff seated by Venus's feet; it was painted out in the nine-

teenth century. If the work was indeed commissioned with the patron's marriage in mind, fertility would have been an appropriate feature of its iconography. The reclining nude female was commonly depicted on Renaissance dowry chests for just this purpose. As a work intended for a private patron and thus for private viewing, the *Sleeping Venus* would have been painted with an eye to personal tastes rather than political or religious convention.

Giorgione's soft brushwork and yellow light muted by several layers of glaze is evident in the *Sleeping Venus*. He draws on both Classical antiquity and the contemporary atmosphere of Venice to create a new type of image. Bellini had primarily painted landscapes as backgrounds to his devotional (Christian) works, where they have a metaphorical relationship to the Madonna—as to his Saint Francis. Giorgione's Venus, however, transports the woman to the more universal plane of myth, transcending specific texts. Like the woman in the *Mona Lisa*, Venus *is* the landscape. The form of her body echoes that of the landscape; her sensual flesh, softened by yellow light, repeats the rolling hills of the background. The red lips resonate chromatically with the pillow, and the white drapery brings the illumination of the clouds into the foreground.

The *Sleeping Venus* was unfinished at Giorgione's death and was completed by Titian. Over twenty-five years later, in 1538, Titian completed a related reclining nude, the so-called *Venus of Urbino* [8.8]. This had been commissioned by Guidobaldo II della Rovere, who became duke of Urbino, hence the traditional title. Like Giorgione's *Sleeping Venus*, Titian's nude has been the subject of much scholarly debate—some interpreta-

tions linking her with myth and marriage, others reading the woman as a high-class courtesan. The patron himself left no clues to the figure's identity, referring to her simply as a "nude woman."

Occupying Titian's picture plane is the interior space of a room, evidently a Venetian palace. It is inhabited by the nude woman, a dog at her feet, and two maids gathering up clothes from a *cassone*. The horizontal space is divided equally into near and far by the drapery behind the nude. The vertical edge of the dividing drapery bisects the figure's left hand, drawing attention to her gesture. This has recently been read, like the Giorgione, as a masturbatory prelude to conjugal lovemaking with a view to ensuring fertility.[14]

The kneeling maid who peers into the marriage chest is a displacement of Venus's gesture, for the chest (a box) in the unconscious is the equivalent of the womb. The standing maid, in contrast, gazes down at the chest, echoing the viewer's gaze into the rectangular, boxlike space of the picture. She also holds the nude's clothing, which may refer to the conventional motif of a nymph awaiting the newly born Venus with drapery (cf. Botticelli's *Birth of Venus*, [5.15]). Other iconographic details in the painting are also associated with the mythological Venus, notably the roses in the nude's right hand and the myrtle plant (which remains permanently in bloom) on the window sill.

Despite the virtually identical poses of the two reclining nudes, a comparison of Titian's picture with Giorgione's *Sleeping Venus* offers instructive contrasts. The latter has a more mythic character because the woman blends formally with a generalized landscape. Giorgione's picture includes a

distant city, which has a dreamlike quality. Titian's picture is more specific; its setting is an architectural interior, complete with a tiled floor, a red couch, white sheets, and household servants. The only landscape reference in the *Venus of Urbino* is the tree visible through the window and the sunset sky—the latter possibly an allusion to nocturnal, romantic pursuits.

Giorgione's Venus is more purely in a state of nature than Titian's, who wears pearl earrings and a bracelet. Giorgione's is entirely nude. Most striking, however, is the reversal of waking and sleeping in the two paintings. Whereas Giorgione's Venus sleeps, Titian's nude is awake and the dog sleeps. Another household feature, the dog can represent fidelity but is also a traditional sign of lust. As such, the dog identifies the woman as both a faithful spouse and a willing sexual partner.

Although there is a seductive quality in the pose of both nudes, the fact that Giorgione's is asleep alters the viewer's relation to her. Viewers can observe the sleeping Venus without being observed themselves, and their gaze can wander unselfconsciously over the surfaces of both the woman and the landscape. Those who observe Titian's figure are simultaneously observed by her. If we assume that the intended observer was the patron and that the nude was *his* intended, then Titian has constructed a visual dialogue between them. This would explain the power of the nude's gaze and her challenging, slightly disconcerting impression, for we are neither the nude's intended nor the intended viewers. As a result, we are intruding on someone else's private erotic conversation and are caught doing so by the gaze of the painted woman.

8.9 Giorgione, *The Tempesta,* c. 1505. Oil on canvas. Galleria dell' Accademia, Venice. (Scala/Art Resource)

Giorgione's *Tempesta*

The mythic quality of Giorgione's *Sleeping Venus* recurs in another work whose meaning scholars have found to be even more obscure. The *Tempesta* [8.9] is first documented in 1530 in the collection of the Venetian nobleman Gabriele Vendramin. It is, however, generally dated to shortly before the artist's death in 1510. In contrast to the apparently generalized landscape of the *Sleeping Venus,* the landscape of the *Tempesta,* particularly the flash of lightning, seems to have specific meaning. But just what that meaning is has been a subject of ongoing art historical debate.

Part of the problem lies in the absence of an obvious or generally agreed-upon visual precedent and part in disputes over the textual basis of the picture. What is manifestly

represented are three human figures in a softly textured, subtly illuminated landscape containing architectural elements. At the right sits a nearly nude woman nursing an infant. At the left, a man dressed in Venetian costume leans on a staff and gazes at the woman. She looks neither at the infant nor at the man but out of the picture plane at the viewer. At the center, a river is traversed by a bridge linking the two foreground areas. The dark tree and bushes behind the woman are balanced at the left by a section of wall supporting two truncated columns and a taller section of wall with parts of two round arches supporting a lintel. Over the city in the background, a storm menaces. X-rays of the painting have revealed that originally a second nude woman had been bathing where the man now stands.

Interpretations of the *Tempesta* have run the gamut from mythological to political, from allegorical to Christian.[15] The range of iconographic explanations in the literature on the painting shows both its elusiveness and Giorgione's genius in having created an unprecedented pictorial vision. The figures have been read, for example, as Mars and Venus, whose union produced Harmony (Harmonia); the pharaoh's daughter Bithia nursing the infant Moses, a guardian beside them; the shepherds who found and raised Paris, the Trojan prince; Danae with the infant Perseus and the shepherd who rescued her on the island of Seriphos (the lightning, by metonymy, being Zeus); Hermes with Ino and the newborn Dionysus (in which case the lightning is still Zeus); and Giorgione himself with his wife and infant. Other readings see the painting as a metaphor for the founding of Venice; a reference to contemporary Vene-

tian warfare; an allegory of Fortitude, Charity, and Fortune; an allusion to the origins of the Vendramin family; an illustration of Ovid's account of Deucalion and Pyrrha following the flood; and the fifteenth-century allegorical text the *Hypnerotomachia Poliphili* of Francesco Colonna.

Many more interpretations of the *Tempesta* have been proposed. A recent reading that is particularly well argued identifies the figures as Adam with Eve nursing Cain after the Fall.[16] In this version, the landscape itself is moralized, the bridge being the now inaccessible route to Eden, the background Paradise (the Heavenly City), the broken columns the entry of death into human existence, and the little serpent crawling under a rock in the foreground the usual suspect. The bolt of lightning "is a discreet evocation of the curse."[17] The bather revealed in the X-ray shows that Giorgione was working out his iconography as he went along and considered—but rejected—including the account of Eve bathing in the Tigris River after both the Fall and the birth of Cain.

It is probably more of a comment on art historians than on artists that several of the former have concluded that the *Tempesta* has no subject—that is, not that there are not a man, woman, and child in the painting but that they do not represent a *particular* man, woman, and child; in other words, there is no "text" underlying the image.

This consideration raises the question of the influence of patronage on iconography, for it would seem to assume either that the painting was uncommissioned or that the patron did not request a particular subject. Even if a work is self-generated, however, the notion that an artist creates a figurative

image with no subject is curious. Yet it would seem that landscape, which occupies a large percentage of Giorgione's picture, has a quality of abstraction not unlike that of twentieth-century nonfigurative painting and therefore might lack a specific subject. To the artist's contemporaries and near-contemporaries, including Vasari, the *Tempesta* was as mysterious as it is to modern viewers. The question whether the painting has a "subject" persists. If it does, it has so far eluded detection. Conversely, one might say that its subject has been overdetected—just as a dream is overdetermined, the apparent "subject" of a dream only one of multiple layers of subjects or unconscious subtexts.

The *Tempesta* shares with twentieth-century nonfigurative abstraction an ability to evoke multiple responses to "content" as well as to form. Giorgione's innovations, like those of the nonfigurative abstractionists, lie in the manipulation of formal elements—particularly, in Giorgione's case, of light, color, and painterly texture. What distinguishes the *Tempesta* from modern abstraction is, of course, the retention of figures and recognizable objects such as buildings and landscape.

From the perspective of the twenty-first century, one must conclude from the elusiveness of the *Tempesta* that figuration alone does not identify meaning. But a figurative image, especially if it is puzzling, inspires detective work, which is a tribute to the investigative instinct of scholars. Even nonfigurative images have inspired voluminous theoretical commentary by writers on art. This is a tribute to the human impulse to match words with pictures, and it assumes that the word, or

word-concept, precedes an image. Paradoxically, however, pictures precede words in child development, and this reality has been reversed to create the logocentric myth that God created by the power of his Word. If there is no patron, by this reasoning, there is no one providing a text, that is, putting a concept into words before it is realized in the painting—a notion that very nearly takes the mind of the artist out of the picture—death of the artist, death of the author. The art of painting, as Giorgione demonstrated centuries before nonfigurative abstraction, is about much more than subject matter.

Colorito Versus Disegno

The Venetians took up writing about art later than the Florentines. This, combined with Vasari's bias in favor of Florentine artists, especially Michelangelo, inspired the author Lodovico Dolce to match words with pictures. This is expressed literally in his title *Dialogo della pittura* (Dialogue of painting), also called the *Aretino* after the critic Pietro Aretino (1492–1556). Dolce's *Dialogo* presented Venetian artists in a positive light, with Aretino as their spokesman.

Aretino's aesthetic sympathy with the atmospheric, painterly qualities of Venetian style was consistent with his enthusiastic promotion of Titian's career. Originally a supporter of Michelangelo as well, Aretino turned against him as a result of personal antipathy between the two men. This led to an ongoing debate in the first and second editions of Dolce's *Dialogo* and Vasari's *Lives* over the merits of *colorito*, embodied by Titian's textured color and subtle

8.10 Titian, *Pietro Aretino,* c. 1545. Oil on canvas. Galleria Palatina, Pitti Palace, Florence. (Scala/Art Resource)

effects of light, and *disegno,* typified by the more "linear," sculptural qualities of Michelangelo's style.

Titian's portrait of Aretino [8.10], of around 1545, can be seen as a powerful expression of *colorito,* for the forms emerge in color and light from a darkened background. The depiction of the critic reveals the artist's genius for conveying individual character—in this case Aretino's energy, quick wit, and critical tongue. Shown in three-quarter view from slightly below the waist, Aretino's proverbial bulk is enhanced by his luxurious, graying beard and voluminous attire. The rich, red-brown coat is illuminated by a flickering yellow light playing over the velvet and silk surfaces. The gold chain lying on the brown vest echoes the broad curves of the collar, sweeping from Aretino's neck to his left hand. Aretino turns to the viewer's right, as if something has just caught his attention, and he seems about to speak.

Titian's Last Painting

Titian was enormously prolific. He outlived Giorgione by some sixty-five years and influenced generations of artists. According to Vasari, Titian himself was most influenced by Giorgione: "Having seen the method and manner of Giorgione, [Titian] abandoned the manner of Gian Bellini, although he had been accustomed to it for a long time, and attached himself to that of Giorgione; coming in a short time to imitate his works so well, that his pictures at times were mistaken for works by Giorgione."[18]

Titian worked for numerous patrons, among them the Habsburg emperor Charles V and his son, Philip II of Spain. His wide range of subject matter includes mythological and biblical scenes and portraits and self-portraits. Most of his works are more readily decipherable than Giorgione's surviving pictures, largely because their texts are known. This gives them an air of specificity as well as a hook on which iconographers can hang their scholarly hats.

As Titian aged, his brush strokes became freer, his tones mellowed, and he began to introduce broken color into his forms. These developments are evident if the loose brushwork of his last painting, which remained unfinished at his death, is compared with the tightly orchestrated colors and textures of Aretino's portrait. Titian's *Pietà* [8.11] was originally planned for his burial place in the Chapel of the Crucifix, on the right wall of the Church of Santa Maria Gloriosa dei Frari in Venice.

In this painting, Titian integrates traditional Christian typological meaning with autobiography, thus drawing on two types of text. In contrast to the *Tempesta,* there are sufficient visual precedents to facilitate a relatively secure iconographic reading of the *Pietà* (although certain details have been disputed). The setting of the *Pietà* is Christian, so identified by the abbreviated apse.[19] The central figures are the dead Christ, miraculously illuminated by light, and his mother, who holds him across her lap.

The Virgin's large size in relation to the architecture identifies her, as well as the apse, as the Church building. She and Christ are accentuated by the gold wall and the diagonals of the three large voussoirs (wedge-shaped stone blocks) at the center

8.11 Titian, *The Pietà,* c. 1570. Oil on canvas. Galleria dell' Accademia, Florence. (Scala/Art Resource)

of the broken pediment. The triple nature of the voussoirs alludes to the Trinity, and the pelican in the semidome denotes resurrection and rebirth. Likewise the burning votive candles on the sloping roof of the pediment symbolize eternal life, as does the lighted torch held aloft by the flying putto.[20] Triumph over death is represented as well by the two winged Victories in the spandrels below the pediment. The fig

leaves at the left corner of the pediment allude to the Fall of man, here redeemed through Christ's death.[21]

Flanking Mary and Christ and extending the broad diagonal across the picture plane are Mary Magdalen and a kneeling penitent. The penitent is variously identified as Saint Jerome and Joseph of Arimathea, patron saint of embalmers and grave diggers.[22] These New Testament figures are re-

lated formally to Moses at the left and to the Hellespont Sibyl at the right by the extension of the diagonal plane.[23] Mary Magdalen and the penitent Joseph of Arimathea are accented by the vertical stone blocks supporting the pediment. At the same time, however, their poses and gestures lead the viewer outside the most sacred space toward the figures who represent the prehistory of the Christian era.

The pose of the Magdalen, whose flowing green drapery echoes her distress, is derived from a mourning Venus represented on a sarcophagus that Titian had seen in Mantua.[24] Her raised right hand overlaps the stone statue of Moses, who holds the Tablets of the Law and a staff. With the latter, Moses struck water from a rock, prefiguring the blood of Christ and the miracle at Cana, where Christ turned water into wine.[25] Moses himself was a type for Christ, and his tablets stand for the Old Law, as the teachings of Christ stand for the New. The Hellespont Sibyl, the pagan seeress believed to have prophesied the Virgin birth and the Crucifixion, stands at the right.[26] She wears a crown of thorns and points to the Cross as her gaze seems to follow Moses' gaze out of the picture to the left.

Moses and the Sibyl are supported by lion pedestals. These refer both to the Resurrection of Christ and to the lion throne of Solomon, another Old Testament type for Christ. Two Greek inscriptions behind Moses and the Sibyl reinforce their significance: they read "The Holy Place of Moses" and "The Lord Is Risen," respectively.

At the lower left corner, a putto (or an angel) bends over the Magdalen's ointment jar, referring to her role as the one who anoints the feet of Christ after the Crucifix-

ion. At the right is a complex set of images that constitute part of the autobiographical text of the *Pietà*. The penitent Joseph of Arimathea wears drapery of the red color identified with Titian and is also the artist's self-portrait. He gazes intently at Christ and grasps his lifeless hand. Just above his left foot is a votive plaque with an image of Titian and his son Orazio kneeling before a second Pietà. Behind the plaque is the coat of arms of Titian's family, the Vecelli.

In effect, Titian has "signed" the *Pietà* three times, first with his self-portrait as Joseph of Arimathea, second with his self-portrait as himself together with a portrait of his son, and third with his family's coat of arms. In every case, the "signature" contains a subtext about time, salvation, and continuity. The generations of Christ that are enumerated in the Gospel of Matthew are implicit in Titian's sweep of Jewish history from Moses to Solomon, as well as in the references to pagan history—both depicted as prefigurations of Christianity, which promises the timelessness of eternal salvation. It is with the birth of Christ that the transition between Jewish and Christian history occurs. A related and more personal history is the family history of the Vecelli, signified by the coat of arms.

Like Raphael's *School of Athens*, though in very different ways and separated from it by some sixty years, Titian's *Pietà* is a summation of Renaissance humanism. Both paintings are significantly dominated by an architectural setting, and both extend the typological system to include the Classical revival. The *School of Athens* is part of a larger program in the pope's library, where Christian scenes are depicted on the other

three walls. In the *Pietà,* Christian and pagan elements are merged in a single image. Both works depict living figures on the structural horizontals of the picture's space, and both elevate the stone statues— Raphael onto wall niches and Titian onto lion pedestals. For Raphael as for Titian, stone denotes the past, flesh the present, and both are set in an architectural context.

Following Renaissance convention, a practice consistent with Alberti's advice of 1435 in *On Painting,* the self-portraits of Raphael and Titian declare their own presence, "in the flesh," in the paintings. Raphael had no wife or children, and his identification with the intellectual giants of Classical antiquity is proclaimed by his image in the *School of Athens.* Titian painted the *Pietà* when Venice was anticipating plague. The inevitable anxiety of that circumstance is reflected in the poses and gestures of his figures, as well as in the abbreviated repetition of the central image in the votive plaque. Identifying with the Holy Family, Titian located his future in the continuity of *his* family, depicting his son and the Vecelli coat of arms.

Titian was an old man when he painted the *Pietà,* whereas Raphael was less than thirty when he began the *School of Athens.* It must be assumed that the autobiographical "texts" of the two works were influenced by the ages of their respective authors. Although Raphael's text embraces past and future, he himself appears very much in the present. His self-portrait exudes optimism, youth, and a bright future. He also communicates freely with the viewer. Titian, in contrast, turns his back to the viewer and communicates with the dead Christ and the Virgin. For Titian, in his eighties, the future is imminent death, hence he looks away from the earthly world of the viewer toward the source of his hope for eternity.

Michelangelo and Titian were the last of the great High Renaissance artists. But their late works contain elements of the Mannerist style that began to emerge after Raphael's death in 1520 and that was affected by the tensions of the Reformation and Counter-Reformation. Later sixteenth-century Italian artists, notably Veronese and Tintoretto in Venice, Vignola in Rome, Bronzino and Giambologna in Florence, and Correggio in Parma, looked forward to the development of Baroque in the seventeenth century.

NOTES

1. Rona Goffen, *Giovanni Bellini,* New Haven and London, 1989, p. 52.

2. See Gisella Firestone, "The Sleeping Christchild in the Renaissance," *Marsyas,* 2, 1942, p. 55.

3. David Cast, "The Stork and the Serpent: A New Interpretation of the Madonna of the Meadow by Bellini," *Art Quarterly,* 32, 3, 1969, pp. 247–253.

4. Goffen, *Giovanni Bellini,* p. 111.

5. Ibid.

6. Millard Meiss, *Giovanni Bellini's Saint Francis in the Frick Collection,* Princeton, 1964, p. 13.

7. For example, in the Palette of Narmer (Cairo Museum), Van Eyck's *Arnolfini Wedding Portrait* (National Gallery, London), and the *Portinari Altarpiece* of Hugo van der Goes. Likewise, Muslims remove their shoes before entering a mosque.

8. Meiss, *Giovanni Bellini's Saint Francis,* p. 15.

9. Ibid.

10. Ibid., p. 23 also notes that the gray heron a short distance from the ass has the positive connotations of "the souls of the elect," "ideas of righteousness," and "penitence."

11. Giorgio Vasari, *Lives of the Most Eminent Painters, Sculptors, and Architects,* trans. Gaston du C. de Vere, New York, 1979, vol. 2, p. 796.

12. Ibid., p. 800.

13. For these interpretations, see the articles and bibliography in Rona Goffen, ed., *Titian's "Venus of Urbino,"* Cambridge, 1997. For the latter view, see Seymour Howard, "The Dresden Venus and Its Kin: Mutation and Retrieval of Types," *Art Quarterly,* n.s. 2, 1, 1979, pp. 90–111.

14. Goffen, "Sex, Space, and Social History in Titian's Venus of Urbino," pp. 63–90, in Goffen, *Titian's "Venus of Urbino."*

15. For a summary of interpretations, see Salvatore Settis, *Giorgione's "Tempest,"* Chicago, 1990. See also his references and bibliography.

16. Ibid., esp. ch. 4.

17. Ibid., p. 118.

18. Vasari, *Lives,* vol. 3, p. 1969.

19. See Kate Dorment, "Tomb and Testament: Architectural Significance in Titian's *Pietà,*" *Art Quarterly,* 35, 1972, pp. 399–418.

20. This figure was probably painted after Titian's death by Palma Giovane and is generally referred to in the literature as an angel. However, given the use of antique motifs in the work, the figure is more likely derived from Roman putti with flaming torches that appeared on sarcophagi to symbolize the eternal life of the deceased.

21. For discussions and other interpretations of this motif, see David Rosand, *Painting in Cinquecento Venice,* New Haven and London, 1982, p. 263, n. 89.

22. For an argument that the figure is Saint Jerome, see ibid., p. 83. Identifying him as Joseph of Arimathea are Alastair Smart, *The Renaissance and Mannerism in Italy,* London, 1971, p. 219, and Laurie Schneider, "A Note on the Iconography of Titian's Last Painting," *Arte Veneta,* 23, 1, 1969, p. 218.

23. Much of the present iconographic reading of this painting was originally published in Schneider, "A Note," pp. 218–219.

24. Erwin Panofsky, *Problems in Titian,* New York, 1969, pp. 25–26.

25. Rosand, *Painting in Cinquecento Venice,* p. 83.

26. Schneider, "A Note."

Glossary of
Art Historical Terms

Abacus A square stone element at the top of a capital.

Aerial perspective A technique for creating the illusion of depth on a flat surface by changing the color intensity and contrasts of light and dark.

Arcade A series of arches supported by piers or columns.

Arriccio A preliminary coat of lime and sand in the preparation of a fresco.

Atmospheric perspective Same as aerial perspective.

Attribute An identifying characteristic or object.

Baldachin A canopy over a sacred space.

Baluster The vertical element of a balustrade.

Balustrade A row of balusters supporting a railing.

Barrel vault An extension of round arches creating a semicylinder that resembles the inside of half a barrel.

Bay A section of the interior of a building, usually one of a series.

Buttress An architectural element supporting a wall.

Caryatid A human or animal figure that functions as a vertical support for an entablature.

Chasing The process of decorating a metal surface.

Chiaroscuro A pictorial method of modeling figures through the use of gradual change from light to dark in a picture.

Coffer A decorative recessed panel in a ceiling.

Colonnette A little column.

Contrapposto A stance of the human body in which the waist and hips are turned in different directions around a vertical central axis.

Corbel (or corbeling) A building technique, in which layers of stone courses on two facing walls project increasingly outward until they meet and form a rough arch.

Cornice The top, usually slightly projecting feature of an entablature, or the projection at the top of a wall or other structural element.

Crenellation A series of notches or battlements at the top of a wall for defensive purposes.

Crossing The area in a church or cathedral where the transept crosses the nave.

Donor Someone who commissions and donates a work of art.

Entablature The upper horizontal section of a Classical Order, consisting of the architrave, frieze, and cornice.

Flute A vertical groove in the shaft of a column or pilaster.

Foreshortening Creating an illusion of spatial recession on a flat surface by drawing a form in perspective.

Fresco A technique of applying water paint to the plaster surface of a wall or ceiling while it is still damp, so that the pigments become fused with the plaster as it dries.

Gesso A smooth layer of prime, composed of chalk and glue, which serves as a ground for a painting.

Glaze In painting, a layer of thin, translucent paint (usually oil) applied over another layer to increase the illusion of depth.

Grisaille A painting in gray tones to simulate the appearance of stone.

Iconography The meaning of the subject matter, or content, of a work.

Illuminated manuscript A manuscript decorated with figures or designs to enhance the text.

Illusionism The impression that a representation is the real thing.

Intonaco A layer of smooth plaster over the *arriccio* in the preparation of a fresco.

Isocephaly A technique of placing heads at approximately the same level in a picture or sculpture in order to maintain an impression of horizontal unity.

Lantern The crowning feature of a dome or tower, often used as a source of light for the interior.

Linear perspective A system for creating the illusion of depth in a picture or relief by diminishing the size of a form to denote distance. In one-point perspective, invented in fifteenth-century Italy, orthogonals converge at a single vanishing point.

Loggia A covered, open-air gallery or arcade.

Lost-wax A process by which metals are cast.

Mandorla An oval or almond-shaped form surrounding a sacred personage.

Martyrium (pl. martyria) A burial place for the relics of a martyr.

Metope The rectangular element between the triglyphs of a Doric frieze. Metopes may be plain or decorated with reliefs.

Naturalism A depiction that resembles nature.

Oculus (pl. oculi) A round opening in a wall or dome.

Oil paint Paint made by mixing pigment with an oil binder.

Opus reticulatum A decorative pattern on Roman walls, revived in the Renaissance, which resembles the diamond shapes in a net.

Orders of architecture The arrangement of architectural features, particularly columns and an entablature, in a prescribed manner. The Greek Orders are Doric, Ionic, and Corinthian, and the Roman Orders are Tuscan and Composite. (See Figure 2.11.)

Orthogonal A line perpendicular to the picture plane.

Pediment In Classical architecture, a triangular gable at the short end of a roof. In later architecture, a triangular or round architectural feature over a door, window, or niche.

Pendentive A curved, triangular architectural element that creates a transition between the curved wall of a dome or drum and the supporting flat wall.

Peristyle A wall of free-standing columns around a courtyard or building.

Pigment Powdered color mixed with a binder to make paint.

Pilaster A pillar having a base, shaft, and capital that is engaged in a wall.

Predella The lower section of an altarpiece, often decorated with small panels depicting narrative scenes related to the main scene.

Program The overall iconographic plan of a work of art.

Quarry-faced ashlar Ashlar used for large masonry walls that is only roughly shaped for use as joints.

Quatrefoil A four-lobed decorative pattern, sometimes framing a relief sculpture.

Quoin A hard stone or brick used to reinforce the exterior corner of a wall.

Rib A thin, curved architectural feature used as a support, often in ceiling vaults.

Roundel A small oculus.

Rustication Roughly cut stone having recessed joints, used to create the impression that a building is impenetrable.

Sarcophagus A stone coffin, usually rectangular, often decorated with sculptures.

Scriptorium A room in a monastery where manuscripts are copied and illuminated.

Shading The gradual transition from light to dark in a picture.

Sinopia (pl. *sinopie* or *sinopias*) A preliminary drawing in red chalk (from Sinope, an ancient seaport in Asia Minor) on the *arriccio* in fresco painting.

Size A primer used in painting to seal absorbent surfaces, usually made of water-based glues.

Spandrel A curved triangle between two arches.

String course A horizontal masonry band across a wall.

Tabernacle A niche with a canopy that houses a statue. Also a place of worship.

Tempera Paint made by mixing pigment with water and thickened with egg yolk.

Terracotta Unglazed, fired clay.

Tondo A round painting or relief.

Triglyph Three vertical elements, usually convex, separating the metopes of a Doric frieze.

Triptych A three-paneled painting.

Typology A system of symbolic parallels of figures or events. In Christianity, used to show that the Old Testament was a prefiguration of the New Testament.

Vanishing point The point where the orthogonals converge in one-point linear perspective.

Volute A scroll-shaped element, found on Ionic capitals.

Bibliography

WORKS CITED

Alberti, Leon Battista. *On Painting,* trans. John R. Spencer, New Haven and London, 1966.

Barolsky, Paul. *Michelangelo's Nose,* University Park and London, 1990.

_____. *Why Mona Lisa Smiles and Other Tales by Vasari,* University Park and London, 1991.

_____. "Michelangelo and the Spirit of God." *Source: Notes in the History of Art,* 17, 4 (Summer 1998), pp. 15–17.

Baxandall, Michael. *Painting and Experience in Fifteenth Century Italy,* Oxford, 1972.

Bell, Janis. "Color and Chiaroscuro," in Marcia Hall, ed., *Raphael's "School of Athens,"* New York, 1997.

Bennett, Bonnie A., and David G. Wilkins. *Donatello,* Oxford, 1984.

Borsook, Eve. *The Mural Painters of Tuscany,* 2nd ed., Oxford, 1980.

Cast, David. "The Stork and the Serpent: A New Interpretation of the Madonna of the Meadow by Bellini," *Art Quarterly,* 32, 3, 1969, pp. 247–253.

Cennini, Cennino d'Andrea. *The Craftsman's Handbook,* trans. Daniel V. Thompson, Jr., New York, 1960.

Cole, Bruce. *Italian Art, 1250–1550,* New York, 1987.

Condivi, Ascanio. *Le Vite di Michelangelo Buonarroti scritte da Giorgio Vasari e da Ascanio Condivi,* ed. K. Frey, Berlin, 1887.

Dorment, Kate. "Tomb and Testament: Architectural Significance in Titian's *Pietà,*" *Art Quarterly,* 35, 1972, pp. 399–418.

Firestone, Gisella. "The Sleeping Christ-child in the Renaissance," *Marsyas,* 2, 1942, pp. 43ff.

Focillon, Henri. *Piero della Francesca,* Paris, 1952.

Goffen, Rona. *Giovanni Bellini,* New Haven and London, 1989.

_____, ed. *Titian's "Venus of Urbino,"* Cambridge, 1997.

Gombrich, Ernst. *Symbolic Images,* New York, 1972.

Gottlieb, Carla. *The Window in Art,* New York, 1981.

Hall, Marcia, ed. *Raphael's "School of Athens,"* New York, 1997.

Hibbard, Howard. *Michelangelo,* New York, 1974.

Hibbert, Christopher. *The House of Medici: Its Rise and Fall,* New York, 1980.

Howard, Seymour. "The Dresden Venus and Its Kin: Mutation and Retrieval of Types," *Art Quarterly,* n.s. 2, 1, 1979, pp. 90–111.

Janson, H. W. *The Sculpture of Donatello,* Princeton, 1963.

Kahn, C. H. *The Art and Thought of Heraclitus,* Cambridge, 1979.

Krautheimer, Richard. *Lorenzo Ghiberti,* Princeton, 1970.

Leonardo da Vinci. *On Painting,* ed. Martin Kemp, New Haven and London, 1989.

Lieberman, Ralph. "The Architectural Background," in Marcia Hall, ed., *Raphael's "School of Athens,"* New York, 1997.

Lightbown, Ronald. *Mantegna,* Berkeley, 1986.

Meiss, Millard. *Painting in Florence and Siena After the Black Death,* Princeton, 1951.

_____. *Giovanni Bellini's Saint Francis in the Frick Collection,* Princeton, 1964.

_____. *The Painter's Choice,* New York, 1976.

O'Malley, Charles D., and J. B. de C. M. Saunders. *Leonardo da Vinci on the Human Body,* New York, 1982.

Panofsky, Erwin. *Problems in Titian,* New York, 1969.

Pater, Walter. *The Renaissance,* ed. Donald L. Hill, Berkeley, 1980.

Pernis, Maria Grazia, and Laurie Schneider Adams. *Federico da Montefeltro and Sigismondo Malatesta: The Eagle and the Elephant,* New York, 1997.

Petrarca, Francesco. *Familiares IV.i. Rerum familiarium Libri* IV, 1, ed. V. Rossi in Francesco Petrarca, *Le Familiari* I, Florence, 1933, pp. 153–161, trans. M. Musa, *Petrarch,* Oxford.

Richter, Jean Paul. *The Notebooks of Leonardo da Vinci,* 2 vols., New York, 1970.

Rosand, David. *Painting in Cinquecento Venice,* New Haven and London, 1982.

Rosenthal, Earl. "The Antecedents of Bramante's Tempietto," *Journal of the Society of Architectural Historians,* 23, 2 (May 1964), pp. 55–74.

Roth, Leland M. *Understanding Architecture,* New York, 1993.

Rowland, Ingrid D. "The Intellectual Background of the *School of Athens*: Tracking Divine Wisdom in the Rome of Julius II," in Marcia Hall, ed., *Raphael's "School of Athens,"* New York, 1997.

Schneider, Laurie. "A Note on the Iconography of Titian's Last Painting," *Arte Veneta,* 23, 1, 1969, pp. 218–219.

_____. "Donatello's Bronze *David,*" *Art Bulletin,* 55, 2 (June 1973), pp. 213–216.

Schneider, Laurie, and Jack D. Flam. "Visual Convention, Simile and Metaphor in the Mona Lisa," *Storia dell' Arte,* 29, 1977, pp. 15–24.

Settis, Salvatore. *Giorgione's "Tempest,"* Chicago, 1990.

Seymour, Charles, Jr. *Michelangelo's David,* Pittsburgh, 1967.

_____, ed. *Michelangelo: The Sistine Ceiling,* New York, 1972.

Smart, Alastair. *The Renaissance and Mannerism in Italy,* London, 1971.

Steinberg, Leo. *The Sexuality of Christ in Renaissance Art and in Modern Oblivion,* 2nd ed., Chicago, 1996.

Tolnay, Charles de. *The Youth of Michelangelo,* Princeton, 1969.

Vasari, Giorgio. *Lives of the Most Eminent Painters, Sculptors, and Architects,* trans. Gaston du C. de Vere, 3 vols., New York, 1979.

Watson, Paul. "The Cement of Fiction: Giovanni Boccaccio and the Painters of Florence," *Modern Language Notes,* 99, 1 (January 1984).

Weiss, Roberto. *Pisanello's Medallion of the Emperor John VIII Paleologus,* London, 1966.

White, John. *The Birth and Rebirth of Pictorial Space,* London, 1967.

Wind, Edgar. *Pagan Mysteries in the Renaissance,* London, 1958.

Wittkower, Rudolf. *Architectural Principles in the Age of Humanism,* New York, 1971.

_____. *Sculpture: Processes and Principles,* New York, 1977.

Wren, Linnea H., ed. *Perspectives on Western Art,* 2 vols., New York, 1994.

Zucker, Mark. "Raphael and the Beard of Pope Julius II," *Art Bulletin,* 59, 1977, pp. 524–533.

SUGGESTIONS FOR FURTHER READING

Adams, Laurie Schneider. *The Methodologies of Art,* New York, 1996.

Alberti, Leon Battista. *The Family in Renaissance Florence,* trans. Renée Neu Watkins, Columbia, S.C., 1969.

_____. *On the Art of Building in Ten Books,* trans. J. Rykwert, N. Leach, and R. Tavernor, Cambridge and London, 1988.

Ames-Lewis, Francis, ed., *New Interpretations of Venetian Painting,* London, 1994.

Barolsky, Paul. *Infinite Jest,* Columbia, S.C., and London, 1978.

_____. *Giotto's Father and the Family of Vasari's Lives,* University Park and London, 1992.

Baron, Hans. *The Crisis of the Early Italian Renaissance,* Princeton, 1966.

_____. *In Search of Florentine Civic Humanism,* 2 vols., Princeton, 1988.

Baxandall, Michael. *Giotto and the Orators,* Oxford, 1971.

Beck, James. *Italian Renaissance Painting,* New York, 1981.

_____. *Three Worlds of Michelangelo,* New York, 1999.

Bertelli, Carlo. *Piero della Francesca,* New Haven and London, 1992.

Bober, Phyllis Pray, and Ruth O. Rubinstein. *Renaissance Artists and Antique Sculpture,* New York, 1987.

Brown, Patricia Fortini. *Venetian Narrative Painting in the Age of Carpaccio,* New Haven and London, 1989.

Butterfield, Andrew. *The Sculptures of Andrea del Verrocchio,* New Haven and London, 1997.

Chastel, André. *The Sack of Rome,* Princeton, 1983.

Clark, Kenneth. *The Art of Humanism,* New York, 1983.

Cole, Alison. *Virtue and Magnificence: Art of the Italian Renaissance Courts,* New York, 1995.

Cole, Bruce. *Sienese Painting from Its Origins to the Fifteenth Century,* New York, 1980.

_____. *The Renaissance Artist at Work,* New York, 1983.

_____. *Titian and Venetian Painting, 1450–1590,* Boulder, Colo., 1999.

Collins, Bradley. *Leonardo, Psychoanalysis, and Art History,* Evanston, 1997.

Edgerton, Samuel. *The Renaissance Rediscovery of Linear Perspective,* New York, 1976.

Goffen, Rona, ed. *Masaccio's Trinity,* Cambridge, 1998.

_____. *Titian's Women,* New Haven and London, 1999.

Hartt, Frederick. *"Lignum Vitae in Medio Paradisi: The Stanza d'Eliodoro and the Sistine Ceiling,"* Art Bulletin, 32 (1950), pp. 115ff.

_____. *History of Italian Renaissance Art,* London, 1970.

Hersey, George L. *The Aragonese Arch at Naples, 1443–1475,* New Haven and London, 1973.

Hood, William. *Fra Angelico at San Marco,* New Haven and London, 1993.

Horster, Marita. *Andrea del Castagno,* Ithaca, N.Y., 1980.

Humfrey, Peter. *Painting in Renaissance Venice,* New Haven and London, 1996.

Jacob, E. F., ed. *Italian Renaissance Studies,* London, 1960.

Jones, Roger, and Nicholas Penny. *Raphael,* New Haven and London, 1983.

Kemp, Martin. *Behind the Picture: Art and Evidence in the Italian Renaissance,* New Haven and London, 1997.

Kris, Ernst, and Otto Kurz. *Legend, Myth, and Magic in the Image of the Artist,* New Haven and London, 1979.

Ladis, Andrew, ed. *Giotto, Master Painter and Architect,* New York and London, 1998.

Lewine, Carol F. *The Sistine Chapel Walls and the Roman Liturgy,* University Park, Pa., 1993.

Lightbown, Ronald. *Sandro Botticelli,* 2 vols., Berkeley and Los Angeles, 1978.

_____. *Piero della Francesca,* New York, 1992.

Lotz, Wolfgang. *Studies in Italian Renaissance Architecture,* Cambridge, Mass., 1983.

Maginnis, Hayden. *Painting in the Age of Giotto,* University Park, Pa., 1997.

Martindale, Andrew. *The Rise of the Artist,* New York, 1972.

Martinès, Lauro. *Power and Imagination: City-States in Renaissance Italy,* New York, 1979.

Martinelli, L. C. "Alberti's *Philodoxeos fabula,*" *Rinascimento,* 17, 1977, pp. 111–234.

Murray, Peter J. *The Architecture of the Italian Renaissance,* New York, 1963.

Panofsky, Erwin. *Renaissance and Renascences in Western Art,* London, 1970.

Pope-Hennessy, John. *Raphael,* New York, 1970.
_____. *The Portrait in the Renaissance,* Princeton, 1979.
_____. *Donatello,* New York, 1993.

Rabil, Albert, Jr., ed., *Renaissance Humanism,* 3 vols., Philadelphia, 1991.

Robertson, Giles. *Giovanni Bellini,* Oxford, 1968.

Rosand, David. "Titian in the Frari," *Art Bulletin,* 53, 2 (June 1971), pp. 196–213.

Rubinstein, Nicolai, ed. *Florentine Studies,* London, 1968.

Schneider, Laurie, ed. *Giotto in Perspective,* Englewood Cliffs, N.J., 1974.
_____. "Some Neoplatonic Elements in Donatello's *Gattamelata* and *Judith and Holo-*

fernes," *Gazette des Beaux Arts,* February 1976, pp. 41–48.

Seymour, Charles, Jr. *David: A Search for Identity,* Pittsburgh, 1967.
_____. *The Sculpture of Verrocchio,* New York, 1971.

Tolnay, Charles de. "Remarques sur la Joconde," *Revue des Arts,* 2, 1952.
_____. *Michelangelo: The Sistine Ceiling,* Princeton, 1969.

Trexler, Richard C. *Public Life in Renaissance Florence,* Ithaca and London, 1980.

Turner, A. Richard. *The Vision of Landscape in Renaissance Italy,* Princeton, 1966.
_____. *Inventing Leonardo,* Berkeley and Los Angeles, 1992.

Verheyen, Egon. *The Paintings in the* Studiolo *of Isabella d'Este at Mantua,* New York, 1971.

Wethey, Harold E. *The Paintings of Titian,* 3 vols., London, 1975.

White, John. *Duccio,* London, 1979.

Wilkins, E. H. *A History of Italian Literature,* Cambridge, Mass., 1954.
_____. *Life of Petrarch,* Chicago and London, 1961.

Wind, Edgar. *Pagan Mysteries in the Renaissance,* London, 1958.

Index